CULTURAL POLITICS

Postmodernism, politics and art

CULTURAL POLITICS

Postmodernism, politics and art

John Roberts

MANCHESTER UNIVERSITY PRESS
MANCHESTER and NEW YORK

distributed in the USA and Canada by ST. MARTIN'S PRESS, New York

Published by Manchester University Press
Oxford Road, Manchester M13 9PL, UK
and Room 400, 175 Fifth Avenue,
New York, NY 10100, USA

Distributed exclusively in the USA and Canada
by St. Martin's Press Inc.,
175 Fifth Avenue, New York, NY 10010, USA

British Library cataloguing in publication data
Roberts, John
 Postmodernism, politics and art. — (Cultural politics).
 I. culture. Postmodernism
 I. Title II. Series
 306

Library of Congress cataloging in publication data applied for

ISBN 0 7190 3228 8 hardback
 0 7190 3230 X paperback

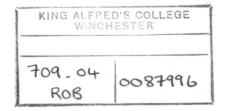
Typeset in Joanna
by Koinonia Limited, Manchester
Printed in Great Britain
by Bell & Bain Limited, Glasgow

Contents

Preface

This book is essentially the product of my frustration with many of the debates prevalent on the left around the question of postmodernism and art. The technological determinism, ahistorical treatment of modernism, and general retreat from Marxism in much of this writing has produced a set of justifications – and denials – of the term which are both confused and reductive.

In this respect the ideas contained in this book owe a large intellectual debt to the writing and art of Art & Language, from whom I've learnt more than perhaps any other writers or artists over the last ten years.

Many people have had a hand in the gestation of this book over the last few years. I would like to thank them all for the practical help or encouragement they have given me: Terry Atkinson, Susan Hiller, René Gimpel, Julia James, Dick Hebdige, Kate Love, Jon Bird, Steve Edwards, Peter Cottridge, Alyson Black, Mike Baldwin and Mel Ramsden, Peter Townsend, Matthew Collings and Mike Archer. I would also like to give a special mention to Dave Evans, for his unstinting scholarly appraisal and intellectual support.

A number of the chapters in the book have been published before in different form. 'Imaging history: the history painting of Terry Atkinson' was published as 'The history painting of Terry Atkinson' in *Mute* 11, Orchard Gallery Publications, Derry, 1989. 'Realism, painting, dialectics: Art & Language's museum series' was published under the same title in *Art & Language: the paintings*, Palais des Beaux-Arts Publications, Brussels, 1987. 'Painting and sexual difference' was published under the same title in *Parachute*, Montreal, July/August/September 1989, and 'Postmodernism and the critique of ethnicity: the work of Rasheed Araeen' was published as 'Postmodernism and the critique of ethnicity: the recent work of Rasheed Araeen' in a very much shorter version in *Modernism to postmodernism*, Ikon Gallery Publications, Birmingham, 1987.

'to be capable of calculation as of dreaming'

Baudelaire

'As a woman I have no country; as a woman I want no country.
My country is the whole world'

Virginia Woolf

For my parents Dorothy and Peter

Introduction

In recent art practice and theory the notion that we have reached a point of crisis, a point of no return, has become commonplace. Theories of postmodernism, as far as the visual arts go, have stressed that we are no longer able to defend – with any certainty – the terrain of modernism; we have reached the limits of its unfolding breaks, its projective horizons. Uncomfortable as it may be, we are now in a period of unparalleled pluralism.

Such declarations of cultural multiplicity are of course not peculiar to the latter part of the twentieth century. We only have to look at the founding proclamations of the Modern Movement itself to realise that the break with the aesthetics of naturalism and realism was a bid for a richer, more heterogeneous cultural mix. But this cultural dynamism of early modernism, rooted as it was in the broad sweep of capitalist modernisation, saw its aesthetic self-enlargements in clearly revolutionary terms. To 'make strange' was not only to clear away the dead wood of academic naturalism and realism but to make a prefigurative claim upon the supercession of capitalist relations. Hence the growth around this time of the ideology of the avant-garde, and the emergence of a propagandist culture. Consequently the artist's commitment to cultural change was by definition a political commitment. The collaborative work of the Constructivists, the inter-media experiments of the Bauhaus, the psychic explorations of the Surrealists, were to be the basis for a new 'social contract' for art. Art was to converge with life.

The reality of art progressing hand in hand with revolutionary consciousness though has been somewhat different. The post-war institutionalisation of modernism under the 'stabilisation' of Western bourgeois democracy as an ideology of 'non-conventionality', far from extending art as social praxis has led to the opposite: to the reification of the artwork as commodity and the restless pursuit of novelty. The history of this decay under commodification is now very familiar: the blank canvas, the film-as-film and the earthsculpture are the point zeros of this transgressive logic. Postmodernism then has

been principally an attack on the political legitimacy of modernist culture. Art should accept its limitations gracefully.

Moreover, this loss of faith in art's social function has been reinforced by an increasing sense of art's historical marginalisation in the face of technological transformation. If late modernism represents the demise of the social practice of early modernism into an enclosed and embattled form of 'authenticity' then this cannot be separated from the huge displacement the production of the visual underwent in the late 1940s and 1950s at the hands of the communications industry. This displacement of course can be traced back to the decades preceeding the social revolution of early modernism itself. The invention of photography and the commercial use of the telegraph began the long erosion of art's public identity. But in the 1940s and 1950s, with the advent of television, the post-war boom in film production, and the growth of the advertising industry, art finally realised the enormity of the conditions weighted against its social visibility and function. If the early modernists saw in the unification of art and technology the prefiguration of new social relations then today, after the massive post-war capitalisation of communications, the possibility of such an equitable relation is now seen as unavailable. Confronted by a media whose power is held to be hegemonic the idea of art mediating any alternative set of values is simply self-deluding. There have been two influential responses to this. One response – what we might call the conservative postmodernist response, as in neo-expressionist painting (for example, the work of Julian Schnabel, Georg Baselitz, A. R. Penck) or attempts to reconvene a new Romantic poetics (Lucian Fabro, John Murphy, Avis Newman, Therese Oulton)[1] – is to celebrate this erosion as a liberation. In a world of media simulacra and pseudo-events, art's value lies in the intensity of the personal and 'private' vision. The other response – what we might term a left-pessimistic postmodernism, as in the work of the American and British simulationists (Tom Lawson, Jack Goldstein, Peter Halley, Jeff Koons, John Stezaker)[2] – is not so much withdrawal from the representation of 'real objective conditions' but the withdrawal from direct ideological confrontation; the signs and images of our media culture are subject to a morally ambiguous reproduction. If the mass media reduces all images and information to the same level, then all art can do, if a pretence of radicality is to be maintained and some vestigial public space for art maintained, is to mirror or stage that lack.

Despite certain differences in response to the crisis of modernism,

the moral ground-tone of postmodernist discussion of art has
clearly been shaped by a profound technological determinism. We
only have to look at the recent profusion of novels and films which
elide technology with fascism to see how deep this sense of resigna-
tion has become. But naturally it is one thing to say that we cannot
claim immunity from the logic of this new social space of maximal
(mis)information and image-production, it is another to say that the
formats of bourgeois representation in a given social formation are
hegemonically in place. Capital may have penetrated cultural produc-
tion to unprecedented heights, but as a consequence (as the
boundaries of class, gender and race shift under the impact of changes
in the relations of production) new forces, new possibilities, new lines
of resistance continue to be opened up. The notion of mass culture
eroding meaning is fatuous when set against an understanding of
culture as a contiguity of practices, forms and discourses that are in
institutional conflict and therefore subject to the ebb and flow of class
struggle. However, this is not to say that art is not marginal, but that
its marginality is never insignificant.

In consequence we should be talking about a changed positional
understanding for the visual arts. The classic modernist account of art's
resistance to the conformities of bourgeois ideology as an act of
perpetual aesthetic distanciation is obviously exhausted, as conven-
tional postmodernism contends. Novelty in art, as a radical break with
the past, is dead. This breakdown is probably best defined in terms
of a shift from a supercessive formal logic to a horizontalised semiotic
one, in which late-modernist categories of 'aesthetic autonomy',
'transcendental form' and 'free-expression' give way to an explicit
understanding of the social production of meaning and value in art.
This in turn necessarily implies the ideologically inflected and
conceptual nature of artistic production. The post-war capitalisation
of communications then, along with the general exhaustion of late-
modernist assertions of art's formal autonomy, has pushed art into a
'second-order' position in its critique of its own resources and of
bourgeois culture.

This leads on to what might be called the radical reading of
postmodernism. Taking its distance from both the conventional post-
modernists and simulationists, it sees the crisis of modernism as
specifically a crisis in representation. In this sense the idea of art as
ideologically combative rests on the necessity to problematise the
referent, to rupture the smooth surface of 'dominant meanings'. Good

examples of this position are The anti-aesthetic: essays on postmodern culture (1983)[3] edited by Hal Foster, Victor Burgin's The end of art theory (1985),[4] Framing feminism (1987)[5] edited by Roszika Parker and Griselda Pollock, and the critical project of the American journal October. It is in these contributions that we encounter the elaboration of a 'radical' postmodern practice. Heavily influenced by post-structuralism's critique of reflectionism and expressionism they seek to link a critique of 'dominant representation' to a critique of representation as such. Thus the political function of art is principally to show how claims to represent the 'truth' and the 'real' are either partial and/or ideologically motivated. Consequently, in line with the Western women's movement's appropriation of the themes of post-structuralism this 'deconstructive' type of postmodernism is rooted first and foremost in feminism's critique of representation as a pure and unitary system of reference. 'Radical' postmodernism then has made its break with modernism not simply in terms of a return to the political referent (as if trying to revive social realism) but in terms of the questioning of the power relations that govern the production and reception of the visual itself. Essentially radical postmodernism is a critique of modernism as a canon and history of Western male authorship. The responsibility of the radical postmodernist artist therefore is to attack the formats of 'dominant representation' as a denial of sexual and racial difference, and the divisions of subjectivity generally.

Central to this project has been the question of the visual apparatus. For crucial to an understanding of modernism as a Western male-centred tradition has been the issue of painting and sculpture as traditions which have actively institutionalised the privileges and subject positions of men. The critique of representation and expression in the Anti-aesthetic for example is principally a critique of the way painting historically has come to displace women as the authors of their own representations. However, because the power of this tradition is so entrenched there is little possibility for women to enter and intervene; the tradition itself has to be rejected, and a new set of resources created, unconstrained by the exclusionary powers of a market based on the high exchange value of painting. Thus the major plank of 'radical' postmodernism has been a defence of photography as a democratic medium and therefore by extension as a source for the critique of the 'self-creating' artistic subject. As Douglas Crimp, one of the contributors to the Anti-aesthetic and a regular contributor

to *October* argues, in the 1950s and 1960s in the work of Robert Rauschenberg photography finally 'began to conspire with painting in its own destruction'.[6] 'The fiction of the creating subject gives way to the frank confiscation, quotation, excerptation, accumulation and repetition of already existing images'.[7] Consequently, given the dominance of photographic reproduction in the culture, photography practically and critically becomes the most persuasive site of art's resistance to the misrepresentations and distortions of capitalist relations.

The attack on the commodity status of painting is of course something that has appeared regularly on art and politics agendas since the 1930s. However, in this instance it is attached to a very different sense of what photography might do politically, rather than conventional defences of reportage or montage. For the emphasis upon quotation, appropriation and confiscation here is essentially a commitment to the *ruin* of representation. This ruin of representation is rooted in what has become the dominant theoretical terrain of radical postmodernism's appropriation of post-structuralism: the reduction of sexual difference to an ontology of paternal Law. Because meaning under 'patriarchal culture' circulates around the primary signifier of the Phallus, then the responsibility of the postmodern artist is to initiate some kind of 'epistemological rupture' in the field of vision, namely the narrative and illusionistic. Insofar as narrative and illusion in painting, documentary photography, film and advertising have subjugated female identity to the sexual pleasures and political interests of men, then the political role of photography must be to *interrupt* this process of centring and construct a specific female spectator instead. Following on from Walter Benjamin, radical postmodernism asserts the critical interchange of image and text.

If radical postmodernism *takes on* the post-war culture of spectacle as a site in which meanings are fought over, a number of other theorists of the postmodern have interpreted the crisis of modernism as a licence to retreat into various forms of aesthetic foundationalism. I have already mentioned the revival of a certain neo-Romantic poetics and theories of expressionism. This is very much an international phenomenon. Thus we have the Transavantgardia of Achille Bonito Oliva in Italy[8] and the 'radical parochialism' of Peter Fuller in Britain. Both claim a postmodernist designation for their respective rejection of the conceptual and political turn of much recent art. Clearly the unifying form of this type of postmodernism is its nationalistic character, for

modernism in their writing is identified closely with a reductive, internationalist perspective, in which local differences are subjugated to the 'grand-plan' of formal systematising. This is particularly strident in Fuller's writing. Fuller not only defends the primacy of painting against other forms of image-making, but defends an indigenous English pastoral tradition as an aesthetically 'healthy' antidote to the machinations of international fashion and the ideological 'reductions' of the political. This battle over meaning for Fuller is centrally an attempt to square up the aesthetic as an act of redemption under capitalism. Art's value lies in its mediation of loss.

This retreat into the affirmative also characterises another version of the postmodern, which although not particular to Britain, nonetheless currently finds its most extended expression there because of the nature of British politics and Britain's historical place within the world capitalist order. This is a revival of what might be called a neo-Stalinist cultural politics. Rejecting the political claims of the simula-tionists and radical postmodernists as either too elitist or adaptive, it seeks to return to the agitational and narrative resources of social and socialist realism. These resources divide along a familiar axis: work which dramatises and stages oppression and exploitation and work which provides a set of 'positive' identities. The latter has certainly been influential amongst women artists whom in wanting to paint and deal with politics, have attempted to produce a feminist social realism. Essentially the common characteristic of this type of work (which might also include murals) is an unproblematic separation of the political referent from the question of pictorial organisation.

If all these positions in some sense represent a response to art's crisis of legibility under capitalism, they nonetheless are all deeply flawed in how and with what art might address this crisis. It is the aim of this book to analyse why this is so. Consequently one of the central issues here is a defence of the position that any adequate reading of postmodernism must be based on the still-determining character of modernism in practice today. In these terms there is a complete misreading of modernism in the postmodernisms outlined above. In the case of radical postmodernism this is based on its de-historicisa-tion of modernism as a formalism and the fetishisation of photography as a source of art's democraticisation. The result is a tendency towards a functionalist cultural politics in which art's relationship to ideology is subsumed under a theory of 'dominant ideology'. Art becomes an extention of ideological struggle. This in turn rests on the politically

dubious reading a number of radical postmodern theorists give to the nature of socialist struggle in the West today after the rise of a New Movement politics. In the case of the conservative postmodernists and the neo-Stalinists, there is likewise a de-historicisation of modernism as a formalism. More specifically though, there is a complete failure to understand and theorise the complexities of the relationship between representation, form and subjectivity.

The result of all this has been in my view an artificial separation between painting and the claims of the new theory, which is why this book concentrates a good deal on the *critical* possibilities of painting today.

But why defend postmodernism as a critical category at all? This is perhaps the most 'scandalous' claim of all of a book which seeks to map out the co-ordinates of political practice today from a Marxist perspective. Postmodernism has so degenerated as a term that it would seem unavailable for use by historical materialism. However, as Marx said, categories are not 'chaotic'[9] in themselves but rather the product of the analysis performed. Moreover, to echo Imre Lakatos, the cognitive value of a theory has nothing to do with its scientific capacity for proof but with its continuing flexibility as a research programme under specific conditions.[10] This is why in analysing postmodernism in relation to the visual arts we need first and foremost to make a clear distinction between the use of the term as an aesthetic–cognitive category that lays claim to changes in various artistic practices' relationship to their own history, function and critical constituency, and the general and more corrigible claim, *pace* post-structuralism, that postmodernism bears upon radical changes in the Western political process and the rule and status of scientific knowledge within it. The problem with much postmodernist theory is that the first is confused with the second, resulting in an unguarded passage of validity claims from one sphere of knowledge to another.

In short, this book claims that the discussion of postmodernism in relation to the visual arts has suffered from a number of specious and confusing justifications. It makes no larger claims for the term beyond that.

The dialectics of postmodernism

Modernism, realism, postmodernism

I have always had the feeling that there was something typically Spenglerian in the historicism – whether explicit or latent – of French philosophy, with its obsessions with the decline and exhaustion of possibilities, with its recurrent pessimism concerning philosophy in general, its submission to the *fait accompli* and to what is unavoidable in the development of philosophical thought, its haste to give into the necessity of the epoch and its resolve not to go beyond what it considers to be its limits and its historical obligations.

Jacques Bouvaresse[1]

The legitimation of postmodernism as a critical category has been subject to intense debate during the 1980s. In fact, as the putative 'logic' of late capitalism, to quote from the title of Fredric Jameson's much cited essay,[2] it has taken on the character of that heroic and pessimistic conception of the history of ideas that Jacques Bouvaresse describes so vividly. Eager to see postmodernism as the dominant cultural and political form of our epoch, numerous commentators and theorists have demonstrated, to quote Bouvaresse again, an 'infantile predilection for systematic excesses and provocations'.[3] Troubled by the seeming irrevocable crisis and effects of modernity – the forward march of labour halted, the reification of the Marxist tradition in the Soviet states, the rise of the nuclear state, the effloresence of a pannational mass culture and the collapse or exhaustion of oppositional realist and modernist cultural practices – postmodernism has come to signify the would-be mutation of the Enlightenment tradition itself. In these terms it is not very surprising that postmodernism has become a catch-all for a whole host of philosophical vagaries and political 'going beyonds'. The downturn in the class struggle in the West, in spite of the gravest crisis of capitalism as a global system since the 1930s, has licensed a rhetoric of the 'break' and the 'rupture' that is unprecedented.

But if postmodernism has been subject in many cases to the speculative and *laissez-faire*, the force of its challenge to those received

identifications and totems of modernity has been equally unprecedented. As confidence in utilitarian and universalist claims to reason and scientific truth have come under increasing assault, unproblematic defences of progress as a sequential process – in either its socialist economistic or social democratic technologist forms – have found few adherents. The centralisation of power involved in the development of large-scale technologies, the destruction of the eco-sphere, and the growth of structural unemployment in both the West and the East, have all sharpened the contradictions of industrial expansionism. Consequently the idea of the West as the 'home' of socialist transformation in the peripheries under the export banner of modernisation has likewise been called into quesion.

As has been noted by a number of commentators on French postmodernism (Perry Anderson,[4] Alex Callinicos,[5] Peter Dews[6]), postmodernism can be seen essentially as an internal critique of Western instrumentalism in the wake of a particularly strong sense of political foreclosure within European culture since 1968. The anti-imperialist revolutions in the peripheries, the continuing failure of the Western proletariat to overthrow capital, the increasing integration of science into the state, the rise of the 'peripheries' within Western capitalism itself – the shift in revolutionary focus away from class to gender, race and sexuality – have all contributed to a decentring of the industrialised West and the Western proletariat as the absolute horizon of socialist, cultural and technological advance. However, if it is legitimate to see postmodernism as an expanded theory of unequal exchange beyond the classical Marxist labour capital matrix, a theory of unequal exchange between men and women, black and white, heterosexual and gay, postmodernism generally has framed such an expansion within highly relativistic terms. The influence of post-structuralism has been a decisive factor. Post-structuralism's critique of metanarratives, its prioritisation of ideology at the expense of production, and its general emphasis upon the rhetorical rather than referential function of language, have all been part of an emergent 'post-Marxist' culture that has met the crisis of the reformist Western left with a *celebration* of fragmentation and the de-territorialisation of disciplines and identities. The 'decisive role of the periphery', in Samir Amin's words,[7] has become the freeplay of the *différend*.

This collapse into relativism and the perspectival is of course at its most explicit in Jean-François Lyotard's *The postmodern condition*.[8] Defending a radical sceptical philosophy on the terrain of a post-

Marxist vision of transformation in politics, science and culture as predicated upon a series of competing but incommensurable language games or 'joustings', Lyotard argues that questions of relevance, adequacy and fit, in discussions of politics, science and art can only lead to 'correct narratives' and 'correct contents'.[9] In fact, a correlation is held to exist between the breakdown of modernist historicism and the great emancipatory narratives; we live on the threshold, Lyotard argues, of an age of micro-narratives, of aesthetic and political pluralism.

That such conclusions are deeply suspect has a good deal to do with what Jürgen Habermas has called post-structuralism's highly selective account of modernity and the legacy of the Enlightenment.[10] The proliferation of the nuclear state, the rise of a manipulative mass media, the post-war commodification of art (its simultaneous spectacularisation and marginalisation) and the sclerosis of the Western bourgeois political process itself, are held to be effects not of *capitalism in crisis* but of technological and industrial processes *out of control*. The tenor of this might be summed up in Paul Virilio's thesis that we are all under the threat of 'non-development'.[11] 'The problem today is that the true enemy is less external than internal: our *own* weaponry, our *own* scientific might which in fact [stands to] promote the end of our own society.'[12] Like Baudrillard, the Heideggerian notion of technology as the death of subjectivity[13] is pushed towards apocalyptic ends.

Thus given the resolute anti-historicism of post-structuralism, much postmodernist theory has failed to give the most basic account of the historical process as a dialectic between quantitative and qualitative change. This absence can be traced to post-structuralism's pervasive anti-foundationalism, a position Stuart Sim, in a fine essay on Lyotard has called 'the rejection of the search for logically-consistent, self-evidently true "grounds" for philosophical discourse, [in favour of] *ad hoc* tactical manoeuvres'.[14] Equating knowledge with power *tout court* under all social systems, the natural and social sciences are not seen as the bearers of socialised knowledge distorted by a given set of social and production relations (bureaucratic 'socialism', Western bourgeois democracy) but as the bearers of alienated knowledge as such. In his defence of the ad hoc as a guide to knowledge Lyotard has gone as far as saying: 'the goal of emancipation has nothing to do with science',[15] i.e., with the systematic meeting of needs on a world scale — just as Michel Foucault has talked, in a

veiled attack on Marxism throughout his writing, about the tyranny of 'globalizing discourses'.[16] That Western science and globalising discourses have been, and continue to be, used for oppressive and coercive ends is the explanatory basis upon which postmodernism as a theory of unequal exchange needs to be defended. This much is obvious and uncontentious. However, by celebrating the 'local, discontinuous, disqualifed [and] illegitimate',[17] to quote Foucault, *against* the possibility of a unified body of knowledge and methodology (one based on conditions of adequacy, empirical evidence and the force of the better argument), the postmodernism of Lyotard, Foucault et al., is forced to align science, reason, politics and Western culture *too* symmetrically with manipulation and coercion. As Sim concludes:

Anti-foundationalism is fundamentally suspicious of the use of meta-levels in any discourse, and while there is a certain justification for this suspicion it can be taken too far – and have unacceptable consequences for the left-wing theorist. If meta-levels are to be equated with authority then its seems inevitable that the radical will have to be opposed to them: especially if the radical is committed to the idea of a paradigm shift. History is littered with examples of theory-bound, foundation-bound institutions which suppressed dissent (that is anything that called domination theory or foundation seriously into question) and the radical is certainly justified in referring to this history of intellectual suppression as a defence of this agonistic practice. What modern anti-foundationalism appears to be demanding, however, is not so much a paradigm shift as a permanent attitude of scepticism, towards any and all paradigms. Paradigms and meta-levels are deemed to be bad things by definition under this reading, and their practical utility in specific sociopolitical circumstances is denied in favour of some kind of anarchistically-inclined permanent revolution.[18]

The central weakness of Lyotard's and Foucault's postmodernism then is that, in conflating science with instrumental reason, Marxism with economism and emancipatory narratives with historicism, they can neither account for progress at the same time as they critique progressivism, nor situate collective political strategy and the institutionalisation of power as anything other than a threat to individual identity. As a result they place undue compensatory emphasis upon the discontinuous, fragmentary and spontaneitist. Breaking the link between the pursuit of truth-claims, historicity and generalisable conditions of human emancipation in the name of a perpetually conjunctural 'micro-politics', they claim that the only progress we can talk about is a history of the *interpretations* of progress. This outright suspicion of historicism is simply untenable when matched against the

actual empirical history of the sciences; new theories or hypotheses are rarely incommensurable with their antecedents. On the contrary, each new stage proceeds from and builds upon what has gone before; an unfolding and contradictory process rather than a unilinear one as in the caricatures of Lyotard. As Sean Sayers has argued: 'The development of knowledge is neither a purely gradual and quantitative process, nor does it involve a total, absolute and arbitrary shift of perspective. Rather it involves a progressive development through qualitatively different *stages*, in which there is *both* a quantitative *and* a qualitative moment.'[19]

Following Lyotard, the emphasis upon the culturally and politically discontinuous has been particularly strident in the theorisation of culture and the visual arts, where the cognitive constraints on 'theory takeover', unlike in the natural and social sciences, are far more malleable. Thus *pace* Lyotard, postmodernism tends to be seen in purely discontinuous terms as a ruptural break with modernism. Modernism's Enlightenment legacy, its emphasis in its early political forms on the critical mediation between art and the life world, is held to be as historically redundant as late modernism's 'perpetual revolution' of means is aesthetically unsustainable. Both collude in their idealism in an overrehearsal of art's critical and emancipatory effects. This is based, however, not just on the collapse of the 'progressivist' cultural politics of the avant-garde but on the post-war expansion of the mass media which has finally deracinated any pretence at a public role for art. For in the face of the massive distributory reality of film and television culture the idea of still-images re-entering the life world in any critical sense – even in a post-capitalist society – is a fantasy. All the artist can do, the argument goes, is stage her or his subjectivity.

This promotion of the artist's subjectivity is principally a political decision for Lyotard. In line with post-structuralism's critique of rule-governed forms and actions as such, the power and value of art lies in its potential freedom from imposed norms, political or aesthetic. For given his theory of the social as a series of incommensurable competing interests, all art can provide in respect of those opposed interests and multifarious subjectivities is a perpetual sense of loss, of the 'unpresentable'[20] nature of reality. 'Modernity in whatever age it appears, cannot exist without a shattering of beliefs and without discovery of the "lack of reality" of reality, together with the invention of other realities.'[21] In other words the self-reflexive nature of art

making lies in its conscious refusal to 'know' the world.

In common with Lyotard and his (contradictory) renovation of what is ostensibly no more than a Romanticised commitment to free-expression, recent postmodernist theory influenced by post-structuralism, in particular the Transavantgardia of Achille Bonito Oliva, has endorsed this retreat from the real as a liberation. Essentially this conflation between post-structuralism and postmodernism has been a theory of withdrawal: withdrawal from any defensible critical function for art, withdrawal from notions of art as social production, and withdrawal from art playing any part in any collective project of human emancipation and communicative rationality.

Such a view therefore takes little account of the *accumulation* of knowledges, skills and forms of life that stand in a position of long-term resistance to bourgeois culture. However, this is not to overemphasise the effects of cultural struggle, or to say that socialism is compatible with the democratic extension of capitalism. Rather the issue is one of perspective. For all 'total system' views of capitalist rationality – be they Foucauldean or Frankfurt School derived – harbour a fundamental weakness. They fail to theorise cultural and political struggles as the bearers of a continuity of anti-capitalist interests. The idea that art's critical function has been superceded in the wake of both the 'end of the new' and a media culture which destroys all difference and distance, is not so much a product of realism but of premature closure. Art's crisis of function and resources is not acknowledged as one *learning* in the face, and problematisation, of the real, but of the breakdown of meaning as such.

This indifference, in the name of political and aesthetic contingency, to an understanding of art as grounded in articulatory struggle within a hegemonic culture clearly makes the conservative claims of Lyotard to have transcended the critical programme of modernism highly implausible. In fact, the failure of most post-structuralist-postmodernist thinking to demonstrate that such a 'programme' no longer holds makes postmodernism's vaunted 'epistemological break' with modernism seem shrill and self-deceiving: namely that the 'good' of art remains bound up with anti-capitalist interests; that human flourishing is bound up with art's non-distorted future place within a popular democratic society. This in turn means of course that, if we are to avoid the negative connotations post-structuralism places on the role of knowledge within representation, we need to argue that all our actions and values involve us in criteria of *relevance*.

The central issue therefore which faces the visual arts today in relation to the culture industry is very simple: there is nothing to be gained in discussing postmodernism by beginning from the abstract generality and fanning out to the particular. For the critical practices of a given social formation soon stand in subservience to that abstraction. This is not to say that independent cultural practices are ever in a strong position to redefine and 'take over', in an Enzensbergian fashion, 'dominant practices' – that is never the issue, but whether the aesthetic resources and theoretical strategies of independent practices are *represented* as active within a given social formation. Without this respect for specificity we are working only with rhetoric.

This lack of specificity around contemporary critical practices is also characteristic of one of the most influential essays on postmodernism in the late 1980s, Fredric Jameson's 'Postmodernism, or the cultural logic of late capitalism'. I mention this because it throws into graphic relief the way conservative post-structuralist readings of postmodernism have even come to dominate those who see themselves as Marxists. Moreover, it shows the general weaknesses of those cultural theorists who *begin* from technological transformation. As relentlessly discontinuous as the post-structuralists in his attempt to rationalise postmodernism as a break with an older cultural order, Jameson likewise weakens the link between modernism and contemporary critical practices. Jameson of course is a sophisticated writer and is not unaware of the problems, but by using the periodising structure of Ernest Mandel's *Late capitalism*,[22] he too eagerly uses key post-structuralist thematics (the death of the subject, the loss of historicity, the celebration of pastiche and the 'post-critical') to construct an *episteme* synonymous with the mass culture of late capitalism itself. In fact Jameson's use of postmodernism is a chronically adaptive one, insofar as he assumes that post-structuralism is *coeval* with post modernism and that this interface is a coherent and dominant cultural force. As such it makes his call for new forms of cognitive mapping in art seem almost feint and adventitious. For there is little dialectical control in the essay between the reality of the new social space we do inhabit and those individuals, practices, works which *are* mapping out a critical response. In an excellent essay on Jameson and the postmodern debate Warren Montag outlines the major deficiency of Jameson as a tendency towards 'pure systemacity'.

The historical present becomes an undifferentiated totality of contemporaneous moments in which instances lose their relative autonomy and art, architecture, literature, philosophy – even the Marxist philosophy of Althusser – are no more than unmediated expressions of 'the Being of Capital'. The classical thesis that 'class struggle is the motor of history', i.e., that as capitalism establishes its domination it simultaneously constructs and organizes the force which opposes that domination (the industrial proletariat) begins to sound positively post-modern! In his desire to escape theories of random difference and disorder, Jameson embraces a theory of domination without resistance and revolt and a theory of capitalist development devoid of unevenness or contradictions.[23]

Thus by defining the dominant tendencies of mass culture as postmodernist, there is little sense in Jameson's geneaology that postmodernism might be a valid critical category within the visual arts, given both the crisis of late modernism and conventional descriptive realism (be it social realist painting or documentary photography). Literally weighed down by the moribund legacy of late modernism's conflation of quality with a 'refusal' to signify (from post-painterly abstraction through to minimalism) and post-war social realism's occlusion of the problem of the subject through its claims to be a 'window on the world', postmodernism has become the necessary means of clearing some ideological space around the question of new forms of cognitive mapping in art. Thus, rather than separating postmodernism as a category from the issue of new forms of cognitive mapping as Jameson does, it would seem more profitable to connect them, insofar as it leads art beyond the closures of late modernism and social realism into the question of the politics of representation. To begin from this position then is to assert that there has been a general theoretical exhaustion of late-modernist claims for the 'expressive autonomy' of art and conventional realism's claims to render the truth of a scene, person or event. As a consequence postmodernism represents the crisis of a 'first-order' approach to expression, be it either defined in terms of 'free-expression', the 'authentic' or 'showing things as they really are'. Jameson's discussion of parody, pastiche and appropriation and the crisis of the modernist monadic subject is clearly an explicit recognition of these problems. However, because of the subsumption of these tendencies into a conservative reading of mass culture, their place within a politicised 'second-order' reading of postmodernism is never developed. Moreover, the link between early modernism and this definition of postmodernism is

abrogated in the process. For, as a second-order definition of art's representational resources, postmodernism is clearly continuous with the *aesthetic* interests of various forms of early modernism: the work of the Surrealists, the photomontages of Hannah Höch and John Heartfield, the 'ready-mades' of Marcel Duchamp and the modernist reworking of popular art within the Leon Trotsky/Diego Rivera/Frieda Kahlo nexus.

Jameson's and French post-structuralism's pure systematicity fails to acknowledge the most basic of historical materialist premises: that analysis of a given conjuncture must *begin* from the contradictions internal to it. Thus if we are to ask the right dialectical questions of postmodernism, we need to examine what it both carries over *and* rejects from the modernist legacy.

1.1 The modernist legacy

The origins of modernism are threefold: its proximity to revolutionary politics and the development of the Western working class, the emergence of the second technological revolution (the motor car, the telephone, photography and film) and the break-up of the old artistic academies and their ruling-class allegiance to classical precedents.[24] It is as responses to, and products of, these conditions that all the major theorists of modernism have developed their aesthetics (Trotsky, Walter Benjamin, Clement Greenberg and Theodor Adorno). Whatever their ideological differences, it is their theoretical encounter with the place and function of art under capitalist modernity that forms the conceptual machinery of our understanding of the modern today: for example, the relative autonomy of art, the question of political and aesthetic resistance (in the face of a manipulative mass culture), the exigencies of art's social utility and the future democratic integration of art into living social relations.

In a sense all writers produced their work in response to the massive transformation of needs ushered in by the capitalisation of mechanical reproduction and the development of a mass entertainments industry. How was the artist to cope with these changes? How was her or his critical independence to be maintained? That the responses or 'solutions' of Trotsky, Benjamin, Greenberg and Adorno to these issues were partial or overarching provides of course those hiatuses or 'failed revolutions' that have supplied the ammunition for conser-

vative postmodernism's critique of the myth of the avant-garde. Trotsky's heroicised defence of the independent artist as marching hand in hand with the revolutionary; Benjamin's advancement of photography and film as the forces that would finally democratise art for the public sphere; and Greenberg and Adorno's stoic defence of 'high art' as a prefigurative 'hold-out' against a dying commercial culture all attest to this. Yet, if such a critique has shown all four writers, despite their differences, to be part of a problematic that assumed too much or too little for art in the face of mass culture, nonetheless the culture of modernism they articulated still forms those conditions of relevance by which art makes its critical and aesthetic moves: that art has emancipatory effects (Trotsky); that there is no critical independence without an examination of the *how* of art (Greenberg and Adorno) and the *where* of art (Benjamin), as well as the *what* of art. The tendency, therefore, to stereotype Greenberg in particular as the point where the modernist project collapsed fails to take account of the shared self-critical culture of modernism, of which his work was a continuing, if de-politicised, part. This is why it is necessary in criticising Greenberg to sort out what was both lost to, and clarified for, modernist culture as a result of his writing.

In many ways Greenberg remains the key figure for the postmodernist debate within the visual arts. For as a critic who, in his writing from the 1930s onwards, addressed himself *specifically*, in the spirit of Kantian self-criticism, to the problems of producing 'advanced' art, his closures on modernism at least allow some critical purchase on the validity/invalidity of the term. By defending, as Greenberg did, the Kantian contrast between the cognitive, moral and aesthetic as spheres which uphold distinct validity claims, we can begin to clarify the specificity of values and conditions of relevance to the spheres of politics, art and science. More importantly though, *unlike* Greenberg, we can also begin to clarify where they cross over. The 'de-rationalising' claims of post-structuralist-postmodernism, however, do exactly the opposite. By de-legitimising science and politics as possible realms of generalisable values Lyotard and Foucault reduce science and politics to the aesthetic ('this is true or good, because I believe it to be so'), just as Lyotard's freeing of art from any basis in social knowledge sets up a false divide between the aesthetic and the cognitive.

The necessity for some redescription and causal analysis of Greenberg's modernism as the prerequisite for any discussion of postmodernism has recently been undertaken by a number of British critics

and art historians (for example, Charles Harrison, T. J. Clark, Fred Orton and Francis Frascina). In this corpus of writing Greenberg's modernism is seen as securing certain explanatory limits. Before we examine the implications of Greenberg's writing let us look at what he has actually said about modernism.

The essence of Modernism, lies, as I see it, in the use of the characteristic methods of a discipline to criticise the discipline itself – not in order to subvert it, but to entrench it more firmly in its area of competence. Kant used logic to establish the limits of logic, and while he withdrew much from its old jurisdiction, logic was left in all the more secure possession of what remained to it.

 The self-criticism of Modernism grows out of but is not the same thing as the criticism of the Enlightenment. The Enlightenment criticised from the outside, the way criticism in its more accepted sense does; Modernism criticizes from the inside, through the procedures themselves of that which is being criticized.[25]

The history of the modern in art for Greenberg therefore lies in art's demonstration of an experience which is 'valuable in its own right and not to be obtained from any other kind of activity'.[26] 'What had to be exhibited and made explicit was that which was unique and irreducible not only in art in general, but also in each particular art. Each art had to determine, through the operations peculiar to itself, the effects peculiar and exclusive to itself. By doing this each art would, to be sure, narrow its area of competence, but at the same time it would make its possession of this area all the more secure.'[27] Hence Greenberg's defence of certain kinds of abstraction in the 1940s and 1950s against what he saw as the abrogation of the problem of art's self-definition in the continuing appeal of conservative forms of descriptive realism.

 Greenberg's 'internalist' defence of modernism in terms of the necessary grounding of high-art in its own material substrate is clearly open to thoroughgoing criticism. Its political innocence is particularly striking, insofar as certain forms of abstraction are quite easily shown to be not so much the product of the very best of what modern culture can offer, but of certain manipulative non-cognitive agencies. Nevertheless, Greenberg's commitment to the 'relative autonomy' of art is useful in providing a powerful corrective to those bureaucratically instrumental defences of 'socially committed' art which would reduce quality and value in art to practical ends or goals. The problem with Greenberg's position, though, is that under the terms of his

historicism such a corrective is pushed to the point of total autonomy and negativity. This is not to say that Greenberg wasn't aware of the 'limiting condition[s]'[28] of art, but that the necessity for art to work on its means finally subsumed the necessity for art to work on its ends. Greenberg's reduction of art's powers of self-definition to work on the material substrates of painting and sculpture – as a bid for critical distance – in the end abandoned itself to forms of managerial-class coherence.

Thus if Greenberg's 'pure negativity' is easily deconstructable the aspirations of modernism as a self-critical and critical culture remain ineluctably compelling. In their introduction to *Modernism, criticism, realism*, Charles Harrison and Fred Orton attempt to outline this.[29] As they say, modernism may no longer be dominant in virtue of its adequacy as theory, but as a *culture* – a culture of disaffirmation and cognitive development – it is the dominant one we have to work with. The issue therefore is one of acknowledging modernism as *structurally* grounded in the misrepresentative agencies and mechanisms of capitalist culture. Consequently, to quote Harrison and Orton, we need to recognise that art is '(1) . . . *cognitively* (and not simply culturally) significant; (2) that its cognitive significance is misrepresented in Modernist theory (as it is in many critiques of Modernist theory); and (3) that the Modernist misrepresentation of art's cognitive significance is effectively a means to insulate Modernism against substantive critical and historical examination'.[30] In short, by devaluing the normative resources of communication in art – mimeticism, description, metaphor and narrative content – modernist theory came to separate the question of critical value from a discussion of the relationship between aesthetic and cognitive skills as rooted in the social development of knowledge. What makes Greenberg the key figure in any discussion of post-modernism is that his position both denies and acknowledges this. For however bureaucratic his position became, his defence of self-reflexiveness in art as the means by which art tests the adequacy of its resources in front of the world is grounded in a view of the modern in art, like that of Trotsky's, Adorno's and Benjamin's, that asserts that meaning in art can only be found and generated through transformational practice. It is no surprise to learn then that Greenberg learnt his modernism from Trotsky's writing in the 1930s. The emphasis in Trotsky's *Literature and revolution* (translated in 1925)[31] and 'Manifesto for an independent revolutionary art' (written with André Breton in 1938) on the critical independence of

the artist was an important influence on Greenberg's early attacks on academicism. As Trotsky and Breton say: 'Specifically, we cannot remain indifferent to the intellectual conditions under which creative activity takes place; nor should we fail to pay all respect to those particular laws which govern intellectual creation'.[32] Similarly Greenberg's critique of kitsch echoes both Benjamin and Adorno's critique of those artists who would conflate political commitment with aesthetic interest in art. And it is for these reasons that T. J. Clark in the early 1980s could argue: 'Modernism is our resource. We may have problems with it. We may in some ways be, or feel ourselves to be moving towards the outside of it. We are not somewhere else.'[33]

To assert that we *are* somewhere else, as this book contends, is to assert therefore that modernist culture remains *prior and determining*. For what the leading theorists of modernism addressed and recognised was the fundamental paradox of art under capitalism: that meaning in art is entailed by capitalist relations, but values cannot be secured solely in anti-capitalist reference. In these terms it is far more profitable, contrary to those who would see postmodernism as an epochal break with modernism, to address the term as a proliferation of the modernist legacy. But on what grounds is this possibe? For if modernism is still determining as a culture, then why is it necessaary to use the concept of postmodernism in the first place?

One of the areas not discussed in the anthologies *Modernism, criticism, realism*, and *Pollock and after: the critical debate*,[34] which deals with the ideological conditions of American artistic culture in the 1930s, 1940s and 1950s, is the question of the extension of art's critical constituencies in the 1970s and 1980s across a multiplicity of subject positions and ideological fronts. This may be implicit in the texts or may be the subject of other publications by the editors but no explicit account is given of the production, consumption and criticism of art around the issues of gender, race and sexuality. That these issues have become central to recent radical American accounts of postmodernism, and in the writings of British post-structuralist/postmodernist theorists/artists such as Mary Kelly and Victor Burgin, in a way that colludes with a discontinuist reading of postmodernism, is a problem that undoubtedly has a great deal to do with the editors' refusal to join the general throng of 'post-painting' and 'post-Marxist' celebrants of postmodernism. In the work of the Americans *et al.*, postmodernism represents the end of class struggle as the principal motor of emancipatory transformation and the end of the 'masculine' high-arts of

painting and sculpture. Postmodernism stands principally as a theory of photographic intervention within 'dominant visual ideology'.

Yet, if postmodernism does have validity as a theory of unequal exchange, then it rests on this question of the *dispersal* and extended *particularity* of arts critical interests in the wake of that supplementarity of points of resistance engendered by a symbolically overdetermined late capitalism. For despite the importance of stressing the shared nature of Trotsky's, Benjamin's, Greenberg's and Adorno's modernism as a culture of resistance, the terms of that resistance were locked into a perspective which saw art waiting for its social restitution. This was to be achieved either through technological advance or through a shift in the economic base of society. In a fundamental class-determinate sense the latter still holds. Only a socialist transformation of the capitalist mode of production will bring about the conditions for the democratic integration of art into society. However, this does not answer of course the question of the place of art in relation to those transitional ideological tasks that precede and in some sense 'produce' the conditions for such a transformation. In many ways, though the Benjamin of 'The author as producer' (1934)[35] is a notable exception, modernism had an undertheorised view of art's ideologically contestary place *within* and *on* the culture. Along with Antonio Gramsci[36] it was Benjamin's writing that broke the chronic class reductionism of Marxist cultural writing in the 1930s. 'The author as producer' did much to open the discussion of art and ideology away from the socialist realist bloc-theory of art's class function. Because the dominant ideas of an epoch are those of the ruling class then the socialist artist must express in as cogent form as possible the aspirations of the working class. As Alex Callinicos has said of this kind of tactical class theory: 'Marxist theory was simply the conceptual articulation of the historical experience of the proletariat, its truth-content depending entirely on its contribution to the struggle.'[37]

What Benjamin broke with therefore was the failure of such theory to account for the specificities of the *reproduction* of class rule. By devising a series of contents that simply *expressed* proletarian consciousness, the possible part art might play in locating and resisting the specific formats of bourgeois representation was effaced. The practical implication of Benjamin's writing is clear: the radical artist had to locate through her or his images the contradictory relationships which constitute a given social formation. Consequently the popular forms of capitalist culture were not things to be rejected as constraining or

degraded by the artist but to be treated as an imaginative and political resource.[38]

This semiotic reading of modernism in which art takes its point of departure from the divisions of social life has of course since the 1930s been subjugated to a more culturally powerful reading of art's relationship to ideology; the artwork as in some sense a haven for, or distant critic of, the ideological conflicts of social life. The roots of this question this century lie naturally in the avant-garde's exclusionary view of the modern in art fighting a rearguard action against the recuperative and consoling powers of mass culture. This position of course finds its most assertive modern defence in Greenberg's 'Avant-garde and Kitsch'.[39] Here Greenberg reduces all manifestations of art's appropriation or engagement with the popular to the form of a capitulation to bourgeois culture. The future of art must be placed in the hands of those independent artists who are struggling against the purveyors of commercially derived meanings. Art must find a continuity of resources to resist its levelling to the entertainments of mass culture. This is what we might mean by Greenberg's cultural stoicism. 'Today we no longer look toward socialism for a new culture – as inevitably as one will appear, once we do have socialism. Today we look to socialism simply for the preservation of whatever living culture we have right now.'[40]

In essence, by seeing the question of cultural resistance as one of transgression and non-conciliation in the face of mass culture, the avant-gardist pursuit of the 'new' and the 'difficult' dramatised itself as an historical and critical journey *outside* of the conformities of the bourgeois social order. Greenberg's redemptive emphasis on preservation simply reinforced this, driving a wedge between the *what* and *how* of art. Like the Frankfurt School after him, Greenberg was unable to theorise art adequately as a form of social production. The result was a mystification of the authenticity of high-art.

The critical implausibility of modernism's defence of such autonomy against the now dominant identification of pleasure by the working class and large sections of the middle class, as commensurate with mass entertainment, is that historical juncture that we might legitimately call postmodernism. As such postmodernism could be said to offer a change in the positional logic of the *how* and *what* of art. For if mass culture appropriates meanings already extant in the culture and transforms them in such a way as to reinforce capitalist hegemony, then mass culture or popular capitalist culture becomes not so

much an abstract system of domination which excludes the aesthetic and cognitive insights of art, but a site of contradiction and struggle in which art participates. This was the lesson of Benjamin and Gramsci. That this 'open' view of capitalist culture presents a number of problems for art (see the section 'Ideology, art and postmodernism' in this chapter) should warn us from assuming that we have entered a new and benighted age of democratic enlightenment, as if art's participation in the culture under postmodernist categories is some-how more equitable. However, what it does focus on – in theory at least – is the otiose nature of the high-culture/mass culture split. Thus a provisional definition of postmodernism might be as follows: the production of various cultural forms in which people deal with / articulate/share/resist[41] the experience of late capitalism as a discur-sive political space. Consequently the notion of postmodernism being a proliferation of the modernist legacy across subject positions and ideological fronts is not to be identified simply with a plural extension of art's contents, but with the dispersed, articulatory basis of art's work on capitalist culture. This immediately implies of course a qualitative shift in understanding of art's signifying function following the his-toricist formal crisis of modernism. The critical in art is no longer identified simply with work on formal breakthroughs, but with art's place within the social production of meaning. This is not to say that criticality in art now stands outside the problems of pictorial organisation, but rather that if art is to 'enter the culture' then it must work, pace Walter Benjamin, on those dominant cultural materials at hand, those decathected and de-historicised signifiers which play a part in the reproduction of bourgeois relations.

As T. J. Clark has said in one of the best outlines of what is at stake here:

there are always other meanings in any given social space – counter-meanings, alternative orders of meanings, produced by the culture itself, in the clash of classes, ideologies and forms of control. And I suppose I am saying, ultimately, that any critique of the established, dominant systems of meaning will degenerate into a mere refusal to signify unless it seeks to fund its meanings, on the other side of negation and refusal, but in signs which are are already present, fighting for room – meanings rooted in actual forms of life; repressed meanings, the meanings of the dominated.[42]

This is why of course we might speak of issues around gender, race and sexuality as being central to the postmodernist problematic. For it has been the de-legitimising place of feminism, gay politics and

issues of race that has been the fundamental component of the break-up of universalist and crude historicist accounts of modernism.

What is crucial here obviously is some Gramscian view of cultural politics as a 'war of position' across many fronts: points of resistance where an alternative practice of signification might begin to work and collect its aesthetic and political resources. In this sense postmodernism's extension of the critical interests of modernism, its learning in the face of the real, clearly lies in connecting art's critical interests with the 'revolution of the subject' since 1968, ie., the rise of what is commonly called 'new movement' politics. However, despite the obvious links between art and these new politics, this is not to say that these new interests represent a 'new socialist paradigm'. This is particularly the problem with radical American accounts of postmodernism and Vic Burgin's The end of art theory. Women's issues, anti-racist and gay struggles take their respective places as the non-privileged components of a new radical democratic politics. (In the terminology of this New Revisionism there are no longer any special antagonisms which have a privileged status in constituting political divisions.) Nor is it a case of defending the critical categories of art, as if 'feminist art', 'black art' or 'gay art' were virtuous in themselves. Harrison's and Orton's Greenbergian defence of the corrective value of the 'disinterestedness' of aesthetic judgement is certainly a warning to those on the left who would close off enquiry through the ratification of works on the grounds of reference or sociological content alone. 'The demands of the aesthetic are indifferent to any contingent sense of the worth of causes', as Harrison says.[43] Rather, it is a question of acknowledging that there is now no false grouping of art's cognitive interest under universal headings. The relationship between representation and cognitive and aesthetic interests is now ineliminably distributed across many domains of critical knowledge, expressive resources and social contents.

The struggle for women and black artists therefore is for a place to speak from and not the construction of new curatorial categories. Nonetheless in the pursuit of these ends there has been a tendency to collapse the possibility of a counter-tradition into a discontinuist-type postmodernism. That this is understandable rests of course on the need of women artists and black artists to open up some critical distance from the dominant culture. But in the process there has been a surplus of verdicts, particularly around the status of painting.

Feminism's critique of the Western fine-art tradition has rested

principally upon the historical collusion of the institutionalisation of painting with the interests of men, with the male gaze. For a number of feminist and New Revisionist theorists, therefore, postmodernism has come to signify the 'end of painting' (Kelly, Burgin, the Americans Craig Owens, Hal Foster and Douglas Crimp). In fact an equation is made, particularly in Burgin and Owens, between the end of painting as male-dominated tradition and feminism's critique of a masculinised class politics. A homology is set up between the so-called productivist 'master narrative'[44] of Marxism – to quote Owens – and the modernist tradition in painting. Both collude, they argue, in the perpetration of the interests of men with 'universal reason'. Both are 'totalising'[45] in their claims. We have of course met these objections to Marxism earlier on. In this instance though, the defence of a deconstructive politics is focused expressly through patriarchy theory. Because meaning under patriarchy circulates around the primary signifier of the Phallus then the responsibility of the postmodern artist and political theorist alike is to initiate some critical rupture in those forms, traditions and categories that perpetuate such a system of division. And this is why photography takes on a particularly important political significance for these theorists. For if painting has institutionalised, and continues to institutionalise, the authorship of men through the market, photography's ideological mobility outside of that market, and high social legibility, allows women artists in particular to meet the disavowal of sexual difference head on. In this sense both Marxism and the Western fine-art tradition are the materials for the problematisation of reference. As Owens says in his contribution to the *Anti-aesthetic*:

It is precisely at the legislative frontier between what can be represented and what cannot that the postmodernist operation is being staged – not in order to transcend representation, but in order to expose that system of power that authorizes certain representations while blocking, prohibiting or invalidating others. Among those prohibited from Western representation, whose representations are denied all legitimacy, are women. Excluded from representation by its very structure, they return within it as a figure for – a representation of – the unrepresentable (Nature, Truth, the Sublime etc).

This prohibition bears primarily on woman as the subject, and rarely as the object of representation, for there is certainly no shortage of images of women . . .[46] What is at issue, is not simply the oppressiveness of Marxist discourse, but its totalizing ambitions, its claims to account for every form of social experience. But this claim is characteristic of all theoretical discourse, which is one reason women frequently condemn it as phallocratic.[47]

The problem with such a scenario is not that feminism is not at the centre of a new politics of representation (problematising the activity of reference[48] is central to a defence of postmodernism as work on the representations of bourgeois culture), but that such claims are used in highly idealist ways to displace a caricatured historical materialism. Owens' reduction of Marxism to the monolithic and productivist simply leaves him with no emergent political context in which to 'conceive difference without opposition'[49] or to challenge the closures of post-war American modernist painting non-reductively. In short, Owens does not know his Marxism. For is it the case that Marx – rather than 2nd International Marxism, Stalinism and orthodox Trotskyism – invokes historical materialism as a 'master' narrative? Hardly. To read *The German ideology* and *Capital* is to be made aware of an historical methodology that is heuristic not deductive. Historical materialism is not a stagist roll-call of modes of production but an interlinking set of research programmes which place the relations of production as the *starting point* for the analysis of a given social formation. Thus it is the institutionalised presence or absence of working-class democracy which designates the socialist character of a mode of production and not the nationalised or state-owned form of the mode of production itself. In Marx the forces of production cannot be defined as socialist independent of the social relations within which they are organised. Defenders of the Soviet Union as a degenerated socialist state make exactly this mistake.

It is therefore one thing to keep in view the 'autonomy' of feminism's critique of representation and class-based politics, of countering that view that women's oppression can *only* be explained if it is put forward as mediating another oppression. It is another to see this 'autonomy' as incompatible with the continuing collective struggle of the working class to 'wrest a realm of Freedom from Necessity', as Engels once put it. As Alex Callinicos has succinctly argued:

Feminists and black nationalists often complain that the concepts of Marxist class theory are 'gender-blind' and 'race-blind'. This is indeed true. Agents' class position derives from their place in production relations, not their gender or supposed race. But of itself this does not prove grounds for rejecting Marxism, since its chief theoretical claim is precisely to explain power-relations and forms of conflict such as those denoted by the terms 'nation', 'gender' and 'race' in terms of the forces and relations of production. The mere existence of national, sexual and racial oppression does not refute historical materialism, but rather constitutes its *explanandum*.[50]

Likewise, are all paintings reducible to a master narrative of Western male authorship? Is painting merely, as Owens contends, the 'simulacra of [male] mastery'?[51] In his 'critique' of Marxism, Owens simply reduces painting to its inherited and imputed contents. The result of this, as the four quotations from Owens, Kelly, Burgin and Crimp below reveal, is a collapse of radical postmodernism's deconstructive politics into the twin sins of technological determinism and ideologism:

contemporary artists are able to simulate mastery to manipulate its signs; since in the modern period mastery was invariably associated with human labour, aesthetic production has degenerated today into a massive deployment of the signs of labour − violent, 'impassioned' brushwork, for example. Such simulacra of mastery testify, however, only to its loss; in fact, contemporary artists seem engaged in a collective act of disavowal − and disavowal always pertains to a loss . . . of virility, masculinity, potency.[52] (Owens)

Consequently even if, at the centre of that paradigm, it is not the truth of an author but that of the signifier itself which is sought, as long as the site of that search is designated as the object or even the system Painting, a problem remains. On the one hand the pictorial text, with reference to the object, is too easily attained − taken in at a glance; on the other hand, as Damisch describes it, pictorial textuality is constituted in a divergence between the register of the visible and that of the readable. 'A divergence by way of which it is appropriate, in relation to the system Painting to pose the question of the signifier'. But since the signifier cannot be produced or even recognised by way of a position of exteriority, the effect of painting, like that of the dream-work, is created 'outside any relation to intepretation'. The truth of painting, like that of the signifier, is the impossibility of knowing it. And the pictorial text remains in a certain sense unknowable, impossible, unattainable. That is why it now seems more appropriate, in relation to the signifying system of the artistic text, to pose, not the question of the signifier but that of the statement.[53] (Kelly)

We can trace the historical emergence of stained glass; its period of ascendancy, its period of superiority, its period of decline. Similarly painting has not always existed, we know more or less when it began, we know a great deal about its development, and about its 'greatest moments'. It seems clear to me that, apart from Cubism's moment of brilliance, like a star that burns most brightly in the moment it extinguishes itself, painting has been in steady semiotic decline since the rise of the photographic technologies.[54] (Burgin)

The rhetoric which accompanies the resurrection of painting is almost exclusively reactionary; it reacts specifically against all those art practices of the sixties and seventies which abandoned painting and coherently placed in question the ideological supports of painting and the ideology of painting in turn, supports.[55] (Crimp)

It is no surprise these evaluations have produced a postmodernism that has reproduced those forms of pre-judgement that Greenberg's modernism degenerated into. Painting simply serves the interests of men and bourgeois culture. Now this is not to say that painting is not implicated in the privileges of men, or that painting is more 'aesthetic' or 'pleasurable' than photography, video or performance, though paradoxically there is still a modernist argument to be made claiming that painting offers a set of pleasures interruptive of the instrumentalities of mass culture. Rather, questions of value in art are reduced to essentialist foreclosure. Moreover, if we are to take seriously the continuity of the modernist legacy as the basis for historical materialist work on and with the cognitive and aesthetic resources of the culture, then any retreat from possible sources of new meaning is a retreat from complexity. As such the issue is not one of abstracting value from certain forms or strategies, but of recognising that the critical spaces we make for ourselves can just as easily fall into forms of easy virtue as be 'radically intractable'.

This of course makes the whole idea of a postmodern break around the historical prioritisation of mechanised imagery untenable. For if painting is an open site of ideological production, if it can still lay claim to the mobility of its cognitive and aesthetic resources, then the notion of postmodernism as marking the beginning of a visual culture free of the 'auratic', unique object is spurious. However this is not because mechanised reproduction is not at the centre of the culture, but that painting is assumed to be no longer able to mediate reality. Thus there is little sense that the analytic powers of photography and its theoretical supports are the critical allies of painting, that painting and photography offer the possibility of new forms of aesthetic interchange. But this failure to see any enabling connection between photographic theory and painting has much to do with the fact that the critical culture of modernism is reduced in radical postmodernism, particularly American radical postmodernism, to its formalist postwar manifestations. Modernism's own complex history and problematising of the referent through photography from Manet to Heartfield, Duchamp and Kahlo, is emptied out. As a result it takes little theoretical effort to 'take over' a modernism which has been historically misrepresented in order to reclaim art's critical function.

The same problems of closure and essentialism in defining postmodernism have also dogged, and in a certain sense determined, the analysis of the collective emergence of black art in Britain. However,

this has little to do with the vicissitudes of painting. Rather, the issue of critical distance has centred on the problems of revaluing tradition as a radically recuperative act. The critique of eurocentrism has placed on the critical agenda the recovery of those local, regional and traditional resources that modernism's formal evolutionism and urban political motivations occluded. In the attempt to establish, or recover, a black tradition or aesthetic (a tradition that owes nothing to the spaces of Western modernism) a number of black artists have sought to rework traditional forms and contents. Within the work of Caribbean artists, for example, such forms and contents are held to represent an 'authentic' black tradition, insofar as it is based on the reclamation of the raw material out of which black resistance since the Diaspora has constructed its values and ideas. The problem with the conservation of tradition, though, is that it tends to fall into, or rather collude with, a managerial colonial discourse, that would essentialise black art in the name of the 'exotic', 'different' or 'primitivistic'. Conserving a native consciousness of the world in the face of the global penetration of capitalist modernity serves to reproduce rather than question modernism as an exclusionary zone for black artists. This is a centrally important question for our understanding of postmodernism. For the ideology of third worldism on which this traditionalism tends to be based appears increasingly impoverished with the rise of the Newly Industrialising countries over the last fifteen years and the creation of a world working class. The idea that the cultures of the third world represent the enduring possibility of a 'hold-out' against Western modernity is increasingly unsustainable. As Nigel Harris has said in his path-breaking book The end of the third world,[56] there is beginning to emerge a new set of geographical relationships underlying a new world system of production. Today the divisions of labour between the manufacturing centres and primary-commodity producing peripheries have disappeared – as well as the political influence of multinational empires. 'The impact of slump in enforcing measures of economic isolation on the great trading areas has not been to recreate the old empires, nor regional trading blocks, but rather to increase the integration of a multitude of independent powers.'[57] However, this is not to say that Western imperialist relations do not still hold sway, or that the shift in manufacturing to the Newly Industrialising countries represents a massive growth in jobs or incomes in the third world (in 1980 the majority of workers in the world were still based in agriculture), but rather the dispersal of

manufacturing to the third world involves the interconnection of different parts of the world in collaborative processes of production. This puts an end to the simple picture of industry as located principally in the West.

The central issue that has faced a number of African and Asian artists living in the West therefore, critical of traditionalism as the 'memory' of pre-capitalist relations, has been to secure a status for black art that consciously resists the categories of the 'exotic' and 'different' *whilst at the same time* recognising the importance of the recovery of non-European and non-white history and experience for art. As the British artist Rasheed Araeen has argued in his many writings, the black artist's defence of modernity lies not in a celebration of cultural difference but in the de-Europeanisation of the expectations of art for a white Western audience. The issue of unequal exchange therefore can only be confronted through placing the self-understanding of black artists within the centre and the peripheries outside the conservative containments of both Western modernity *and* third worldism. This in turn returns us to the problem of judging works of art according to valorised political categories. For if we are to avoid the liberal sentiments and/or left bureaucratism involved in not passing judgement on other cultures or subjugated peoples, then the issue for a critical postmodernism is black consciousness *in* art, feminist consciousness *in* art, and not black art or feminist art. The latter categories can only reinforce racial and female difference by ascribing certain contents and effects to black artists and women artists.

However, this is not to disguise the structural paradox involved in the construction of identity through art. For it is the pursuit of difference, of a space of meanings, of self-narration, not attached or reducible to the already articulated that black artists and women artists 'enter the culture'. This is particularly acute for black artists in Britain and America faced with the historical legacy of black experience as slavery behind them. Thus when Cedric J. Robinson says in *Black Marxism: the making of the black radical tradition*, 'black radicalism . . . cannot be understood within the particular context of its genesis. It is not a variant of Western radicalism whose proponents happen to be black. Rather, it is a specifically African response to an oppression emergent from the immediate determinate of Europen development in the modern era and framed by orders of human exploitation woven into the interstices of European social life from the inception of Western

civilization',[58] he is referring to a powerful sense of imagined community that despite its conservative implications for a modern black culture – that black people were torn from some *whole* culture – supplies the very terms of independence of that culture.

Essentially postmodernism represents a twoway critical interruption of the universalising early European metropolitan modernist experience: internally from within the European and American centres of imperialism, and from without in the production of independent modern practices in the non-Western world that draw on local and provincial resources as a critical corrective to the universalising modernist and conservative de-modernising agencies of imperialism and traditional national popular cultures alike. However, just as modernism itself was subject to uneven development as a result of the place of European national cultures within the hierarchies of Western imperialist power and wealth,[59] the form and character of the dispersal of these changed cultural relations in the non-Western world is subject to the uneven effects of national cultural development. Thus we need to acknowledge the absence or presence of older modernisms, and the indigenous strength or weakness of traditional popular culture, in the formation of these new modernising impulses.

In short postmodernism allows us to speak not only of national cultures being assimilated into the global structures of modernity in different and contradictory ways, but of the fundamental dialectical tension between the the national cultures of the centre and the reclaimed/remembered cultures and practices of their black, non-European critics. It is out of this tension that black identity in art in the West is currently being constructed.

1.2 Realism, relevance and value

If postmodernism could be said to theorise the displacement of modernism's self-understanding as the evolutionary domain of white, Western men, it does not do this on aesthetically and politically relativist terms. The redescription of modernism is not an invitation to retreat into tradition or the perspectival. The struggle continues to be one of realism: the determining and examining of the conditions of relevance and adequacy under which art addresses/symbolises/articulates/shares/resists the experience of capitalism on a global scale. Now this is not to co-opt art into functionalism, but is rather

a question of justification and use. For if representation is an intentioned activity, if representation cannot refer in any meaningful sense but by way of the manipulation and transformation of aesthetic and cognitive materials extant or latent in the culture, then there must of necessity be some discussion of relevance and validity. Thus against the traditionalist or anti-modernist argument, expression is not an occurrence but an ability and if it is an ability then it follows, *pace* any realist theory of knowledge, that it answers or addressess the relevant questions, *viz.*, our culture is a profoundly undemocratic and mis-representative one, and that this un-democracy and misrepresentation is secured, served and reproduced by certain economic, ideological and symbolic agencies. Consequently, if we take a realist theory of knowledge to be adequate to the real cognitive situation men and women find themselves in, then art as an aspect of, and causal agent in, such a theory of knowledge must evoke or call for the 'relevant' data. However, this is not to say that such goals can be prescribed (though some might be), or that such goals in the name of critical use-value or moral strenuousness can be separated from aesthetic performance. But certain goals might be said to be more justified in art – as being in the interests of the 'good' if we take the 'good' to be in the interests of raising various 'truth claims' about the world – given the nature of capitalist culture. But, of course, irrespective of denying that art is a form of knowledge, this begs more questions than it answers, particularly in the light of post-structuralism's refusal to countenance any claim to realism within representation. It is necessary therefore in order to clarify my position and my claims for post-modernism that we look at the realist debate.

To talk of realism in relation to art is immediately to presuppose art's link to the cognitive demands of a theory of knowledge. For if a theory of realism must be adequate to the real situation men and women find themselves in, then realism must submit itself to general criteria of relevance and applicability. David-Hillel Rubin in his *Marxism and materialism* argues that an adequate theory of knowledge must abide by six general criteria: (1) a respect for the irreducibility of the external world, (2) a consistency with science, (3) a defence of a *social* conception of knowledge, (4) an understanding of human activity as central to an understanding of knowledge, (5) an awareness of this in turn needing to be explained in terms of dialectics, and (6) a commitment to the view that an adequate theory of knowledge does not necessarily accept the world as it appears but the way the

world *essentially* is.[60] Rubin here is in principle defending a classic re-flectionist theory of knowledge. Thus as he says: 'There must be a real world of structures (natural and social) in order for us to 'recognise' reality, or come to beliefs about it. There has to be a moment of cor-respondence in our knowledge'.[61] As such, however extensively we have created and transformed the world through our actions and ideas, we need our thought to correspond to reality in order to gain knowledge about what we have done. Rubin is proposing a two-tier system for a materialist theory of knowledge. On one level thought creates and transforms social objects, but on another level it provides us with a knowledge of the objects which corresponds to reality; thought is a product of, and dependent upon, reality but reality is independent of thought and not its singular product. Without this distinction, say the defenders of this 'objectivist' position, concept and reality coincide. Consequently it becomes impossible to talk of objects existing outside of discourse. Moreover, if concept and reality are convergent then we must assume that a change in consciousness will bring about a change in reality. Another 'objectivist' theorist, Andrew Collier, has summed up the correspondence position as follows:

One knows the world, not in pure contemplation, but in acting upon it; that is true. But it is the opposite of pragmatism. It is not that reality is a construction made by us for practical considerations; it is that the practice of transforming reality shows the resistance of that reality to our ends, and forces us to acknowledge it as an *independent* reality, which cannot be moulded by our consciousness, but only by strenuous practical effort guided by painstakingly objective knowledge.[62]

Although we actively create concepts which correspond to the world, this does not mean that we create the reality we contemplate. Rather, the definitions with which we reproduce reality are them-selves derived from that reality, so we can speak of what reality is like apart from our conceptualisation of it. The obvious problem here though is the attenuated status of the subject itself, a problem which Hilary Putnam has characterised as The God's Eye Point of View.[63] How can we define objective truth when we stand in internal relation to the reality we seek to explicate? Or rather, how can we claim that our theories correspond to the world when they are themselves part of it? Internalists or conventionalists therefore prefer the contextual production – or articulation – of the real, rather than its reflection. We are then implicated as producers of the reality we seek to expose, for without this sense of internal relation the idea of arriving at the real

in material reality by deriving abstractions from it breaks down in the face of the transitive nature of the real itself. In this line of argument therefore it is a question not simply of our concepts shaping the real but of contributing to its production.

This attempt to transcend the classic dualism of thought and reality by proposing that every object is constituted as an object of discourse or conceptual scheme is of course the bed-rock of post-structuralism. Post-structuralism's conversion of Ferdinand de Saussure's theory of differentiality into a theory of representation that privileges the place of non-identity and the play of meaning, over identity and the referent, transforms conventionalism into a radical anti-realism.[64] Because language is always at work in our understanding of the world there is no going beyond meaning as relative to, and produced by, discourse. Knowledge of things always holds between a sign and a concept and not between signs and things independent of signs. Moreover, the signified can never be grasped because it is always giving way to other signifiers (interpretations, definitions). The signifier always misses the referent, as Derrida and Lacan say.[65] On these grounds there can be no assignation of the real to any form of representation because the production of meaning is at all times framed by a system of difference 'behind' and beyond the sign. To talk otherwise is to essentialise signs as full presences. As Sollace Mitchell puts it:

The sign's deconstruction is designed to rehabilitate the signified by fixing it within an inescapable domain of language (or text). Thus when Derrida says that the interruption of the movement of signification is impossible, he means that we can never, either by semantic theory or interpretative practice, bring to a halt the reference of one sign to another that constitutes signification. The signified then would consist of a semantic deferral that is never-ending, since both routes out of the play of signification are closed to us. First, the thing itself is claimed to be a sign, so there is no arriving full-stop at a referent that would determinately settle for us the question of semantic value. Second the signified is but one point in the chain linking one signifier to the next; so, at this end as well, there is no coming to rest at a concept that would fix the sign's content.[66]

Clearly it is the transformative link between language, reality and knowledge that classic reflectionist theory misses. However, is the excavation of the real in post-structuralism any kind of answer? For it is one thing to emphasise the place of language in the construction and interpretation of the real (as reflectionist theory does in fact

acknowledge in a contingent sense), it is another to obliterate the possibility that signs might refer and that in saying what we mean we might say what is true. There may be many ways in which the same objects may be used to make representation real, just as there may be many interpretations of such objects that would extend their claims to the real, but does this make it any less easy to escape the possibility that on occasions there may be an appropriate 'fit' or 'match' between our representations and the world and in our interpretations of such representations? As Mitchell says: 'The charge I [level] against the idealist semantic theory found in post-structuralism is that it fails to give us any clues as to why our words [or representations] are meaningful, either in terms of a referential relation holding between sign and thing or in terms of what a speaker must know if he is to understand the language.'[67]

A stronger way of looking at the problem of realism then needs to avoid both the 'objectivism' of the reflectionists and the relativism of the post-structuralists. We might call this an internalist or fallibilistic realism. We may not be able to speak of the real separate from conceptual schemes and the interpretative instabilities of the sign, but this does not prevent us from arguing that what does get said or represented is real up to a point, or to the best argument available.

Let us be clear here. In talking about realism in art we should dispense with any latent commitment to talk about the truthful rendition of an event or state of affairs as a 'window on the world'. We should not conflate meaning with correspondence, as was the case with the socialist realist tradition, as if certain contents, irrespective of the partiality of signs, could 'show things as they really are'. On the contrary, if the real is transitive and contradictory and therefore unavailable outside of conceptualisation, then art's possible realism lies in the articulation of those asymmetries, antagonisms, hiatuses and conflicting relations which constitute this process. In many ways this is what T. J. Clark was angling at in his reference to the 'clash of classes, ideologies and forms of control',[68] and what I referred to earlier as a second-order approach to practice. One begins from the assumption that there is no such thing as immediate knowledge. The question then is immediately one of defining the real at the same time as it is laid claim to. In these terms the place and discussion of the real in art involves a moment of 'truth' and its simultaneous denial; or possible extension. The real is both located and argued for, and denied coextensively (acknowledged as partial and transitive); which means

'it is how the interpreter reads the object, as the product of an intentional action . . . that is crucial to his intepretation' (my italic).[69]

The understanding of realism here in fact owes as much to the natural language philosophy of Donald Davidson and its 'occasions of truth' as it does to any theory of dialectics. As Davidson says in Inquiries into truth and interpretation: 'Truth (in a given natural language) is not a property of sentences; it is a relation between sentences, speakers and dates.'[70] In rejecting the simple correspondence of reality and thought, Davidson though is not defending a coventionalist position, in which truth is relative to discourse. Rather, what is at stake here is a sense of the truth of our sentences or representations as articulated approximations of an objective world. The consequence of this is that claims to truth are to be guided by the regulative principle of satisfaction. Claims to realism are to be judged by the right perlocutionary force or maximum explanatory power of our representations within a given set of circumstances. In applying to this art we might say the 'relevance' or 'cognitive significance' in art is not a property of images; but a relation between context, the intentions of producers, critical use-value and aesthetic interest.

As a theory of knowledge which seeks to intervene in and struggle for the real, realism allows us to clear away a number of misapprehensions and confusions about what may be meaningful or not meaningful, interesting or not interesting, in the pursuit of conditions of relevance for art under capitalism. Little more can be said than that. Thus we need to return to the modernist argument that value in art must be secured in practice. As the critical basis through which social practices begin to find their conditions of relevance, realism asserts the priority of learning in the face of an objective world. It is in no sense a set of conventions or a style. As the British artists Art & Language have said:

It seems clear (pace Walter Benjamin) that a truly anti-academic art – that is, one which is potentially transformatary and not just antagonistic – will somehow have to be critically unstable (i.e. resistant to incorporation within prevailing modes of identification and consumption), and that this instability will be a feature of its position in the relations of production, and not just of the 'critical' or 'progressive' or 'inconsistent' nature of the images, reflections and representations which it furnishes for the enchanted viewer'.[71]

Art & Language, following the claims of historical materialism, have talked about the vagaries of artistic production as close to the notion of research programmes (see chapter 6). The upshot of the modernist/

realist conjunction then may be more profitably discussed as that heuristic meeting between theory and practice that allows art to 'go on', to gain some knowledge, independence and aesthetic resources for itself against both capitalist misrepresentation *and* socialist senti- ment. Postmodernism in turn represents such an open enquiry on the terrain of a non-linear, post-avant-garde concept of art's critical function within capitalist society.

1.3 Ideology, art and postmodernism

In a certain sense such a view of art's critical powers corresponds to radical British and American readings of postmodernism. As already explained, the deconstructive politics of this work clearly takes its point of departure from the break both Benjamin and Gramsci initiated in the discussion of art and ideology. However, the rationalisations of these positions tend to push a specific attention to ideology into an overarching view of art as 'ideological intervention'. But doesn't this contradict everything I have just said about the possibility of realism? Isn't art's intervention into the 'clash of classes, ideologies and forms of control'[72] exactly that? Well yes and no. Let us return to the question of value. If what *is* at stake is a form of realism that accords central place to what I have termed the structural paradox of art's production under capitalism – that the real in art is entailed by capitalist relations, but that aesthetic value cannot be secured simply in anti-capitalist reference – then we have to be vigilant against collapsing art into functionalism no matter how sophisticated and 'up to date' it might be. Thus it is one thing to defend the articulatory basis of oppositional practices, it is another to collapse art's cognitive interests into a textualist politics. This latter position might be encapsulated along the following lines. Art, as one form of visual representation amongst others (i.e., as 'signifying practices' painting and sculpture have no privileged status as forms of representation), must involve itself in the 'disarticulation' of those 'signifying/textual practices' or 'regimes of truth' in Foucault's words that mediate, construct and reproduce men and women's subjectivity under bourgeois culture. Hence given that these conditons are produced and reinforced by a hegemonic mass culture, art must contest the power of such a culture on its own ground: mechanised imagery.

The art/political consequences of this are obvious. Art becomes an

interventionist force in the struggle against 'dominant ideology'. The artwork as counter-text has to 're-write' those dominant signifying texts which articulate, construct and reproduce the subject in ideology. As Griselda Pollock has said:

Learning to speak is learning to be spoken by the culture to which one is accessed by language. Therefore there has to be a struggle not only about the content of representations but about the signifying systems which are points for the production of definitions, meanings and positions for the subject . . . Art works are texts and can be understood as a site of a particular organisation of socially instituted signs which produce meaning composed of other signs, i.e. other texts and general cultural systems of representation. The viewer must be familiar with these if she is to be able to read the work or text . . . Artworks then – particularly feminist artworks in this case – must be conceived as an 'ideological critique of the power relations of society and with a commitment to collective action for their radical transformation'.[73]

Now to be fair to this position, its defenders do not subsume art into ideological struggle *tout court*. Nevertheless, as with post-structuralism and the New Revisionism as a whole, ideology remains centrestage. In short, art/photography is given the 'new socialist paradigm' treatment: art, as a component part of the ideological struggle for socialism, serves the internal transformation of bourgeois relations.

This model, based to a large extent on a 'culturalist' reading of Gramsci's theory of hegemony (exemplified recently by the work of Ernesto Laclau and Chantal Mouffe)[74] and the functionalist legacy of Althusser, has had considerable influence on a whole generation of writing on the left: the editors of *October*, various contributors to the formation now known as the New Art History in Britain and *Block* magazine, *Re-codings* by Hal Foster,[75] and the various writings of Victor Burgin and Griselda Pollock herself. Outside the world of art, one of the most eloquent defenders of this 'open-system' theory of cultural struggle has been Stuart Hall. His contribution to the anthology *On ideology* in the mid 1970s did much to introduce into cultural studies in Britain a eurocommunist-type culturalist reading of Gramsci: that one of the principal functions of the socialist movement under late capitalism is the struggle of the attainment of ideological hegemony.[76] This view is furnished, more or less, by the Althusserian notion that it is through ideology that social formations are reproduced. As Hall says in an essay published in the 1980s, the struggle within the space of populist popular culture is to '*constitute* classes and individuals

as a popular force – that is the nature of the political and cultural struggle: to make the divided classes and the separated peoples – divided and separated by culture as much as by other factors – into a popular democratic force'.[77] The struggle is to construct a culture which is genuinely popular from the 'bottom upwards' so to speak. The pitfalls for art and politics are obvious. By placing the emphasis upon the construction of political interests in discourse and representation, intellectuals, and in this case artists, are given a leading role in the struggle for socialism. Socialism is to be constructed on the ideological plane out of popular elements irrespective of the class interests that divide them. The self-activity and interests of the working class are subordinated to a Popular Front type strategy of cross-class alliances. The implication for art from this is that the dictates of ideological critique subsume the aesthetic interests and intractabilities of art under a functionalism of 'ideological gains'. Forced into an accountability to the popular and democratic, art is reified under the categories of 'feminist art', 'black art' 'gay art', etc., as part of some would-be routing of the critical effects of art into living social relations.

Now this is to say not that ideological struggles through art cannot contribute to an emergent socialist culture (it is in the hope of such things that the struggle for realism in art is contested) , but that from a textualist/interventionist position the notion of a particularist 'war of position' serves a largely idealised and potentially bureaucratic view of art's transformative capacities under capitalism. The distributory fantasies of Hall have soon shown up their class limits in the 1980s as the labour movement fails to take up the mediating role of the institutions of the art-world. As John Caughie has said in a pointed reply to Hall in *High theory/low culture*:

simply, it seems quite difficult to map the language of struggle, force and resistance on to a culture which is increasingly sophisticated and centralised in its production and dissemination, and which is increasingly experienced by the vast majority of consumers as a comfortable and largely enjoyable necessity. Where and how is the struggle to be conducted, with whom, and with what support? Who is to construct the culture which will constitute the classes into something which at the moment they are not?[78]

To acknowledge this void is not to collapse the argument back into a Frankfurt School perspective and devalue the distributive possibili-

ideology is absolutely central in creating a sense that art participates in the culture. However, in 'vulgar' Marxist terms there are explanatory and functional limits to this. A successful socialist revolution is not just a matter of ideological struggle but of revolutionary strategy. Consequently, given the class limits on art's distribution and consumption, the conflation of art with a counter-hegemonic politics in radical postmodernism lays itself open to the worst kind of political idealisations. In fact art's relationship to ideology takes on a completely different perspective, once we break with ideology as the cement of capitalist relations. Pollock's and Hall's thinking on culture and ideology is predicated essentially on the view of the subject as constructed by ideology. Dominant ideology functions to subordinate the working class to the bourgeoisie. The success of this in the post-war West explains the stability and class integration of capitalism. However, as a number of recent theorists on the ideology question have argued, the penetration of dominant ideology into the working class has been slight.[79] Conrad Lodziak has even gone as far as saying that the majority of the working class is, rather, ideologically indifferent.[80] The ideas which are foregrounded in the consciousness of the subordinated, he says, tend to relate directly to practical needs. 'The consciousness and commitments of the subordinated say far more about their relative powerlessness in the total order of things, than about the influence of the dominant ideology.'[81] Far from dominant ideology securing subordination, it has been the economic manipulation and the prospect of violent coercion by the state that has. As Lodziak argues, there is massive empirical evidence for this view.

The idea of the working class being materially rather than ideologically incorporated into capitalism may be overstated. But nonetheless a fundamental point is at stake here in our discussion of art. The rise of post-structuralism and the New Revisionism, with their emphasis upon the non-correspondence between political interests and material interests, has inflated ideological struggle to the point where the problems that face art *as* art have become mere epiphenomena. The routine signifying chain: the subject: language: dominant ideology, has downgraded what is *excessive* about art as human production: the subjectively intended.

Contrary to this perspective, we might say therefore that it is the tension between the claims for the 'autonomy' of art, rather than a form of social technic, and art's pursuit of use value, of realist accountability, that must form the intellectual basis of any adequate

Marxism, postmodernism and art

Faced with the critical closures around modernity and modernism it is not too difficult to see current discussion around postmodernism as a replay of cultural struggles that have been going on for well over a century: the conflict between art's claims to the status of a 'special' form of knowledge – in Althusser's well-known phraseology – and art's pleasures as being essentially disinterested. The attempt to define a critical function for postmodernism under conditions of art's increasing alienation in the West is not so far removed from the aesthetic debates that preoccupied Marx in the 1840s.

Marx of course never made his views on the visual arts explicit, which is why every attempt to construct a Marxian aesthetics has fallen foul of the snares of 'reading-in'. But nonetheless we see the same conflict between the critical and consolatory at the basis of his critique of the consensus art of his day, as we do today in the struggle over postmodernism. For Marx the art of the Nazarenes and its spiritualist values, which had dominated Prussian culture up until Marx's own time, was held to be, given its religious idealisations, an art of alienation. In the 1840s when Marx's interests were primarily cultural and philosophical, Marx in fact was commissioned to write a critique of Christian art by Bruno Bauer, the left Hegelian. This project appears to have developed from Feuerbach's critique of Christian art in The essence of Christianity (1841)[1] as a 'fetishistic' alienation of human nature, Heinrich Heine's celebration of the sensuality and securalism of Hellenistic culture, and Saint-Simon's theory of the avant-garde and its transforming function. The book of course was never written but these thematics are scattered through Marx's economic writing: the reading of art as a question of showing the 'how' of historical change, rather than simply showing the 'what'; art as a form of produced production like any other social practice; art as ideologically performative (the interrelationship between the production of values and consumption of values as moments of a single act; the production of consumers). Now even if we can point to the fact that the last point has played a massively overburdened role in the history of left

modernity is seen as the basis upon which we think and act collectively through the negative, rather than the failed capitalistic logic of the new, then the post-avant-gardism of postmodernism can be seen as continuous with the demands of the modern. To defend postmodernism as a proliferation of art's critical interests across subject positions, ideological fronts and expressive resources is to defend the necessary and emergent relationship between knowledge, representation and the world.

Modernity in art therefore is not to be identified as some unidirectional force that can be invoked to displace the not-modern or not-so-modern, but that unfolding political space into which art's transitive relationship to knowledge projects itself (see the next chapter).

Thus, from a continuitist/discontinuitist perspective there is no retreat from the complexities of contemporary art's production and consumption. A postmodernism which emphasises the multiplicity of art's causes and effects across many subject positions, ideological fronts and expressive resources attempts to secure this.

philosophical culture of realism, that the term can begin to exhibit the 'cognitive rationality' I claim for it. Or rather, by laying claim to the validity of such continuities, my claims for postmodernism allow us to unpack some of the misrepresentations and idealisations that have accompanied, and continue to accompany, the production and distribution of art this century. This is why I emphasise the need to see postmodernism as a proliferation of certain critical interests. For as a materialist and aesthetically inclusive account of art's production across subject positions, ideological fronts and expressive resources it teleologically extends and *takes over* the dictates of philosophical realism (the pursuit of conditions of relevance and adequacy) and the demands of modernism (the grounding of value in practice; the non-correspondence between political reference and value). The word teleological, though, perhaps needs to be explained here, given its unfortunate 2nd International Marxist connotations. What I am invoking is not some kind of art-theoretical process of natural selection, in which my version of postmodernism is the inevitable outcome of the political crisis of late modernism and conventional realism. This is to assume that some events have later events as their efficient causes, which is bad history. Rather, to talk of teleology is to talk of there being a tendency for a certain outcome to occur.[84] Thus given the crisis in late modernism and conventional realism there was an historical tendency for the question of the politics of representation and art's necessary second-order status to be put on the art-historical agenda (irrespective of how such a question has actually been dealt with). We explain something teleologically then not by saying one thing makes another thing possible – that capitalist society *makes* communist society possible for instance – but by showing how a given set of phenomena contributes to the tendency of a system or a set of relations to achieve a certain result. When I explain postmodernism in terms of a continuity in certain claims of modernism and philosophical realism, I am claiming therefore that postmodernism is *best* understood as the transformation of certain *persistent* tendencies within art given the nature of its place under capitalist society.

Postmodernism is at its most coherent as a 'strong alternative' theory when it is addressed not as a shift in stylistic allegiance or as the final overthrowing of the auratic object but as the political and contingent 'calling back' of art to a particularised and non-transcendental view of its conditions of production and effectivity. As such, postmodernism's *compatibility* with modernity becomes clearer. For if

discussion of postmodernism. Or to put it another way, we need to problematise the political status of art *at the same time* as asserting this is where art is to find its conditions of relevance. A particularist approach to cultural production must avoid assimilating itself to a counter-hegemonic approach to political transformation.

Habermas's writing on aesthetics makes some pointed reminders here. For Habermas the real historical stake for art – the real historical materialist stake – lies not in transcending the 'autonomy' of art but in transforming the 'constellation'[82] of institutional forms that prevent it exploding its aesthetic capital into living social relations. This defence of 'autonomy' though is not to be be confused with Greenbergian notions of aesthetic withdrawal. On the contrary, it means that the advance towards, or retreat from, such a transformation of the 'constellation' of art's production and distribution – i.e., a break with capital – cannot, in the name of realism, be separated from questions of aesthetic value. To paraphrase Art & Language, 'autonomy' has to be worked for. Thus in distinguishing postmodernism from its functionalist and technologist readings, before artworks are 'interventions' or 'objects of resistance' some real transformations of aesthetic and cognitive materials have to be demonstrated. There can be no assertion of value, political effectiveness, etc., outside the judgement of such a demonstration.

Postmodernism is not a stable sociological category. Clearly it cannot be. However, as a theory which, in my estimation, exhibits 'cognitive rationality', to borrow the terms of Imre Lakatos[83] – rather than a theory which has scientifically passed the test of high falsifiability – I believe it provides a good explanation of a large amount of data. My differences with radical versions of postmodernism then lie not in contesting the possible use of the term to designate changes in Western art culture, but what it has been called upon to signify in the name of these changes. Radical postmodernism is at turns idealist and reductive in its political and aesthetic claims. By addressing the question of the problematisation of reference solely within photography, there is no sense that what is always at stake is the transformation of a culture at many levels and across many practices. Moreover, as with all prescriptive art criticism founded on the prioritisation of certain media or effects, radical postmodernism takes little account of the aesthetic implications of what is being argued for. Thus in my view it is only by addressing the continuities, as well as the discontinuities, between postmodernism and modernism and the

aesthetics, legitimatising the worst kind of agit-propagandist and, recently, theoreticist role for the visual arts, these three proscriptions clearly point to the view that Marx saw art as the product of active social knowledge and thus compatible with a definition of historical materialism as critical enquiry within open systems. The notion of art being based upon a contemplative model of knowledge (of the privileging of doing above thinking) is thus untenable. This is why we should be grateful to Margaret Rose for finally laying these ghosts to rest. In *Marx's lost aesthetic: Karl Marx and the visual arts* (1984)[2] Rose painstakingly reconstructs the aesthetic debates that informed Marx's scattered thinking on the visual arts, in particular the famous introduction to the *Grundrisse*.[3] For Rose, Marx's continual stress on art's productive character, on its necessary subjection to the same laws and conditions of material and intellectual life as other forms of production, clearly distinguishes Marx's view of the cognitive role of art from both crude reflectionist theories and notions of art as pleasurable illusion. Contrary to popular myth, there is nothing in Marx's writing that would make him a defender of socialist realism or any other affirmative practice. This means, therefore, that if art has explanatory power as a human activity in virtue of the examination of its means of production and consumption, then we cannot assent to a concept of creativity as being categorically separate from the critical.

It is perhaps no surprise then that, after a period of relative theoretical silence within the area of the visual arts, Marx should recently have been proclaimed as an ally for aesthetic modernity in the face of the general 'call to order' of the conservative postmodernists. Not only does Rose's book emphasise the necessary relationship between the modern and the critical in Marx's productivist view of art, but in Marshall Berman's *All that is solid melts into air* there is a clear and ambitious attempt to reclaim Marxism as a modernism.[4] However, if Berman, like Rose, sees the importance of 'discovering connections and continuities with the past in the past and the past in the present' to borrow a phrase of Tony Fry's,[5] there are many problems with his view of the modern that mirror, in a reversed form, the vagaries of the conservative postmodernists. Moreover, it confuses what is important in Marx in a defence of postmodernism in the visual arts. For like Lyotard's, Berman's view of modernity in art is not based on any examination of the relationship between picturing and the active development of cognitive skills, but on a de-historicised defence of the continuing validity of the avant-garde as a space of free experi-

mentation. Nonetheless, this should not distract us from an extended analysis of Berman's claims. For what is of primary interest about *All that is solid melts into air* is the opportunity it offers – as Perry Anderson in his reply in the *New left review* has cogently demonstrated[6] – to discuss what is not possible in any adequate account of modernity and the visual arts. As such, Berman's book and Anderson's essay provide a profitable basis for a summary discussion of modernity and post-modernism.

For Berman, Marx was the 'first' modernist; the *Communist manifesto* (from which the title of the book comes) is the home of 'some of modernist culture's deepest insights',[7] insofar as what stirs Marx is the 'active and generative process through which one thing leads to another'.[8] Thus, as Berman notes, it is the bourgeoisie who are praised in the *Manifesto* for their energy and organisational ability. This drive for development and change is for Berman the key to Marx's vision of the future, and the motor behind Marx's communism of the 'free development of all'. Modernity, modernism and the productive forces of capitalism will lead us onward to new cultural and technological heights. As Berman says: 'To be modern is to find ourselves in an environment that promises us adventure, power, joy, growth, transformation of ourselves and the world – and, at the same time, that threatens to destroy everything we have, everything we know, everything we are'.[9] Cultural modernity lies therefore, in Marx's phrase, in the pursuit of a life without auras. For without the promises of modernity we are confined to the narrow horizons of tradition and community and the circumspection of old allegiances and patterns of behaviour. This is why, Berman argues, modernity is feared so much: 'It is modernist culture that keeps critical thought and free imagination alive in much of the non-Western world today.'[10]

Such an uncompromising defence of modernist historicism may be a spirited attempt to face up to the radical anti-historicism of post-structuralism, but it is also clearly incompatible with those current far-reaching critiques of the developmental logic of modernist culture that I mapped out earlier. And this has much to do with the lack of empirical controls throughout Berman's account. For Berman's alliance between Marxism and modernism is less analytically sustained than a rhetorical declaration. As a result it is the symbolic and visionary prospect of Western culture's need to 'go on' that carries the argument, rather than the more mundane verities of who is speaking to whom, and for what reasons and with what resources. Con-

sequently, despite lengthy discussions of the 'Petersburg Tradition'
(Gogol, Dostoyevsky, Biely, Mandelstam) and the Paris of Baudelaire,
Berman fails to relativise and contextualise the achievements of
modernism in relation to its continuities of effect and audience today.
This absence is particularly acute in his discussion of the visual arts.
Modernism is simply that which 'comes next', what continues to be
vital, what promises to be new; ideology and institutions are barely
in evidence.

It is this reduction of modernity to the amorphousness of an *élan
vital* and, as such, Berman's failure to differentiate the culture of
modernism across practices and disciplines and their constructed
constituencies that forms the basis of Anderson's reply to Berman,
'Modernity and revolution'. For as Anderson says, modernism was a
product of a triangular configuration of forces: its proximity to social
revolution, its rejection of aristocratic academicism, and its empathy
with the emergence of the key technologies of the second industrial
revolution. Modernism emerged at the 'intersection between a semi-
aristocratic ruling order, a semi-industrialised capitalist economy; and
a semi-emergent, or insurgent, labour movement'.[11] This more
circumspect analysis is missing in Berman's account because what is
at stake for Berman is not the *making* of modernism but the defence
of a vision of cultural innovation that he feels modernism embodies
and that he believes is being undermined by the onslaught of recent
eclectic conservative postmodernist modes. It is in the split-off
therefore between what he calls the 'adventure' of modernism and
modernism's post-war pacification and institutionalisation that forms
the core of the book and that lays the ground for his overarching view
of modernism's continuing potential for innovation. The result is that
he not only fails to differentiate modernism across its heterogeneous
practices and their respective cognitive claims but fails to distinguish
between the formal, practical and ideological limits of those respective
claims. Thus the 'freedoms' and formal 'liberations' of post-war
American art are not held up to be the contingent products of a
powerful American art market and its ideologies of artistic brinkman-
ship (or what the painter Leon Golub once called 'art gestures. . .
uncoerced by history and circumstance'[12]) but as the continuing
evidence of modernism's formal richness, such as his cited examples;
the earthworks of the late Robert Smithson, the formalist site-specific
sculpture of Richard Serra, and environmental art in general. In fact
Berman's defence of modernism in the visual arts, with its paeans to

the extra-gallery initiatives of the 1960s, represents the victory of what we might call the voluntarist side of modernist avant-gardism: the belief that taking art 'on to the streets' and therefore circumventing the bounds of bourgeois institutions might secure a democratic exchange between artwork and audience. In these terms the 'adventure' of modernism remains above all else a transgressive experience for Berman. It is the critique of art as transgression though – embodied in either the terms of 'shock value' or Romantic anti-institutionalism – that has formed the critical base of postmodernism. Berman does not address this at all.

In essence if we are to avoid the pitfalls of reducing modernity to the transgressive and supercessive then we need to counter its reduction to the economic and technological. In effect we need to make a distinction between the modern, modernism and *modernisation*. A distinction between the modern as a transitive relationship between knowledge, representation and the social world (specific to art and literature), as a set of discrete historical cultural phenomena (Constructivism, Surrealism, etc.) and as the impact of technological innovation on the forces of production. To perform this tripartite division is of course not to separate base from superstructure but rather to demonstrate that there is no *symmetry* between being culturally modern and being technologically and economically modernised, just as modernity in art is not to be reduced to formal novelty. It is only by doing this that we can begin to loosen the notion of modernity in art away from Berman's blanket unilinearity to addressing the contingencies and constraints of certain practices. For the fundamental mistake Berman makes (given his stagist reading of Marx) is to elide the modern, modernism and modernisation into a single narrative in which art, literature, lifestyle, politics and architecture 'clash'[13] and 'interfuse'[14] into an exhilarating, existential *mélange*.

Principally, Berman's failure to introduce any differential controls in his discussion of art, literature and architecture lies in his failure to separate the relationship between the various cognitive interests of modernity and the economic determinations of modernisation along different time-scales. Architecture as a *capital-intensive* discipline faces qualitatively different cognitive constraints and therefore has been subject to very different (and more fixed) notions of the modern, than art, which needs very little capital outlay, and is far more aesthetically and intellectually mobile. The crisis of modernism in architecture is a very different experience to the crisis of modernism in art (nobody

got arthritis from looking at a Mark Rothko). Similarly the 'deep structures' of narrative have played a far greater delimiting role on experiment in the modern novel than has narrative in art. Thus, despite Berman's avowed commitment, like Rose's, to establishing the critical link between Marxism and modernity, Berman fails to locate what is historically constitutive of that link for art: the relationship between art and the 'new' as the unfolding relationship between knowledge, representation and the social world. Berman's book of course is not addressed to the machinations of art theory as such; but nevertheless where discussion is made, this absence seems indicative of a general tendency on the left when dealing in a non-specialist way with the modernist experience in the visual arts: the visual arts are *invoked* in relation to modernism rather than causally examined.

Now surprisingly, but for quite different reasons, something similar occurs in Perry Anderson's reply to Berman. For if Berman is overly optimistic about what passes for modernist metropolitan culture today, Anderson entertains *no* illusions. Because no 'new aesthetic movements of collective importance'[15] have developed since the Second World War, Anderson concludes that 'what marks the typical situation of the contemporary artist in the West. . . is. . . the closure of horizons'.[16] This seems to be an extraordinary thing to say. For what is occurring here, only at the opposite end of the ideological spectrum, is what affects Berman's view of the modern: *the evacuation of any cognitive and empirical controls in the discussion of contemporary art that would show the plurality and diversification of practices and points of resistance that share the political ground of late capitalism.* Thus Anderson can say quite openly:

If we ask ourselves, what would revolution (understood as a punctual and irreparable break with the order of capital) have to do with modernism (understood as a flux of temporal vanities) the answer is: it would surely end it. For a genuine socialist culture would be one which did not insatiably seek the new, defined simply as what comes *later* itself rapidly consigned to the detritus of the old, but rather one which multiplies the different, in a far greater *variety* of current styles and practices than existed before: a diversity founded on the far greater plurality and complexity of possible ways of living that any free community of equals, no longer divided by class, race or gender, would create. The axes of aesthetic life in other words, in this respect run horizontally, not vertically. The calendar would cease to tyrannize, or organise consciousness of art. The vocation of the socialist revolution, in that sense would be neither to prolong nor to fulfil modernity, but abolish it.[17]

In replying to Anderson in the same issue of the *New left review*, Berman calls Anderson 'Olympian' for such prophecies.[18] Olympian

may be a somewhat exaggerated response to what is an eloquent
defence of cultural multiplicity under socialism, but all the same there
is a certain lack of proportion in Anderson's reply. For if Berman fails
to differentiate the problems of modernism across practices and
disciplines by overstating modernism's vitality today as a universal-
isable democratic cultural force, Anderson underdetermines moder-
nity's continuities of affect by periodising the modern in art too
generally as a phenomenon in decline. Ironically Anderson views
modernity from within the same transgressive paradigm as Berman,
as a series of quantum jumps of creativity and novelty. But because
'no movements of importance'[19] and no 'masterpieces' have been
produced since the 1930s and 1940s, then art's ongoing relationship
to critical difference is taken to be exhausted or foreclosed. As a result
Anderson can then claim that all the visual arts need to restore cultural
vitality is the punctual break of socialism. He even quotes Gramsci:
'the old is dying and the new cannot be born; in the interregnum a
great variety of morbid symptoms appears'.[20] There is no doubt that
this is a powerful interdiction, but it is also one that is used too easily,
particularly within the purview of the visual arts, to bypass the harder
task of building those cultural institutional resources in the present –
those new relationships between audience and text – that will carry
us through to this 'punctual' break. Thus although Anderson argues
for the need for a conjunctural reading of modernism, he fails to locate
those 'connections and continuities with the past in the past and the
past in the present'[21] that would establish the differentiated trajecto-
ries of modernism as underpinning the emergence of a new horizon-
talised post-modernist political culture today. Now this does not mean
that the development of such conditions allows us to talk of a fully
formed counter-public sphere *already in place*, particularly in Britain. But
rather that there can be no talk of art's 'health' or 'crisis' of 'popularity'
outside the specificities of its constitutive relationship to language and
conceptual thought generally and therefore the *construction* of needs in
relation to diverse constituencies. Thus it is one thing to assume the
class limits on this process at the present time, it is another to assume
that modernity understood as the ongoing relationship between
knowledge, representation and the social world can ever be *ended* by
socialism as such. That post-revolutionary culture would alter and
celebrate the 'axes of aesthetic life' along real, democratic, interactive
lines must be the indisputable claim of all socialist cultural strategy,
but nevertheless this does not answer the question of the future

epistemological status of those practices themselves. For we cannot assume that the relatonship between representation and knowledge under socialism will not be a new moment within the future unfolding the 'knowing how' of art. To assume otherwise is to assume social relations under socialism will not need picturing. This may be the case, but it would seem highly unlikely. Thus it is not a question of perpetually seeking the new for art as a continuous unfolding of the *different* but of holding on to the possibility of *difference*.

What all this peregrination on modernity I hope has foregrounded is that to argue from the point of evolutionism or termini is to close off what makes art a heterogeneous and transitive form of social production. It would seem therefore far from profitable, if we are to sustain this open-endedness, to extend our productivist defence of art from a philosophical realist defence of Marx's method. For it is philosophical realism's insistence on men and women as causal agents able to act retrodictively on the materials out of which objects are formed that captures what is essential to art's status as produced production: the reproduction, development, rejection, modification of antecedent materials and knowledge as the transfactual means by which art 'goes on'. The inescapable condition of art's modernity – or rather its status as ongoing *social* activity – lies therefore not in any shimmering vision of the formally new but in a materialist commitment to analytic and imaginative work *on* and *with* given symbolic and intellectual practices as part of a political, oppositional culture which is self-monitoring and non-predictive[22] – which makes all the toing and froing between modernity and postmodernism less confusing than it appears. For if art is produced at the intersection of a number of subjective impulses and aesthetic and cognitive materials, there must be a second-order conceptual apparatus that is open enough to match the dialectical complexity of this process. That is why post-modernism, as a proliferation of the critical legacy of modernism across subject positions, ideological fronts and expressive resources, is an attempt to keep faith not only with Marx's materialist view of art, but with his historical method. For postmodernism's commitment to analysing the different causal factors in the production of art stands as an attempt to redescribe the current capitalist conjuncture as a complex *totalisation* of practices and agencies.

The political understanding of art as a series of critical moves made within the culture, rather than in transgressive opposition to the culture, now becomes clearer. For if postmodernism is adequate as

theory with regard to its critique of expressionist/individualist ideology in art, then not only is it necessary to show art to be a product of work on, and with, given socially determined (and conjuncturally limited) materials, but also to show this process to be rooted in the work and development of critical communities of like-minded practitioners. The importance of critical communities (recently the constituencies of feminism and black politics) as places of shared enterprise, places where knowledge, skills and values are generated and sustained; is thus an important discursive framework in the struggle for those counter-public spaces that will enable art to move beyond the 'privatised' relationship between spectator and artwork. This is not to say, however, that all artists should work collectively, but that making art, looking at art, and talking about art, are inseparable parts of communal activity, actual or imagined.

The defence of communities as places where intellectual, artistic, moral and political resources can be developed and sustained has been a central part of the Marxist critique of bourgeois-individualist readings of the modernist tradition. It's there in Voloshinov, Benjamin, Trotsky and recently, in a powerful and eloquent form, in Raymond Willliams.[23] It has also been a central concern of Alasdair Macintyre, in particular in his book *After virtue*.[24] Although Macintyre no longer sees himself as working within the political tradition of Marxism, his book nonetheless provides a language of community and filiation to the past in the present and the present in the past that has important implications in transforming our notions of modernity from the supercessive and transgressive to the horizontal and interactive.

Criticising the possessive individualism of the ethics of Sartrean existentialism and Erving Goffman's sociological functionalism, Macintyre argues that there is no way we can possess moral values, or practical or intellectual skills in any substantive sense, except as part of an extended community of interest. Thus for Macintyre it is continuity with the contents of inherited practices, traditions, forms, that give value and meaning to our acts and beliefs. As Macintyre says: 'the past is never something merely to be discarded, but rather that the present is intelligible only as a commentary upon and response to the past'.[25] Now, this is not to say that practices and traditions do not degenerate or become ossified, or that certain practices and traditions can be shown to be inadequate or oppressive, but that it is only through the development of skills internal to practices distilled and performed over a period of time in relation to preceding practitioners that human powers

achieve coherence and excellence.

There are thus two related issues here: that the development of cognitive and practical skills outside of the facticity of inherited rules, customs, and techniques is *existentially* unsustainable and that the development of these skills remains impotent or disenfranchised as part of a system of active social and political values without their accumulation and exchange within critical communities. Essentially Macintyre's critique of 'emotivist' or existential/individualist accounts of modernity rests on the reworking of the Marxian/ Wittgensteinian notion that the individual is in key part the product of what she or he inherits. Thus the idea, as in emotivist accounts of modernity, that we can choose a life, a moral or artistic identity outside of a community or tradition, is simply unintelligible. However, this does not mean, contrary to Lyotard, that as members or future members of such communities and traditions we are *constituted* by communities and traditions, but that without the particuliarities and conventionalised meanings and protocols of such communities or traditions there would never be any place to begin to act or signify.

Macintyre's emphasis upon the development of skills and knowledge as an unfolding, socially embedded process of interaction between individual, community and critical tradition is thus a powerful ally of our post-Romantic concept of postmodernism in the visual arts as political intervention on many fronts and on many symbolic levels. For in emphasising the community as a site where moral, critical and artistic life might be sustained against the emotivism in our culture, he could be said to offer not only a view of the inseparability of knowing and doing in art, but a self-understanding amongst the dispersed and embattled political constituencies of the art-world of cultural producers as the bearers of tradition of counter-public interests across the social domain. However, this is not to inflate the political effects of these constituencies, or to create an enclave mentality around their imaginative and cognitive interests, as if art, and art alone, had the resources to keep the flag of socialism flying against the barbarians waiting outside the city gates (a rhetoric, in fact, that mars Macintyre's stoically political conclusions on the future of the 'moral life' in the West). Rather, if communities are bearers of values, and if political art-communities are bearers (ideally) of non-bureaucratic values, places where other ways of doing and being might find their expression, then art cannot but remain, with

all the idealisations and misrepresentations that entails, a site of resistance and socialist aspiration.

What is at stake therefore in our definition of art as produced production is the need for a Marxist/materialist view of art that takes its sense of progressiveness not from universal systematising, futurist imaginings or earnest socialist affirmation, but essentially from *disaffirmation*, from the cognitive mapping of those forces, agencies and structures that have brought us to where we are. Art's critical relationship to socialist interests is more profitably aligned to notions of the counterfactual rather than the production of predictive visions or parallel worlds. In the philosophy of science counterfactual arguments are those that assess what might have happened in the absence of particular causes. They are the arguments that in a sense propose a view of events outside the normal and predictable channels of cognition, in order to generate the conditions for further enquiry. Art's reworking of the antecedent follows a similar pattern of adjustment and projection: the creation of difference from the counter-inductive. This means of course, as always, that as cultural producers we must begin from the adequate redescription of present conditions before we 'glimpse into the future'.

Thatcherism and the visual arts 1

The next two chapters concern the production, distribution and criticism of the visual arts in Britain since the late 1970s and the rise of Thatcherism. They do not propose to be empirically exhaustive, just as they do not purport to be an overview of 'art in our time'. On the contrary, they concentrate principally on the culture of left criticism of art and the fortunes of critical theory and practice generally over this period. Thus the questions they ask of necessity place the rise of the New Right in the foreground of analysis. However, this is not to use Thatcherism as a sociological convenience. 'De-industrialisation', unemployment and 'authoritarian populism' are not to be read off as the causes of art's recent political recomposition and extension, just as the expansion of the art market under an extended money and commodity economy and the return to 'conservative values' in certain dominant sectors of the art world are not to be identified simply with any Thatcherite credo. This kind of left-liberal journalese in which Thatcherism has *captured* art for market values or armed a new political art should be left far behind. Nonetheless, the 1980s *have* seen substantial changes in attitude, opportunities and interests as the right, with its revival of *petit-bourgeois ressentiment*, has set the cultural and political agenda. The aim of these two chapters is not to apply Thatcherism as a cultural and political logic to the development of art in Britain in the 1980s. Rather it is a question of seeing it in terms of a set of values and interests that have mobilised certain forces, latent or extant, within the culture, that the culture of art has either resisted accommodated or capitulated to. This is an important distinction, for it allows us to think the relationship between Thatcherism and art as a relationship between late capitalism and art and the crisis of the British state.

The widespread notion of Thatcherism as 'hegemonic' needs, therefore, to be firmly resisted. As a number of its critics have argued, this position is unduly 'ideologist'[1] (assumes a coherence and manipulative power to ideology that just isn't there) and excessively discontinuitist (overemphasises the would-be break of the Tories with

post-war democratic consensus, as if that consensus was in any real sense socialist). Abandonment of full employment and the privileging of the fight against inflation actually began in 1976–77 with the Callaghan Labour government, when public spending levels were cut by 8 per cent in real terms.[2] But, if the continuities with the Labour Party have been underemphasised, it would be equally misleading to downplay the specificities of Tory policies. Stuart Hall, who has done much to defend the problematic idea of Thatcherism as a break with post-war social democracy, is at least right when he says that Thatcherism has had real material ideological effects on the way ruling blocs attempt to construct and reinforce their interests in capitalist democracies. Hall's view of Thatcherism as having reconstructed the 'terrain of what is "taken for granted" in social and political thought', needs to be given some credence.[3]

Essentially Thatcherism represents an extended control of the ideological apparatuses of the state by the ruling class, as the crisis of capitalism's uneven reproduction of the relation of production deepens. This is becoming increasingly apparent in the sphere of art and culture, where the coercive/consensual mechanisms of this process of control are shifting in favour of the coercive side. The Tories' strengthening of the national-technocratic nature of the capitalist state can clearly be seen to be affecting culture in terms of how privitisation secures dominant ideological agendas through economic exclusion. Thus what we have witnessed in Britain in the 1980s under the cover of so-called economic rationalisation is a massive ruling-class holding operation on the democratisation of the culture and art's possible place within it. At the point where new kinds of cultural production were being done, new forms of distribution being put into place and new kinds of thinking being broached, the potentially enabling powers of such work and initiatives within the *culture as a whole* were blocked by Thatcherism's local successes. In general terms, the prospects of a *post*-modernist culture that had begun to problematise the means and ends of art under capital outside the old institutions were stifled. This no more so than in art education where the 1980s have seen a kind of counterrevolution under the aegis of 'internal restructuring' push back the feasibility of other ways of doing and knowing. (The amalgamation of fine art into design is perhaps the crudest aspect of this[4]). Compounded by unemployment and widespread frustration, a whole generation in art education and higher education generally has gone 'critically missing'; or rather has

been theoretically contained, as Raymond Williams has put it, by 'the protected and self-protected modernisms'[5] of an early stage. What faith has been placed by the left in the emergence of a new socialist culture within the public education system[6] has certainly found the ground recently within art education increasingly hostile to such initiatives.

Thus if we are to talk about an intensification of ruling-class dominance in relation to the visual arts, this is where we will find it. Just as the Poll Tax is, in part, an attempt to break the hold of municipal socialism, the Tories' exhortations to art institutions to find private funding, and the cutbacks in education, are the best way of policing cultural agendas and dissolving the wider critical and educative effects of the new postmodernist culture. The reality of the situation is no better illustrated than by the infamous quotation from an anonymous Department of Education and Science source, in Brian Simon's book *Does education matter?*:

> Our focus must be on the strategic questions of the content, shape and purpose of the whole education system and absolutely central to that is the curriculum. We would like legislative powers over the curriculum. . . We are in a period of considerable social change. There may be social unrest but we can cope with the Toxteths. But if we have a highly educated and idle population we may possibly anticipate more serious social conflict. People must be educated once more to know their place.[7]

All this of course would seem to imply that things might have been very different, that the theoretical optimism of the 1970s has been betrayed in practice. Labourism though has been no friend of radical democratic cultural initiative, as the anti-culturalist days of Callaghan's regime reveal in all their painful mediocrity. To look at the 1980s as a period when the socialist transformation of British culture was blocked is simply gross idealism. Rather, what Thatcher's local suc- cesses have done is, in a sense, make the process of capitalist cultural colonisation more *unpalatable* and less *negotiable* than it might have been. There are fewer public spaces to put into view and practice the *cognitive* significance of art. In short, as far as the visual arts go within the structural limits on their democratisation under bourgeois culture, Thatcherism has further weakened the possibility of art's place within a new counter-public sphere.

Without this sense of Thatcherism as an extended form of 'crisis mangement' in the face of the exigencies of modernity, class struggle and democracy, we will not be able to establish a clear picture of why

certain left responses to the vicissitudes of British art and culture in the 1980s have taken the form and continuity that they have.

3.1 The politics of containment

The notion of a 'culture of containment' has been specific to the historiography of the New Left since the late 1960s, in particular Perry Anderson and Tom Nairn and recently the Canadian Martin Weiner (though in no strict sense is Weiner a Marxist). Both Anderson, in his prescient essay 'Components of the national culture',[8] and Weiner, in his more culturalist *English culture and the decline of the industrial spirit 1850-1980*,[9] have used the phrase to denote the 'exceptional' nature of the British bourgeois state and the continuity of certain archaic, nostalgic and empiricist cultural and political formations. This history of the failure of the English bourgeois revolution is by now very familiar and does not need to be rehearsed at length here. Nevertheless, for the purposes of this argument we might recap on the main points. Following the peaceful accommodation between the political demands of industrialisation and the anti-modernity of the rentier artistocracy, the aristocracy succeeded in maintaining cultural hegemony and thus revitalising the industrial bourgeoisie in its own image. Moreover, the successful patriotic counter-revolution of the propertied classes in the war against the French in the latter part of the eighteenth century and early part of the nineteenth century effectively retarded the democratic republican aspirations of the masses: a 'non-democratic mobilization'[10] of popular forces, to quote Tom Nairn, that remains so virulent today.

Whether we can argue for British exceptionalism in such certain terms is beyond the scope of this chapter. The tendency within the 'Nairn/Anderson thesis' to treat bourgeois revolution from a normative standpoint clearly has a number of problems. Democracy is contained in Britain not simply because the state is 'patrician', but because it is capitalist.[11] Nevertheless, the 'archaism' of English monarchical-constitutionalism should not be underestimated in securing a bipartisan consensus on the limits of this democracy. Consequently the absence of a popular democratic republican consensus this century, even under Labour and the Keynesian welfare state, has served the renaissance of anti-modernist motifs under Thatcherism extraordinarily well. With no prior commitment to the need for a

defence of the link between the modern, democracy and socialism outside the framework of parliamentary constitutionalism on the part of mainstream Labourism, the conservatives have been able to reshape national popular interests as constitutional/ monarchical issues with little resistance. The Falklands *débâcle* is a case in point. The revival of myths of Deep England (the continuing denigration of the Celtic peripheries), the public celebration of the trappings of feudalism and *petit-bourgeois* taste (the rituals of royalty, country house life) and the recourse to a central-core traditionalism in education and shrill moralism in the arts and media, have all underpinned and framed the cultural advances of the Tories. The notion of a culture of containment therefore certainly has its weaknesses as a nomenclature for ruling-class self-understanding. However, despite this it offers a useful and graphic image of the organic crisis of the British state, for it requires us to acknowledge that oppositional cultural work has to be done in the face of *real determining limits*, both within the framework of Thatcherism and beyond.

The development of British art criticism and theory during the late 1970s and 1980s has to a great extent been determined by these constraints and would-be advances. In fact, the 'play of differences' that has circulated through British art discourse over this period has in a fundamental sense centred on, and issued from, this general democratic crisis of the culture. Thus there are those who have made undue accommodation to the legacies of the culture of containment, and those, who in *wishing away* its disappearance have volunteered various political nostrums, in a familiar overturning of material conditions for the speculations of theory.

European commentators on British art and intellectual life invariably argue that British art and artists are mired in politics and morality. Given the deformations of British social democracy, this of course is not surprising. The development of various postmodernist practices and discourses throughout the late 1970s and 1980s has been an attempt to come to terms, first and foremost, with the undemocratic nature of Britain's major art institutions and the undemocratic place of art generally within the culture. Nevertheless, if class division can be seen as the central determinate of much of this discourse, the very lack of a class *perspective* on the question of cultural democracy has become increasingly apparent. Seizing on surface appearances many commentators have overly and idealistically concentrated their criticisms and complaints on the contradictions of distribution. Much of

this writing has been framed within liberal debates on distributive rights: that as citizens and consumers all people have a right to an equal share of satisfaction from art. The result has been a general *populist* tone and character to a large amount of art political writing: that if art can produce the right socially minded themes, accompanied by the right open institutional provision, some organic link between art and the working class can be forged. John Berger's proclamation to artists in the 1950s to find themes for their art which will connect them to their missing public, and the spectre of Popular Frontism, stand reinvigorated behind this writing. Shows such as 'Art for whom? (1978),[12] 'Art and society' (1978)[13] 'Lives' (1979),[14] 'The forgotten fifties' (1984),[15] 'State of the nation' (1987)[16] 'Critical realism' (1987)[17] and the writings of Peter Fuller, Richard Cork and Brandon Taylor all defend some variant on this theme. Now this is not to say that this is the only postmodernist tradition of engagement with these issues. Its counter-tradition, which has been touched on already – the cultural Trotskyism of the Open University modern art and modernism course, feminist practice and criticism, and the new photography practice and criticism – is dealt with further in the next chapter. But in virtue of its strong sense of continuity, dominance within the thinking of a great deal of the left, and capacity to engage the allegiance of a wide number of art critics and galvanise the objections of many others, it has to be taken seriously as the dominant theoretical tendency or power-bloc within British art culture from the late 1970s onwards. As a tradition though, it is by no means internally coherent. The transformation of populist into *national*-populist in the writings of Peter Fuller is not so evident in the writings of other contributors to the tradition. Rather, as a loose collection of presumptions and expectations about art and socialism, it provides a 'commonsense' view of art and politics. Moreover, the misrepresentations of this 'commonsense' view can be seen to be causally linked to the misrepresentations of the so-called conflict between modernism and political art as it is played out in the mutual dependence through ideological contrast of Stalinism and social democracy.

In analysing the development of British artistic culture and the lineaments of a British culture of containment it is important therefore that we begin with a look at the moment of 'Art and society'. As the cornerstone of this tradition, it has been an alliance with, or rejection of, the political sentiments of this show that has laid the foundations for a number of competing critical trajectories (both within and

outside its orbit) through the 1980s.

When Richard Cork, one of the organisers of 'Art and society' argued in 1978 for art to become more socially relevant – for art to become 'truly social' – he was offering not just a routine sense of the crisis of American modernism and the alienation of the modern artist but a view of the political *capabilities* of art in our culture.[18] Faced with what he and a number of other critics at the time saw as the insufferable visual intractability of high modernism, represented in the popular imagination during the period by Carl Andre's *Equivalent VIII* at the Tate Gallery, Cork sought a re-theorisation of art's 'social function' through a new commitment to Bergeresque 'social themes'. The artist must find ways to 'act socially among the "rest of humanity"'.[19]

The ill effects of failing to make art relate to its own time have snowballed over the past few decades to the point where alarmingly little connection between the two can be discerned. That is why the late 1970s, and indeed the rest of this century, must be dedicated to redressing the balance.[20]

'Art for Whom' should be seen as a touchstone for the aspiration of *every* artist who refuses to settle for a function as marginal as those which dominate today. The art of the future must not obsess itself with questions of idioms, cliques or particular media: all that partisan lumber ought to be cleared away, in order to make a breathing-space for the non-divisive exploration of how a comprehensive people's art might be best evolved.[21]

The debt to Berger is actually made explicit in the introduction to the catalogue for 'Art for society'. Acknowledging the importance of Berger's show 'Looking forward' at the Whitechapel in 1952, Martin Rewcastle and Nicholas Serota look to 'Art for society' as a revival of its aims:

'Looking forward' combined the work of established and younger artists 'because it may hearten those who realise the futility of art being separated from the beliefs and problems of society "looking forward" to the time when artists will again be able to communicate with their unselected neighbours' and not simply among themselves. Again, one finds the emphasis placed squarely upon the necessity for the artist to communicate about life and social conditions with a wide public. The work of the artists in the exhibition 'avoids the sterility of over self-consciousness or over-specialisation because it gains its vitality from the artists' convictions about life rather than art'. It would be difficult to find a more succinct statement about the social purpose of art.[22]

The critical re-engagement with the issue of 'social themes' in the face of the orthodoxies of American modernist abstraction, had been

something that had been gaining ground over the preceding years. This was rooted principally in a reassessment of the representation of the human body. Standing not far behind 'Art and society' and 'Art for whom?' is very clearly R. B. Kitaj's selection of figurative work, 'The human clay', at the Hayward Gallery in 1976. As Kitaj says in his introduction: 'The single human figure is a swell thing to draw. It seems to be almost impossible to do it as well as maybe half a dozen blokes [sic] in the past. I'm talking about skill and imagination that can be *seen to be done*. It is, to my way of thinking and in my own experience, the most difficult thing to do really well in the whole of art.'[23] Moreover such skills 'prepare a very serious and ambitious romance – an art in the image of the people[24] . . . Some argument may be suggested here but argument within the art, within a Popular Front, a grand old concept which is being revived in Southern Europe in a beautiful way.'[25] The populism of this line has been the key point around which a whole generation of participants in the 'Art and society' debates have measured their 'realism' and socialism: that certain kinds of art might empower cultural democracy. In this respect Cork and his co-selectors' political updating of the pursuit of a People's Art offers yet another variant of that dualism that has haunted the whole experience of art under modernity this century, and that I tried to locate as the central problem of postmodernism in chapter 1: the oscillation between claiming *too much* for art and claiming *too little*. Greenberg and Adorno (at times) claimed too little for art, Cork, Kitaj and others claim too much, pressing art to the work of politics or social psychology itself. Now this is not to say that Cork is wholly insensitive to the problems modernism posed, but that there is a strong sense, as with Berger, that the crisis of art's social legibility might be solved by somehow 'humanising' it. Berger's own confusion over the problem is of central importance in understanding the myth of a People's Art within the 'Art and society' legacy. Before we continue with the main thrust of my argument, let us take a look at the context out of which 'Looking forward' emerged.

John Berger's debates with Patrick Heron in the 1950s have an important bearing on understanding the intellectual horizons and confusions of the 'Art and society' legacy. Writing in the defence of social realism in the 1950s Berger saw the entry of various proletarian themes into post-war British painting as an important lever against the 'dead subjectivity'[26] of a rising American modernism. However, if Berger saw the new social realist painting as an extension of 'social

action',[27] for Heron it represented the maw of academicism. Defending the new American painting against Berger's attacks, Heron accused Berger of weakening the freedoms of the artist and her or his need to experiment.[28] For Heron, though, experimentation means principally work on form and colour. What is at stake, essentially, in this confrontation is a clash of world views. Berger's defence of figuration carries a moral tone, in which the presence of human beings in pictures allows the artwork to find its place within living social relations. Heron's defence of abstraction, on the other hand, castigates the imputed moral link between figuration and value. Artworks are good simply because of the aesthetic pleasures they provide. Here then in diluted form is Britain's own version of the debate which swept the Western European countries during the onslaught of the Cold War: 'social responsibility' versus 'social freedom'. It would of course be wrong to suggest that, a member of the Communist Party at the time, Berger's position was Cold War Stalinist. Berger always made a principled distinction between social realism and the hackery of Soviet-style socialist realism. However, Stalinism and its Popular Front cultural politics was the context out of which he framed his criticisms of Abstract Expressionism. The profound pathos of this moment in the history of British art and criticism lies then to a great extent in its Manichaeist contrast between socialist sentiment and bourgeois individualism. What is missing from Berger and Heron's counter-blasts is a sense that their respective commitment to the political and the experimental might be part of the *same conceptual act*. Instead we are given the torn and unexamined halves of painting's status. What these two halves point to, in fact, is how such Manicheaism serves to camouflage the mutual extension of the power and interests of these positions. As with the ideological confrontation between the superpowers, the conflict between 'socially concerned' figuration and abstraction as a straight fight between socialism and cultural freedom concealed the defensiveness of each posture from the troubling introduction of a set of contents not determined by the security and coherence of the other's projected image: i.e., the quality and percipience of art cannot be gauged simply by its imputed effects (its 'access to a lot of people') or by recourse to ahistorical defences of free-expression. Both arguments obviously disavow their positionality.

It is no surprise therefore that, given the 'exceptional' nature of British national culture, the recurrent defence of the need for a new

popular art should take its cue from this opposition. For the pursuit of a new People's Art by the 'Art and society' contributors was in many ways a response to the institutionalisation of modernism in Britain in the 1960s and 1970s as a *comprador* ruling-class culture. Heron's defence of experimentation had become a managerial rallying cry for art's cultural transcendence. However, in exposing the apolitical manoeuvres of this culture, 'Art and society's' defence of populism easily played into the hands of that culture. Any argument that empowers art as a form of politics was bound to look weak when faced with arguments that stressed the 'relative autonomy' of art, the instabilities of interpretation and the subjectivities of pleasure. Defenders of Cork's new People's Art had a hard time.

The re-emergence of Bergerism as seemingly the most progresssive force in British art in the late 1970s clearly has a lot to do with the character and timing of the impact of modernism on British culture generally. The absence of any modernist revolution in the 1920s and 1930s in any substantive critical sense, what Terry Eagleton has described as the product of 'English culture's relative impermeability'[29] to foreign importations, created a context for debate in which Heron could pose modernist aspirations as a rejection of politics. It is the lack then of a politicised European-type modernist culture in which the non-sufficent but necessary link between politics and aesthetics could be argued openly that has consistently produced the conditions on the left in Britain whereby 'accessibility' and 'popularity' are posed against experimentation. Although things have changed since the 1970s, the organised left's cultural politics are still very much rooted in this Labourist perspective. Art tends to be seen *as* a set piece of Britain's culture of containment.

These contradictions very much cross and contain the 'Art and society' debates. Looking over his shoulder at the left, whilst poking the bureaucratic modernists in the eye, Cork's farrago of good intentions simply left the misrepresentations of a People's Art untouched and the insularities of the modernists compounded. In fact this confusion to a large extent undermined Cork's career as a critic. Unable to think beyond the consumerist categories of Labourism, his writing descended into a bureaucratic defence of Public Art.

The same confusion over what to identify as the problems of the cultural crisis in Britain, and the same recourse to populist/consumerist solutions, also characterise the other would-be critic of Britain's culture of containment at the time, Peter Fuller. Fuller,

however, launched his career with an attack not only on American modernism but on Cork and his version of 'social functionalism'. Here then it seemed was the possibility of some dialectical grasp of the problems of making art outside of the old antinomies, outside of the binarism of Political/People's Art = social effectivity, modernism = social anomie. We were of course to be sorely disappointed, as his reactive career has bathetically proven. What was interesting though about his attack on modernism and Cork in 1980 in his essay 'Fine art after modernism'[30] was the way he used the Nairn/Anderson account of the absence of a culturally progressive bourgeoisie in Britain in the 18th/19th centuries to foreground the dominance of a certain set of jejune and 'retardate'[31] aristocratic contents within British painting, a history punctured only by the sole example of Hogarth, who wasn't British anyway. The lack of historical consciousness in pre-modernist British painting was simply reproduced and extended by the development of an American-dominated British modernism. At the limit Britain could only produce a Ford Madox Brown and not a Daumier, Courbet or Millet:

Even in the late-nineteenth century no indigenous minority tendencies like the Impressionism of France, Cézanne's dialectical vision, or the later manifestation of Cubism arose; all these aesthetics were characterized by a preoccupation with the depiction of change and becoming. Compare, say, a Rossetti painting with an Alma-Tadema. These artists occupied polar opposites within the British Fine Art tradition and yet today we are more likely to be impressed by their similarities than by their minor differences, so narrow was the range of painting in this country in the last century. In the absence of a progressive bourgeois culture artists fulfilled the 'social duty' demanded of them by the ruling class almost with servility and, despite the ideology of artistical 'specialness', without even that degree of imaginative distancing which led, on the continent, to the creation of Bohemia.[32]

The contemporary political implications of this history, though, were barely thought through by Fuller. Instead of using his critique of both a de-historicised pre-modernist British painting tradition and a weak, aphasic British modernism as the basis for asking questions about the cognitive status of contemporary art, he simply retreated into a kind of revivalism. Now that modernism had put the traditional skills of the fine-art tradition in jeopardy, the reclamation and defence of those skills was a priority if the demotic that British painting had barely possessed was to be won back for British art.

Kitaj's recall of the 'human image'[33] was given a kind of historical

backup, which is why in retrospect the differences between Fuller and Cork seem actually negligible, despite all Fuller's noise about the work in 'Art for society' being 'dull'[34] and 'derivative'.[35] Rather, what was at stake, as this other extract from 'Fine art after modernism' makes clear, was some critical breathing space around a definition of the popular – a tactic that was eventually to preponderate over everything else:

I believe the professional Fine Art tradition is worth preserving. Why? Simply because it is here and only here that even the potentiality exists for the imaginative, truthful depiction of experience through visual images, in the richness of its actuality and possible becoming. This is not an idealist assertion: despite all that I have said about the ideological character of the concept of 'Art', I consider that certain material practices – namely drawing, painting, and sculpture – preserved within the Fine Art traditions cannot themselves be reduced to ideology.[36]

There is little in principle here that Cork would have objected to. Fuller's critique of Cork and defence of 'realism' (David Hockney) was principally an attempt to place *painting* in the forefront of populist debate, an area of practice which, in Fuller's eyes, had a relativist position in Cork's writing, given his commitment to 'post-object' work (video, performance, artists' film). The subsequent history of Fuller's commitment to painting and his retreat into a hypetrophic aestheticism rests in a fundamental sense, then, in his failure to take up painting in any other way than as a set of *craft skills* under threat. Essentially he has not been able to theorise with any degree of complexity that painting's capacity to deal with 'society in its totality'[37] in the latter part of the twentieth century is singularly dependent upon both painting's aesthetic and its cognitive mobility. Failure to acknowledge the formal and critical instabilities of conceptual art is central to this (which Cork at least did not fail to do under his editorship of *Studio international*). In *Beyond the crisis in art* (1980) Fuller characterises conceptualism as 'unaesthetic' and reductive. In fact, for Fuller, conceptual art represents the final *kenosis*, or self-emptying of modernism. Irrespective of the *ad hominem* nature of the attacks on conceptual artists, Fuller's description of conceptualism as anti-art is a category mistake of some size. Conceptualism's scepticism about painting was essentially diagnostic. By aligning mechanically reproduced imagery with text, by exploring the aural and textual, it aimed at problematising the very notion of art as transcribing the real through picturing it. So comfortably placed is this latter notion in

Fuller's call for a 'new "realism"',[39] that he is incapable of dealing with
the recursiveness of representation as such. Armed with 'proper'
human content and 'proper' craft skills, painting is simply led back into
those stable empiricist spaces of the culture of containment that Fuller
claimed to have escaped from.

Conceptualism's discursive strategies, emphasis upon the constitu-
tive nature of language on art production, and the de-stabilisation of
art's formal hierarchy and forms of connoisseurship, remain very
much the 'unconscious' of these debates in the late 1970s. For in their
materialist commitment to an examination of the means of art's
production and distribution, they negate any easy and rhetorical
expressions of the 'popular', 'People's Art', 'accessibility' and 'univer-
sality'. All Fuller could reply with was that these strategies of disaf-
firmation were forms of 'visual ideology'. Thus, it is no surprise that
in the face of the self-conscious recursiveness of much art in the
1980s, Fuller's defence of the aesthetic as a transcendental category
of experience has become more refractory and hysterical.

Abandoning, or avoiding, the reality of the fact that the problems
of producing art are tied to the vicissitudes of a contingent world, and
therefore to the development of adequate cognitive skills across
media, Fuller's only way forward has been back. The culture at large
of course has commended him for it, as his shift into an English
pastoral mode and national-populist sentiment has reconvened those
old life-room skills in the name of putting British art 'back together
again'.[40] It is revealing, therefore, in the light of what has been said
so far about Britain's 'culture of containment', that Fuller should make
such an easy alliance with it under its revivification under Thatcher-
ism. His commitment to an 'informed and intelligent parochialism'[41]
finds its anti-modernity in the wider parameters of 'green thought',
as his paeans in Theoria[42] to Ruskin's artisanal aesthetics makes
abidingly clear. In fact, with the English Romantics of the inter-war
years as his contemporary bench mark, Fuller's celebration of the
iconography of Englishness and Deep England – the experience of the
English landscape as a 'sustaining mother'[43] – has its antecedents in
that very national culture of patrician reaction to the modern that his
early soi-disant Marxist writings criticised. There is certainly a capitu-
lation to the more blatant ideological functions of the English pastoral
tradition: the image of the landscape as restorative.[44]

In this respect Fuller's writings have recently sought to enter a
broader cultural debate; the growing popular reaction to the modern

(from architecture to pottery) reflected in the anxious reclamation of the 'auratic' and 'unique' as spaces of 'resistance' to the increasing commodifiction of cultural relations. However, even if the New Right has played a large part in endorsing such sentiments, particularly Roger Scruton whom Fuller has made opportunist alliance with, this anti-modernist theatre of reaction and mourning is clearly not to be identified as a rightist conspiracy. On the contrary, as Patrick Wright has argued in his book *On living in an old country*, we need to see this as a reflection of real needs contained by the effects of capital under Britain's post-war settlement.[45] The fragmentation of once-settled communities; urban decay (the ravages of post-war municipal sub-modernist architecture); and the erosion of the nuclear family (the gradual demise of the two-child family and working father as economic norm) have all destabilised everyday life, creating in their wake a huge desire for experience and images of belonging, stability and community. If Wright tends to undertheorise the fact that capitalist modernity has always been built upon the dialectic between an uncertain future and an idealised past, nevertheless the retreat into the past under Thatcherism is real and palpable enough. Fuller's 'informed and intelligent parochialism' has without doubt found the change in ideological climate conducive to his version of Romantic organicism.

Now, it could be said of course that this has another 'progressive' side. That Fuller's 'radical' regionalism represents an attack on a culturally homogeneous internationalism, in this instance the market dominance of New York, Germany and Italy. Fuller's search for pastoral 'sanctuary imagery' legitimately asserts the variegated virtues of the provincial against the would-be internationally advanced: a reasonable anti-imperialist argument one might assume. However, in Fuller's writing this argument at no point becomes an examination of the political relationship between the centre and the peripheries. Simply a nationalist-type act of cultural protectionism. Fuller never makes explicit the link between geographical place and the politics of cultural identity. There is no sense that a critique of a market-led internationalism might carry with it a theory of cultural identities outside of the dominant agendas of metropolitan power. Clearly Fuller's regionalism is an English regionalism. At the same time as he takes up his distance from the stratifications of an Atlanticist or Nato modern culture, he falls back into endorsing all those old imperialist English reflexes. In short, the absence of any theoretical engagement with art's cognitive

status in Fuller's writing prevents him from taking up the issue of regionalism as a political question that directly affects the geographical division of resources of British visual culture. Furthermore, this absence is particularly misrepresentative, given certain changes within British art culture over the last ten years or so. One of the most conspicuous progressive changes in British art cultural life over this period is the rise of new regional power bases for the visual arts under a nominal anti-metropolitanism (Glasgow, Belfast and Derry). Here regionalism is directly a political matter, insofar as the issue of 'finding another voice', one that is not beholden to the interests of the international art market, means of necessity taking on the political ideolect of geographical place, rather than simply celebrating geographical difference.

Fuller's project as a whole then acknowledges the anxieties of modernity in terms of what modernity routinises and disavows. However, the suppression of these needs will not be met by offering a set of values and aspirations which simply compete with the disfiguring powers of capital outside of the modern. What Adorno had to say on such identitary or affirmative thinking is absolutely correct: to affirm one's way out of the contradictions and asymmetries of capitalism is to affirm the culture itself. And this is what Fuller does, in as much as he merely *occupies* a defence of the 'aesthetic', 'craft skills' and the 'English pastoral'. Redemption becomes blind assertion. Consequently Fuller's career as it has descended into the sentiment of national-populism, has exhibited a spectacular failure of dialectics. That he has recently embraced the monarchy as the home of resistance to the modern in the pages of his magazine *Modern painters* confirms just how risible and wretched his project has actually become.

3.2 'Images of hope'

The continuation of the populism of the moment of 'Art and society' and the retreat from complexity in the face of the crisis of modernity is to be found in a number of other commentators' attempts to solve or ameliorate the crisis of British art. In no strict sense are these writers epigones of Cork and Fuller. There is an earnest celebration of the political in art (as another variant on affirmation) that both Cork and Fuller have long since dispensed with. Still they represent similar responses to the artist's 'lack of a genuine social function',[46] as Fuller

once put it, flawed as they are by that particular mixture of theoretical confusion and sanctimoniousness that the 'Art and society' debates generated. Thus we might say that what links this group with Cork and Fuller is a continuing sense of competition for the stakes of accessibility, realism and hope in art. In these terms there is something of Marx's True Socialist about the organisers of 'The forgotten fifties' and 'Critical realism'. Deborah Cherry and Juliet Steyn, the organisers of 'The forgotten fifties' and Brandon Taylor, the organiser of 'Critical realism', offer a version of that elevated socialist tone that Marx and Engels castigated in The German ideology[47] as having abandoned the contradictions of real history. Furthermore, there is a return to a 2nd International Marxist-style bloc-theory of art's class function to underpin it.

'The forgotten fifties' was organised for the Graves Art Gallery, Sheffield, in 1984 and included all the major figures that we associate with the period: John Bratby, William Coldstream, Peter de Francia, Derrick Greaves, Edward Middleditch. John Berger was also represented, along with a short retrospective view by the writer on that moment: 'we were right in that, whilst refusing the current forms of academicism, we foresaw the dead-end of modernism. We were right, too, in believeing that the hard sell of contemporary American art was politically motivated, and was one of the many chains of American cultural imperialism.'[48] The intention of the show was clear: to place this history of engaged painting up against what was held to be the pluralistic mass of subjectivities which characterised the final demise of modernist abstraction in Britain. Contemporary British painting had forgotten its other history; what was needed today was a new social realism, in which images of working-class labour, pleasures and political solidarity would restore a sense of 'lived history' to art. A similar line is taken by Brandon Taylor in 'Critical realism'. However, if Cherry and Steyn advocate a set of conventionalised proletarian content spaces, as a would-be holding action against a decadent postmodernism,[49] Taylor goes one step 'further'. Taking his cue from Lukács' version of the class-bloc theory of art, he advocates the creation of positive images embedded in social consensus. As he says in his book Modernism, postmodernism, realism today artists should pursue 'optimistic and critical-character types that can serve as models for social action'.[50] We have of course been here before. Modernism was rooted in strategies of negation and refusal; the art of today and the future must root itself in a 'shared symbolic order'. The only

perspective then that can achieve this is a realism based on *typification*. 'The hallmark of Critical Realism for Lukács was that through it, artists should approach their subjects not as isolated exceptions, but as *typical* of their circumstances of their time. A type according to Lukács is not merely an average character, nor solely an individual one, but an embodiment of all the humanly and socially essential qualities of a particular historical moment'[51]

The weaknesses of both positions have in a sense been dealt with by implication in the section on realism in the first chapter. I don't want to repeat arguments here; however, there is something fatuous about these positions that needs stating quite clearly. Taylor talks self-contradictorily about not reducing realism to images of working-class experience, but all the authors equate realism with an unproblematic demotic, in which uniformity of convention is mistaken for critical meaning. The espousal of causes disguises the complexities of *revealing* social contradiction. These political and aesthetic short cuts are much the worse in Taylor. Much like Fuller's panegyrics to 'moments of becoming' in art, Taylor's critical-character types and simplistic defence of an aesthetic of hope actually do violent misrepresentation to the reality of the violence they would wish away. Taylor at times writes like a paranoid Zhadanov: 'unmitigated despair and despolia-tion are *in themselves* thematically unaesthetic'[52] Attacking the adaptive aesthetics of much conventional postmodernist art is one thing, 'fitting up' art as moral guidance is another. The meanings of the dominated cannot be paraded as a 'guide to social action',[53] as if the crisis of that guide to action didn't exist, as if art was free of class subordination, was *structurally* in a position to offer hope. This is *realism*.

Let us be clear then about this question of representation and social consensus. The weakness of Taylor's Cherry's and Steyn's position, and for that matter Peter Fuller's, is that they begin from the ideal of consensus and a possible shared symbolic order, rather than from the contradictions internal to a given social formation. In these terms the idea of a 'shared symbolic' order is in fact *antithetical* to the interests of critical practice in art, insofar as it subsumes non-identity under a general law of identity. The most damning question feminists would ask of Taylor's writing for example would be, how can the creation of positive character types deal with the complex question of women's authorship? To talk of the divisions of meaning in critical practice though does not mean that we cannot take shared pleasures from such oppositions. Rather it means there is no 'shared symbolic order'

waiting to be occupied. Consequently we also need to be clear how this 'world of difference' actually relates to the future of socialism. Under capitalism the alienations of intersubjectivity are rooted in the maintenance of non-identity over identity. 'You are not like me therefore we cannot have any shared interests'. Under socialism, in a culture where the removal of class, racial and sexual division allows women and men to act in each others' interests – we will be able to recognise ourselves freely as both subjects and other. This acknowledgement of difference in unity, and more pertinently the massive weight and manipulative power of those structures and agencies that currently prevent its realisation, is miles away however from Taylor's understanding of art and politics.

Taylor in many ways represents the neo-Stalinist end of the 'Art and society' legacy, insofar as his identitary aesthetics are focused through a functionalist account of 'common interest'. Echoing the Communist Popular Front cultural politics of the 1930s even more closely than 'Art and society', 'common interest' in art is made to serve some hegemonising socialist project. This is not to say that Taylor is seeking to limit what might come under this heading of 'common interest', but that the typical in art offers the quickest route through to an audience. 'Realism is developing again in British art because (social) problems are urgent, and because artists know they cannot afford to waste time on solipsistic exercises that are relevant only to them.'[54]

The celebration of effectivity is common to much art-political discussion. In the 'Art and society' tradition it is almost a structural myth. Substituting the image of struggle for learning through struggle, there is an extensive failure to acknowledge the functional limits of art's real popular advance under bourgeois democracy. In an interview in the mid-1980s in Screen, Raymond Williams provided a sharp reminder of the problems: 'I think the two things that have to be said are: one, that the radical left in Britain has never been more vital or more theoretically informed or more capable of doing all kinds of cultural work, and two, I also think there's never been a greater distance between it and where most of the people who are the objects of its concern, are living and thinking.'[55]

Essentially there are two fundamental hiatuses within the thinking of the 'Art and society' legacy. The first is an adequate theory of the sign as site of ideological conflict and interpretative instability; the second, a defence of the 'relative autonomy' of art and of the political realism of the modernist tradition. Adorno's insistence that social

critique in art has to be embedded in the form of the work emphasised that value in art has to be grounded in transformational practice if art's critique of ideology is not to become conventionalised and thereby transformed into politics. Similarly, the political realism of Trotsky's writing on art always lambasted those who would confuse political content in art with political advance. As he says in his attack on the Proletkultists in 'Class and art' (1924),[56] the idea of a certain set of images or interests guaranteeing an organic link between the artist and the working class is a 'pious but unreal wish for something good'.[57] Refusing to accept the prescriptions of the Proletkult artists (that Soviet art must become the direct expression of the working class) he offers both a sophisticated materialist defence of the need to see the production of culture as something that as to be built through the accumulation of skills (Proletkultur was an idealisation of what was feasible in conditions of mass illiteracy and poverty) and the necessity for art in the interests of its own development to be 'judged by its own law, that is by the law of art'.[58] In these terms Trotsky had a complete loathing for unrealisable objectives. 'It is one thing to understand something and express it logically, and quite another thing to assimilate it organically.'[59] Proletkultur was simply a fetish in Trotsky's eyes, the product of a misrecognition of the conditions of artistic production. 'The heart of the matter is that artistic creativity, by its very nature lags behind the other modes of expression of a man's spirit, and still more the spirit of a class'.[60] The emphasis on artistic form therefore is always uppermost in Trotsky's mind. 'Art must be judged by achievements in form[61]. . . Artistic creation is always a complicated turning inside out of old forms, under the influence of new stimuli which originate outside of art.'[62]

The only critics of/contributors to the 'Art and society' debates who took their measure from this political modernist tradition were Art & Language and Toni del Renzio, who contributed one of the essays to the 'Art for society' catalogue. As within the Trotskyist tradition, Art & Language and del Renzio both begin their critiques from an examination of the relations of art's production. This is del Renzio in the catalogue: 'To change an apparatus of production means breaking down the barriers surrounding contradictions that confine intellectual production within the constraints prescribed by the bourgeoisie[63]... 'You cannot sell socialism like soap with posters of Che Guevara.'[64] This is Art & Language from their 1978 essay 'Art for society?':

Mr. T. del Renzio remarks in the catalogue of 'Art for Society' that what is
required is a technical transformation, that Che Guevara posters won't do. It
can be suggested that it is not the relation of fine art to its audience that brings
about such a transformation, or even confrontation of art with its manage-
ment. It can join in, it can participate, but only if it ceases to be management.
The real problem is not how to make art which is pro-working-class and anti-
bureaucratic but how to be pro-working-class and anti-bureaucratic. Fine art
has no real history. It is propped up by metaphysics. Love-the-people left wing
fine art is just the same. It has no way of being a technical transformation of
the apparatus of ruling class control.[65]

The failure to face the lag between politics in art and socialist
transformation is the product, as Art & Language say, of the 'Art and
society' tradition's obsession with 'ratification in consumption'.[66]
This is also symptomatic of an ambitious political art show in 1987,
which in general terms sought to extend the 'Art and society' legacy
to the state of art in Thatcher's Britain. Organised by Sara Selwood for
the Herbert Art Gallery in Coventry, 'State of the nation' represents yet
another attempt by leftist art management in Britain to 'solve' the
contradictions of art's production through an over-anxious concern
with distribution. However, in no sense is the show a celebration of
'images of hope' or the 'long-lost virtue of realism' [sic].[67] On the
contrary, far more-pluralist in its contents than 'Art for society' and
'Art for whom?', it seeks a more heterogeneous response to the
democratic crisis of British culture. The wilder shores of neo-Stalinist
moralism and late 1970s theoreticism are significantly absent from the
political rhetoric. Nonetheless, the show can be contained quite easily
within the populist terms of its 'Art and society' forebears, insofar as
it claims that under Thatcherism British art has found that set of missing
social themes that Berger argued would link art and its public. As
Selwood says in the catalogue, the intention of the exhibition is

to demonstrate that contemporary art is produced out of a society which we
all – artists and public – inhabit, that it actively involves both its authors and
audiences and that its place is in the 'public domain'. The work of the
individual artists represented in the exhibition, may be more or less
committed to the public. But the exhibition as a whole emphasizes the ties
that bind the work to the public.[68]

What distinguishes this argumentation though from the claims of
'Art for society' and 'Art for whom?', and what makes it of particular
conjunctural interest, is that far from being a call to such interests,
'State of the nation' can actually put into critical view a wide variety

of work that has been the product of the nascent post-modernist culture of the intervening years. In this respect one of the main functions of 'State of the nation' is to provide a platform for the enormous growth of the political image during the 1980s in Britain. Consequently there is a strong sense that things have changed for the better. Under Thatcherism the emergence of numerous anti-Thatcherite and oppositional motifs and content spaces has brought art closer to the workings of the public sphere. In one sense this is undeniable. The extended production and consumption of art and theory in the 1980s under an inflated art market has increased the circulation of the representations of art and its agencies as a realm of value *irrespective* of political meaning. (As the history of art under late capitalism demonstrates, the dissemination of political content through art is absolutely no problem for commodity relations.) But in another, more substantive, sense, what 'State of the nation' fails to acknowledge, and perhaps of course can't, is that quantitative change is no guarantee of qualitative change. Again we are back to the fundamental question of the relations of art's production. We may be able to talk about an increased commitment on the part of artists to the public, but to what extent does this translate into an adequate culture of *reception*? Moreover, and more pointedly, to what extent can quantitative change maintain art's escape from cognitive closure and academicism, from method dominating material as Adorno once put it?

What 'State of the nation' actually represents in a beautifully paradigmatic way is the completed administration of political art within the art world as a spectacularised category of formulaic dissent. This is not to say that there aren't a number of excellent artists and works in the show, but that Political Art here as a curatorial category becomes yet another would-be solution to art's opacity under class culture. In much the same way that 'images of hope', extra-gallery initiatives, social realism, and People's Art, have been used in the writings of the other contributors to the 'Art and society' legacy, the problems that face the production and reception of the political in art are substituted for a generalised sense of 'engagement'.

The show is divided thematically into various anti-Thatcherite sections (the Falklands War, Northern Ireland, the anti-nuclear struggle, civil liberties), resulting in a kind of 'sociological' overview of the 1980s in Britain. Fitting work into these categories then becomes a means of linking images back to those social conflicts that individuals have actually lived through. However, what this exhibition

pedagogy fails to make any sense of is how the political in art is inscribed across the methodological problems of representation and its material resources, in short the problems that face painters, photographers, sculptors *as such*. The political here is simply a compendium of themes that the artist 'takes up' or 'expresses'. There is no examination of *how* these themes are appropriated and whether they are *successful*; whether or not they fall into the routinised and stereotypical as much of the work actually does.

What I am aguing here is that there is structural absence, as in the 'Art and society' legacy as a whole, of an adequate engagement with artistic means; a lack of analysis on linking artistic specificity to the real and complex changes within a social formation and the problems that presents for new forms of cognitive mapping in art.

Many of these problems, as I have said, can be traced to the way modernism has been received into Britain's culture of containment by the 'Art and society' legacy and its leftist contributors. Failing to acknowledge that art since Manet, as a matter of critical legibility, not ruling-class conspiracy, has been linked to a critique of the prevailing forms of pictorial organisation, it has treated the avant-garde descent of this process post-war into an increasing autonomy of means, as evidence of the *end* of pictorial innovation in art. The stage then is set for the return of social referent as a popular and affirmative corrective on the back of some fetishised view of modernism as transcendentally autonomous. Modernism as a history of course has had its transcendentalists – it still has them – however, what modernism recognised as an ineluctable problem for the production of art was that value could not be secured *solely* in references. The question of pictorial organisation was a constitutive factor in the production of meaning. Now, this is not to say that pictorial transformation remains attached to the supercessive logic of the avant-garde, but for art to continue to secure its conditions of critical contrast in the face of capital, there must be a recognition of what is no longer possible, in order to 'go on' politically. There are no guarantees here, guarantees of where art might find these conditions of critical contrast, simply that some historical materialist work needs to be done as minimal requirement of 'going on'. The legacy of 'Art and society' though, and its bureaucratic espousal in the cultural politics of Labourism, Community Arts, et al., denies this, suppresses it even, in the pursuit of what Terry Atkinson and Sue Atkinson have called in an essay on the work at Coventry 'moral issues as a set of consumer items'.[69] As they say,

the similarity between Labour Party culture and the conceptual and technical mundanity of much of the art in such a show are the linked ground of two frozen cultures.

Resistance then to premature closure, to the self-certifying claims of the human, the political, the popular, the aesthetic, must be the basis of any understanding of the critical function of art as transitive, unstable and multifarious in its productions. Such a view of course has been prevalent in British art culture, as I argued earlier on; but as I also mentioned, its ideological and institutional gains have tended to fluctuate, particularly under Thatcherism and the shift in higher-education provision in art towards technical and vocational courses. The roots of this counter-revolution go back to the moment of conceptualism. What conceptualism placed on the historical agenda in the late 1960s and early 1970s, and what the criticism so far discussed has consistently denied or undervalued, is the centrality of language in generating the means cognitively to 'go on' and questioning what 'going on' might mean: the fact that the formation of concepts determines what can be made and judged as art. Conceptualism needs to be seen therefore not simply as a form of aesthetic de-legitimation (although in many of its trivial anti-art forms it was just that), but rather as a set of pedagogic strategies and initiatives within art education and practice that questioned the very basis of identitary thinking in art, be it modernist or social realist. As Charles Harrison has said in a discussion of the part Art & Language have played in this critique:

Conceptual art is now subject to the normal procedures of art-historical and curatorial ratification. These procedures tend to impose amnesia regarding contingent references and critical functions. Given the persistence of the political status quo, or rather its deepening entrenchment since the late '60s, what must be occluded in the process of ratification are just those aspects which give Conceptual art its cutting edge and which were consistently identifiable with Art & Language: a determination to counter the anti-intellectualism associated with modernist painting and sculpture in the 1960s: a commitment for forms of production and distribution which circumvented normal forms of consumption; and a tendency to propose art objects of such a kind as to generate anomaly and absurdity in normal critical or curatorial practices.[70]

In reality what was at stake was a resistance to the post-1950s erosion of art's relationship to cognitive skills under decayed late modernist notions of 'free-expression', 'artistic intuition' and 'native ability', a breakdown which was embodied in the 1970 William Coldstream-

chaired National Academic report on art: 'We do not believe that studies in fine arts can be adequately defined in terms of chief studies related to media. We believe that studies in fine art derive from an attitude which may be expressed in many ways.'[71] There have been four main responses within art education to this: late-modernist re-trenchment ('this is interesting because I believe it be so'), traditional assertions of 'good motor skills' (as in Fuller), politicism (People's Art) and critical scrutiny and scepticism (a commitment to some historical understanding that art's problems lie in developing areas of cognitive interest and competence in its critique of capitalism through continually monitoring art's own inherited technical domain).

What has been of central importance then in the wake of concep-tualism as a specific movement has been the necessity to reconnect understanding in art with a concept of cognitive ability, as a counter to the conception of understanding as a condition of consciousness. Understanding *consists in* and is *constituted by* capacity, and not something coming before one's mind as Wittgenstein put it. Now this is not to defend some intellectualist approach to art, as if art were made *solely* out of ideas, or rather were equivalent to the realm of ideas. Rather, such an approach seeks to confront the failure of late modernist (expressionist) and conventional realist (empiricist) theories of art to deal with the question of creativity and subjectivity in an openended and projective way. One of the conventional distinctions in the psychology of thinking is between open and closed systems.[72] In a closed system the thinker (or here the artist) works within the framework provided by her or his existing knowledge; properties are established unproblematically and do not change radically in the course of solving problems that may come up. In an open system the thinker (or artist) is continually aware of the limitations of her or his knowledge and therefore is always being pointed towards discerning the reality of new problems. In an open system the thinker (or artist) does not possess a set of rules whose application *governs* successful problem-solving, since there is a sense in which the rules themselves emerge, change or at least extend their scope in the act of problem-solving. In one sense this is a false distinction; open systems work on the properties of closed systems; to change or extend a set of rules or moves is to be guided by a sense of what is already in existence. Nevertheless, what open systems acknowledge and incorporate as a principle of self-definition is the capacity of the thinker (or artist) to monitor the monitoring of her or his own activity, which in turn is

a function of language. As Roy Bhaskar has said in a discussion of human agency from an open-system perspective:

The capacity for a reflexive self-monitoring of one's own states of awareness during one's activity (to monitor the monitoring of one's own activity), is intimately connected with our possession of language, conceived as a system of signs apt for the production and communication of information. . . Such reflexivity over time would seem, then, to be a necessary condition for any discursive (non-intuitive) intelligence. And given our actual linguistic (and para-linguistic) skills, it enables a simultaneous, retrospective or anticipatory commentary upon our actual or imagined causal interventions in the world, typically expressed in the media of sound, mark or gesture.[73]

However, this is precisely what a good deal of late-modernist and conventional realist theories of art deny. In treating the production of meaning extra-linguistically as something that is already there waiting to be retrieved and transcribed (either 'out there' in the world, or buried 'inside' the self), it conceives of the relationship between subjectivity and social objectivity in aesthetically fixed terms. The closures of late modernism as self-expression, and conventional realism as a 'window on the world' lack then what is essential for genuine creative development: a *confrontation* between subject and object.

In essence, in the retreat from the complexities of art's production across subject positions, ideological fronts and expressive resources in the 1980s, a climate of unproblematic realism, expressionism and empiricism has been revived in the art schools. This in many ways can be traced to the crisis of conceptual art itself: its lack of pleasurable *visuality*. Thus the intense and rigorous re-skilling of art in the 1970s may have broken with the 'old skills' and 'content-spaces' of the traditional social realist/figurative and modernist abstract canons, but its radical anti-morphological claims on art paradoxically led to a sense of diminished resources of expression. This is why Fuller's essentialism, with its emphasis upon craft skills and perceptual veracity, on looking *long* and *hard*, became so popular in the 1980s, because he could exploit this crisis of visuality on the back of the crisis of late modernism without actually addressing what was historically and technically so important about the conceptual moment: the unpacking of all those decayed claims to the authentic ('self-expression', 'the real', 'universality'). Moreover, he could exploit this within a conservative framework of anti-professional values that stressed a plurality of positions as the most rational and reasonable option for art after late modernism. There is thus undoubtably a sense that

Thatcherism allowed Fuller with the rise of the New Right to make the kinds of allegiances he has.

More generally what the 'Art and society' legacy represents in its various forms is a defence of a traditional humanism in art against what it sees as the anti-aestheticism of those whom it constantly denigrates as anti-humanists. A good portion of the writing within this legacy then consistently attacks post-Wittgensteinian and post-structuralist theories of representation for denying proper or authentic human content to art. The problems of post-structuralism as a philosophical system have already been dealt with. (Its specific political effects on art in Britain will be dealt with in the next chapter.) However, the idea that the anti-foundationalist critique of reference in post-structuralism – the Saussurian argument that the meaning of a sign depends (in part) upon the contrast with all others – releases art from the depiction of things into a world of free-floating signifiers is just fallacious. What it does rather is problematise the very nature of that 'of-ness'. By addressing the character of representation as an articulated system claims upon the realism of works of art cannot be held to be identifiable simply with the depicted image or object. What artworks signify cannot be contained by what they look like or resemble. For clearly a given image or object possesses a mediated relationship to its referent. This requires us to recognise therefore that genesis is a far more powerful explanatory conception determining the meaning of representations than description. Understanding the genesis of pictures then allows us to infer cognitive use from cognitive function, insofar as what the producer claims to be doing determines the parameters of our enquiry. This in turn means that there can be no essential link between claims to the of-ness of pictures and descriptive or iconic content. For of-ness is also a relation to a real world of knowledge and dispositions outside of the picture. 'The discursive elaboration of an of-ness claim in respect of some picture will be a representational activity itself.'[74]

The defence of real humans doing recognisable things in recognisable settings in the writings of Fuller, Taylor et al., as the would-be cyphers of a stable system of humanist values, is the product therefore of a simple philosophical error; that making the recursiveness of representation explicit is somehow expressive of the *collapse* of meaning and the possibility of realism. Thus if there is a central confusion in this tradition between figurative resemblance and realism there is by extension a confusion between anti-foundationalism and anti-human-

ism. Against this tradition we do not need to be anti-humanists to have an anti-foundationalist understanding of representation. In fact the most powerful writing in the social sciences at the moment could be said to incorporate the fallibilist arguments of anti-foundationalism with a Marxist humanist framework (that of Roy Bhaskar, Alex Callinicos, Peter Dews, Sean Sayers). To defend an anti-foundationalist critique of representation, therefore, is neither to loosen the referential link between representation and the world nor to deny 'human content' to art. Rather the issue is to make humanism *critical*.

The retreat into cultural and philosophical perspectives where stability is sought and celebrated is of course not the result of Thatcherism. The counter-revolution was well under way by the mid-1970s, as Harrison notes. Callaghan's Great Debate on education in the mid-1970s clearly paved the way for the Conservative education minister Kenneth Baker. However, with the general crisis of the Western left and the rise of a new perspectivalist politics, represented no more so than by post-structuralism's anti-holism, *and* the local successes of Thatcherism, it is no surprise that the populism of the 'Art and society' legacy should mutate in the writings of a number of its contributors into a crude foundationalism. That it is rooted principally in a defence of a certain kind of painting is also not surprising. For in terms of what capital continues to deny and routinise in everyday life, the aesthetic 'otherness' of painting is clearly an attractive option. But it is one thing to see the aesthetic investments in painting as redemptive – and defend the interests of painting accordingly against theorists of the 'post-auratic' – it is another to return painting to the centre of the cognitive interests of the culture, as if the last twenty-five years hadn't happened.

Painting's lack of a critical *differential* place within the wider culture of representations and media in the writings of Fuller, Taylor et al., is the inevitable consequence of the signifying chain: figurative painting = humanism = aesthetic healthiness = political effectivity.

The legacy that I have mapped out does not, as I have said, purport to be coherent in its aims and judgements. As I have tried to draw out, there are certain differences in emphasis in what might be considered popular, accessible, real and hopeful. Nevertheless, what does unite this tradition is recourse to various forms of essentialism, and as a consequence a failure to acknowledge and theorise the *overdetermined* nature of art under late capitalism. The fact that to speak of art's interests, of what we take to be the 'real' and 'good' in our discussions of art, is to apply criteria of understanding that are necessarily provisional. It

is therefore in this spirit of open enquiry that the next chapter will deal with that counter-tradition that has in some sense ghosted the 'Art and society' legacy and thus might justifiably be called postmodernist and not simply post-modernist: the work of that group of artists and writers who have attempted to theorise a way out of late modernism, empiricism and social realism within British culture, without loss of cognitive complexity and political acumen. The contradictions, critical over-investments and retreats of this tradition as it deals with Britain's culture of containment will be no less a priority.

Thatcherism and the visual arts 2

Despite the rise of various forms of conservatism left and right in the British art world during the 1980s it would be undoubtedly shortsighted to say it was a period of retreat for critical theory and practice. On the contrary, the 1980s have witnessed a growth in theory and the emergence of numerous critical practices in painting, sculpture and photography that has made Britain a particularly invigorating place to work during this period. As explained in the last chapter though, in tandem with such advances in theory and successes in practice has come a weakening of the social effectivity of such initiatives. Although much influential work has been done, its position within the culture has become increasingly marginalised under Thatcherism.

The maturing of a whole generation of artists and artist-writers who learnt their aesthetics and cultural politics through the conceptualism of the 1970s will show the 1980s to be an important watershed in Britain in the construction of a distinctive political culture around the theorisation of postmodernism. Terry Atkinson, Art & Language, Mary Kelly, Susan Hiller, Rasheed Araeen, Bill Woodrow, Tony Cragg and Jo Spence have produced a body of work which is rich and manifold in its critical aims. Likewise, in conjunction with this work, the 1980s have witnessed the extension of a theoretical materialist culture around the visual arts that reveals how strong independent socialist culture remains in Britain, despite all the economic and ideological attacks on it. The consolidation of feminist criticism and scholarship, the emergence of black studies, the continuing development of photography theory, the Open University modern art and modernism course, the formation of the New Art History and related cultural studies areas, present a formidable picture of counter-hegemonic interventions within texts and institutions. Taken as a whole the work looks accumulatively impressive.

It was one of the political commonplaces in academic institutions and on the left in the 1960s that Britain had no theoretical socialist culture to speak of. The provincialism of British intellectual life was

thought irredeemable. In fact one of the historical ironies of recent times is that the French theoretical models that were so eagerly absorbed by the left in the 1970s and early 1980s have been absorbed into a culture that can now claim a degree of theoretical resilience that French Marxist culture no longer can. In In the tracks of historical materialism (1984),[1] Perry Anderson talked of a shift in Marxist culture away from Europe to America and Britain. This is very true. The expansion of the higher education system in the 1960s and early 1970s in Britain, and the particular social conditions prevalent in the country – a dominant and theoretically weak Labourism that offered poor intellectual resistance to critical theory, unlike the ideological dominance of the Communist Party in France and Italy – created the space for energetic new work. This of course affected the visual arts and thinking on visual culture as a whole. The need to retheorise art's relationship to popular culture and ideology in the wake of Berger's Ways of seeing (1972)[2] was a pressing requirement. The twin vagaries of bourgeois humanist connoisseurship and modernist formalism remained entrenched.

Yet we must ask why it is the case that so much theoretical work on the production and consumption of visual culture has been produced in Britain since the early 1970s. We have to go to the Germany of the late 1920s and early 1930s for a comparable expansion of theoretical work on visual culture. The expansion rests, in fact, on the ruling-class realities of Britain's 'culture of containment'. For it is with the working-through of the democratic effects of the expansion of higher education in the 1960s that the balance of class forces changed in education to produce a new left intelligentsia. Moreover this change in class forces occurred in a country that has had a highly developed popular capitalist culture. The interchange between the expansion of higher education and the relative sophistication of British popular capitalist culture (compared, say, to Italy, France and Germany) produced the basis for a whole new era of socialist scholarship and theoretical intervention. The development of feminist discourse around art, the new photography criticism, and the New Art History all owe their provenance to the shift in cultural studies away from the analysis of texts to images and artefacts in response to these changes. This is not to say that textual criticism was left behind, but that there was a conscious attempt, particularly at institutions such as the Centre for Contemporary Cultural Studies in Birmingham, and through journals, such as Screen, to study those forms of symbolic production that now dominated the Western cultural

landscape: film, photography and popular music. Retheorising the visual arts as forms of ideological production then was essentially a process of incorporation of materialist image-analysis into the purview of cultural studies generally.

The development of such work of course has been subject to intense disagreements and the fluctuations of fashion over the period. Nevertheless, what has united its concerns across disciplines is the 'turn to language': the analysis of the lived relationship of men and women to the social world as one determined by, and constituted through, the ideological interpellations of language. Under the influence of Althusser, Lacan and Barthes, the 'turn to language' dominated the critical horizons and political interventions of cultural studies from the late 1960s onwards. This turn was particularly important for the visual arts. For what this concentration upon the ideological function of language provided was a focus for the culturally specific reproduction of class rule. Moreover, the concentration on images and artefacts as textual production, as constructed and coded sites of meaning, was important in breaking with organicist and expressive accounts of the artwork. In fact, what this concentration upon language as social force provided was a radical continuation of the rupture Gramsci and Benjamin and Voloshinov (though Voloshinov was very much the invisible figure in these debates) made with Hegelianised theories of the social whole. Clearly there are sharp ideological differences and discontinuities in such an extension (Lacan was no friend of Marxism), but nevertheless the turn to language as the building bricks of social reproduction was central to dislodging the monadic bourgeois humanist and existential Marxist view that the social world exists independently for the subject.

The story of such a turn in the 1970s and 1980s though is less palatable to relate, as explained in chapter 1. The inflation of language under Althusserianism and post-structuralism as the ideological cement of social reproduction has driven a good deal of cultural studies into the heartlands, if not of reaction, then of a sophisticated idealism. In many ways this remains the current crisis of cultural studies. For under the changing balance of class forces in the 1980s in Britain – the attack on the institutional base of the advances of the 1970s – a good deal of work done under the rubric of cultural studies has used the 'language paradigm' to defend what amounts to no more than a counter-hegemonic liberal politics of difference. If 'New Realism' has become the watchword in the British Labour movement

it has also settled imperturbably as a framework for analysis in humanities departments and senior common rooms up and down Britain: the trade-union bureaucracy's mesmerisation in front of Thatcherism, and the critique of 'class politics' and 'economism' have become intellectual partners. This general political shift is no more evident than in the theorisation of postmodernism on the left in Britain in the 1980s. Postmodernism is judged simply to be 'New Times', 'A Politics of Difference', 'Post-Fordism', 'The End of the Working Class as We Know It', 'The End of Realism and Modernism'. The trajectory of Stuart Hall from analyst of working-class culture to leading *Marxism today* ideologue, a magazine which has played a large part in disseminating these ideas, is indicative.[3] Now this is not to lump all work being done under the heading of cultural studies into this category – far from it. However, I think a legitimate generalisation can be made, even if it is only based on looking through the popular political weeklies and monthlies and cultural journals and magazines. That generation of intellectuals who in a sense dragged cultural studies into universities, polytechnics and art colleges have invariably taken their points of departure from and accommodated to, the most superficial aspects of recent social changes. As Roy Bhaskar has said, the 'New Realism' 'effectively empties the social world of any enduring structural dimension'.[4] Central to this has been the failure to theorise adequately the recomposition of the working class. Because manual employees are a (relatively) declining proportion of the workforce, it is claimed we can no longer talk about the working class as the central industrial organising force for socialism. However, for Marx *occupation* could never be the sole focus for an analysis of class. Rather, class for Marx was always an antagonistic relationship between social groups based on their access to and control of material and intellectual resources. The expansion of the white-collar sector does not alter this reality. Furthermore, working-class occupations have never been fixed in character. When Marx was writing, the majority of the British working class were actually employed in the service industry, in service. These points would seem to be obvious; however they have been generally forgotten in the rush to embrace the 'New Times'.

A similar process of adaption has occurred within the study of the visual arts. The days of Nicos Hadjinicolaou. T. J. Clark, and Art & Language rattling on about ruling-class culture seem a long way away. Today we have the New Art History. Context-sensitive and swim-

mingly attuned to *différance*, it has ended up not so much as the final overthrowing of bourgeois art scholarship and 'vulgar Marxism' but a new set of career moves. Harsh words? Paul Wood, one of the best sniffers-out of art-world cant writing in Britain in the 1980s, had harsher ones in a review of the *New art history* anthology.[5] 'Idle liberalism masquerades as non-sexist, anti-authoritarian democracy; the lowest common denominator.'[6] Is this what we have come to? Well, yes and no. For Wood is also quick to point out that amongst all the non-sexism and non-racism there are those still working within the purview of a materialist analysis of the visual arts who think that epistemology and that 'bugbear' quality might still have a part to play. He quotes Charles Harrison in an oracular mood: 'It remains true that the most interesting and difficult thing about the best works of art is that they *are* so good, and that we don't know why or how.'[7] That is why, as I said earlier, at least this Kantianism offers some corrective to all the anti-authoritarian blather. The role of the Open University modern art and modernism course – which Harrison helped to write – has been important then in keeping this gap open during the 1980s. For as all around collapsed into discourse theory and the politics of difference, their debt to the Kantian moment within the Trotskyist cultural tradition allowed them to speak of things that nobody wanted to hear any more: that quality in art was a political problem, but it was quality in art that still made art interesting under class society. My own debt to this tradition is obvious.

The recent influence of feminism on art theory needs to be seen therefore from a dual perspective: on the one hand, as massively important for *any* adequate engagement with the culture, and in certain cases, a conservatively 'settling influence'.

Feminism has been that agency of cultural transformation that has left the British art world in the 1980s completely changed. One only has to look back to the miserabilist days of the mid-1970s to see what advances have been made for women during this period. The construction and placing of a feminist culture around the image, as Griselda Pollock and Rozsika Parker have argued in *Framing feminism*, is one of the abiding achievements of these years. Central to this is the continuing historicisation of women's contribution to visual culture, and the emergence of singular and important reputations. The two most obvious names of course are Mary Kelly and Susan Hiller. Both expatriate Americans, their involvement in the women's movement in Britain since the mid-1970s has contributed considerably to the

D

strong theoretical base that has underpinned British feminist art culture. The routine denigration of feminist art and practice by both the right and the populist left though is a continuing facet of these advances. Thus we at least need to be clear about the level of acceptance and status such artists have achieved. For despite their widespread critical influence, their positions within the hierarchies of the British art world remain relatively low. In a way this is not surprising. As I said in my opening remarks, the theoretical construction of a counter-hegemonic tradition is one thing, grounding its power in the world is another.

The same problems have confronted the emergence of black visual culture in Britain in the 1980s: an initial indifference on the part of management, followed by a flurry of interest (on the back of liberal guilt) and then a general tailing off under the assumption that things had 'been done'. Nevertheless, the critical culture around black art has now solidified, producing in the work of Rasheed Araeen, an important artist and combative writer and editor (see chapter 8). The utter paucity of Fuller's English nationalism is no more vividly exposed than in Araeen's critique of ethnicity, an ideology which has been an unconscious mainstay of Britain's 'culture of containment'. Araeen practises as a modern British artist in his native and adopted culture and not as a 'curator' of the racially exotic or picturesque. The 1980s then have seen a continuing advance of the self-determining and self-critical powers of black art culture. Thus, as with the influence of the women's movement, one only has to look back to 1978 and the infamous 'The state of British art'[8] debates at the Institute of Contemporary Arts, to which Araeen contributed, to see the advances. The former director of the Tate Gallery, Sir Alan Bowness, wouldn't say this now:

I think, and this brings me to the final point about Third World artists, nothing is sadder than the kind of feeble imitations of what is being done elsewhere that you find in places away from the centre. It is extremely important that each society should search for a particular national tradition, going again back to this feeling, that I have very strongly, that all art is the product of the society that produces it.[9]

Talking on a platform with John Tagg, Patrick Heron, Bowness and Richard Cork about 'neo-colonial domination'[10] and quoting Sivanandan, Araeen could have been talking in Urdu for all the practical effects his intervention made in changing cultural bearings at the time. This was of course before the emergence of a young and politicised gen-

eration of black artists in Britain. Today, despite continuing marginalisation, black artists' strengthening voice within the culture has actually made calls for a defence of the national tradition as an essentially pastoral one sound like racist demagoguery. That is an advance.

Weighing up the advances of women artists and black artists is to show in fairly direct terms how art management in Britain in the 1980s has responded to broader political changes within the culture. Significant cultural change though cannot be measured simply in terms of institutional advance, no matter how important this is. For what, on the whole, has characterised such changes has been a transformed conceptualisation of what constitutes art practice. The political advance of women artists and black artists in Britain in the 1980s is inseparable from important critical changes in painting, sculpture and photography. Consequently the most interesting work has made explicit its break with late modernism and social realism on the basis of a reconceptualisation of the subject and representation and the social world. In fact what has emerged during this period is an expressly political urban semiotic tradition within British art. This is important on two counts. One, for the first time this century – and I would go as far as saying that – art in Britain can claim a degree of independence from received critical models, thanks to the strength of its theoretical culture, and two, art in Britain has greatly increased if not its practical and organic links to new social forces then its discursive links. This is what I mean by postmodernism being identifiable with a new positional logic for art: the retheorisation of art across subject positions, ideological fronts and expressive resources within the culture.

Before going on to discuss critical changes in painting in chapters 5, 6 and 7, I want to discuss here the importance of the new sculpture and photography in evaluation and defence of an alternative postmodernist tradition within Britain in the 1980s. In particular, I want to discuss the theoretical development of photography, because it is in many ways in the development of the relationship between photography and theory where much of the thinking on new forms of political address in British art have been worked out. Moreover, the critical value of this work owes a great deal to the links it has made with extra-artistic social forces.

4.1 Photography and politics

Simon Watney was right when he said in 1986 that 'the democrati-
zation of photography in England is one of the most remarkable and
significant achievements of post-war culture'.[11] The development
throughout the 1970s and 1980s of a network of galleries, academic
departments, journals and magazines devoted to the political theori-
sation and 'accessing' of photography has no comparison anywhere
else in Europe or in America.[12] The strength of this culture of course
is directly related to the residual strength of the British Labour
movement. The construction of a counter-hegemonic photography
cannot be divorced from the increasing demand on the part of the
Labour movement and socialist campaigners generally for new
images. In this respect there has been a considerable ideological
struggle between those who defend the functional virtues of the
documentary tradition and those who see it as flawed and adaptive.
In fact the democratisation that Watney talks about is double-edged.
For a large amount of photographic theory during this period has
mirrored the populism of the 'Art and society' legacy in its claims to
accessibility. The defence of community photography as a counter to
the 'elitism' of 'high art' has been one expression of this.

Nevertheless, the expanded production and theorisation of political
photography has also taken another form: an explicitly anti-reporto-
rial position. In fact, bête noire to both late modernist and left populists,
it has represented a continuing space where the materialist insights of
conceptualism could open up conventional left culture. In breaking
with the 'reportorial moment' it supplied the critical focus through
which the major symbolic productions of capitalism could be subject
to a second-order analysis – advertising, film and photojournalism.
Linking photography to a new set of critical agendas and resources,
new forms of cognitive mapping were made available. My disagree-
ments with 'deconstructive' postmodernist photographic theory
therefore (chapter 1) have nothing to do, with its attempt to link up
photography to new orders of symbolic production, rather how such
connections have been theorised politically as part of art-world power
struggles.

Central to the new photographic practice and theory has been its
work on the politics of representation. In these terms it is work done
on representation via photography that to a great extent supplied the
basis for conceptualism's attacks on expressionism and social realism

or, as it came to be known somewhat disparagingly in post-structuralist photographic theory, 'trivial realism'. As Victor Burgin put in in his contribution to the show '1965–1972 – when attitudes became form' (1984)[13] a retrospective look at conceptualism: 'one of several reasons for the recourse to photography in conceptual art was to exorcise a ghostly 'logos' in the ideological machinery of art; the author as punctual origin of the meanings of the work.'[14] Linked to the 'revolution of language', photography began to dismantle those conventional expressivist and reflectionist approaches to art that had become ossified in late modernism and social realism. However, in debates conducted specifically on the terrain of photography, it was the documentary tradition that was singled out for particular opprobrium. From the anthropologist photographers of the middle of the nineteenth century to the political reportage of today, documentary photography has been concerned unproblematically with recording the presence of things. Photographic truth was predicated upon an empiricist or positivistic view of reality. Moreover, this empiricism directly served ideological ends. By treating the appearance of things as equivalent to fixed sociological categories (the 'poor', the 'good and the great', the 'primitive') photography objectified the subject. Classification became objectification, and objectification became stereotypification. The 'mastering of the other' within this tradition has been somewhat exaggerated.[15] There are a number of photographers who could be cited as counter-examples to the prevailing ethos, in particular Julia Margaret Cameron. Much of the technical literature on photography in the nineteenth century was sensitive to the subjective moment in framing the world. Nevertheless, a general political point can be drawn from this dominant tradition; a tendency to treat photography's indexical functions as equivalent to the real.

The central shift in photographic thinking since the late 1960s then, has been based on unpacking the naturalising claims of photography. To this extent the major part of the theory of the 1970s owes a great deal to the work of Benjamin and Brecht of the 1930s. Benjamin's problematisation of the claims of the political documentary photograph to produce knowledge clearly underpinned this anti-naturalist theory. This is particularly the case with Burgin's anthology Thinking photography (1982)[16] and Peter Wollen's Readings and writings (1982)[17], which both looked to the Benjamin of the 'Author as producer' (via Barthes) as a way forward. However, what characterised this theory was not simply an emphasis upon the critical potential of image and

text. For Benjamin the failure of the documentary tradition was the absence of understanding in how captions both anchor and transform the meaning of images. Rather the issue was one of the compromised relationship between the photographic image and the world of appearances *as such*. Photographic theory and practice in the 1970s and 1980s has situated its break with the documentary tradition not so much in terms of linking the 'reportorial moment' with the extended caption or slogan, but with disposing of the reportorial moment in photography altogether. Much in the same way as painting and sculpture historically have emphasised artifice and the rhetorical as constitutive of art's powers of disclosure, post-1960s photography has turned wholesale towards the constructed image as a source of photography's critical renewal. There are obvious links here with the legacy of modernist photography. However, the new photography has looked to more than the montaging of received elements or the adulteration of the print. Rather, images are constructed and staged for the camera.

What this explicit second-order move signifies in many respects is the final historical elision between art and photography: the 'completed' move of the indexical into the rhetorical. It was one of the major polemics of conceptualism that photography was a legitimate area of artistic practice. Along with Burgin both John Hilliard[18] and John Stezaker[19] argue that photography's imputed connection to the positivistic and anti-aesthetic is merely an ideological prejudice. Far from being rooted in the intellectually timid and crudely artisanal, photography's indexical resources are rich in semiotic potential. There is no unbridgeable gap between the photographic image and aesthetic manipulation, as the modernists of the 1930s ably demonstrated. The rise of the constructed or staged photograph in the late 1970s and throughout the 1980s then, is one of the clearest indications that photography is now aware of its resources of meaning and social function as lying in a very different social space to that which produced Mass Observation in Britain and the Federal Art Project in the United States in the 1930s. This is not to say that the indexical functions of reportage can no longer play a significant part in a political culture of photography, but that photography can no longer claim, as a discrete medium, a valorised political function over and above painting and sculpture, on the grounds of its would-be privileged access to the real. Photography can no longer be opposed to painting or sculpture either in terms of social objectivity or political

effectivity. Ironically, as a theorist who continues to pose photography against painting (albeit from a non-realist perspective), Victor Burgin offers a succinct summary of what is at stake: 'Art practice [is] no longer to be defined as an artisanal activity, a process of crafting fine objects in a given medium, it [is] rather to be seen as a set of operations performed in a field of signifying practices, perhaps centred on a medium but certainly not bounded by it.'[20]

The release of photography from the reportorial moment seems to me to be politically uncontentious. However, problems begin to arise when we begin to examine the grounds on which such a move is being made, for the rise of an explicit second-order definition, photography has served quite different ideological ends through the 1970s and 1980s, as was touched upon in chapter 1. The use of the constructed or staged photography to critique the claims of realism has been a common move in this theory. Thus Burgin can argue that because representations construct our reading of reality, then 'representations cannot be tested against the real'.[21] The philosophical weaknesses of this position have been dealt with in chapter 1. But suffice it to say, what is missing from such idealism is any sense of the claims of realism not as being tested from within the image but as being constructed discursively outside of the image.

The influence of post-structuralism on left photographic thinking in the 1970s and 1980s needs to be seen, therefore, as having a contributory influence on the 'New Times' and 'New Revisionist' cultural politics in the journals and magazines. Moreover, this can be related to the theoretical elision of cultural politics with politics following the break with a class politics. As a consequence, accompanying the shift to a second-order theorisation of photography has come a widespread downplaying of the pedagogic. The development in theoretical understanding of the symbolic functions of photography across subject positions has been tied to an implicit, or explicit, disdain for the 'older' public functions of photography. Or rather, the question of photography's second-order or rhetorical status has been detached from photography's educative public role. This has important implications, for the release of photography from overburdened validations of political effectivity and objectivity has tended to push thinking on photography in two opposed directions. On the one hand, photography as a politics of representation is defended as art and therefore distinct from any educative function, and on the other hand, as a reaction to the latter, photography's traditional indexical functions

are reasserted as outside of the domain of art and therefore politically progressive. Both positions are flawed then, not just because they fail to acknowledge how the critical role of photography might operate from context to context but in terms of how the question of photography's second-order status might actually transform the documentary tradition itself. In fact, one of the most conspicuous and interesting developments within the area of constructed or staged photography in Britain in the 1980s is the growth of second-order educative or pedagogic photography.

As a counter to the claims of anti-realism and as evidence of the postmodernist reconstitution of the categories of 'art' and 'political photography', I look now at four constructed photographic practices. The first three, Pete Dunn and Lorraine Lesson, Jo Spence and Peter Kennard fall into the above category of pedagogic photography, while the fourth, Susan Hiller, uses photography to destabilise the way the formal categories of the fine art tradition are used to contain the authorship of women. What unites them all though is that they provide a focus for the possible link between photography, postmodernism and *realisms*.

One of the political moves conceptual photographers made in the mid-to-late 1970s in Britain was to work in the 'community'. The most direct way of establishing photography's commitment to the production of new knowledge was to ally it with the interests of those who might be in an advantageous position to use this knowledge: the working class. Photography's 'directness', flexibility, and relative cheapness not only allowed consumers to become producers very quickly but allowed images to be situated at the forefront of political struggle and not just alongside it. The 1980s photography projects of Pete Dunn and Lorraine Leeson, Jo Spence and Peter Kennard are very much within this tradition of intervention. However, this is not to say that these photographers in any way see their work as at the cutting edge of class struggle. One of the big mistakes of interventionist or community photography in the 1970s and 1980s, as the post-structuralist photographic theorists have rightly argued, was its paternalistic socialism. In fact, such work exhibits a similar idealism about political effectivity as the 'Art and society' legacy. For example, Owen Kelly's *Community, art and the state* (1984)[22] makes all the right noises about community intervention, but does little to convince the reader that anything is being challenged at the level of representations and readings.

Participatory photography then has had its virtuous and sentimen-
tal side like any political practice. The strength of the work of Dunn,
Leeson, Spence and Kennard is that it avoids such postures. This is
based on a conscious tension in their photography between the
politics of representation and the representation of politics.

Working with the local community around the London Docklands
since 1981, in opposition to the Docklands Development Board set up
by the Tories in 1980, Dunn's and Leeson's mural-size constructed
photographs have a clear base in the struggles and experiences of the
local working-class community. Working with various resident
groups, the local borough, political pressure groups and individuals,
Dunn and Leeson mapped out a shared knowledge of what were felt
to be the most important issues affecting the community in its struggle
against the development. Translated first into small collages with text,
these words and images were then discussed and modified at meetings
between the artists, residents and activists until a suitable format was
arrived at that would provide the model for the full-scale in-situ
image. Measuring 18 ft by 12 ft and constructed from large photo-
graphic sections blown up from the original, the photo-murals com-
bined various drawn and photographic elements representing various
scenes from the labour history of the area and of the social
consequences of the development. Situated near to service or shopping
areas, images and words from the past and present provided a dramatic
'memory of the community'. Unlike conventional hoardings or com-
munity murals though, the posters were completed on a gradual basis
so as to establish an active narrative interest in the work's progress.
As such the hoardings functioned as both an information board and
as a symbolic site of resistance to the unbridled development.

The emphasis upon process in Dunn's and Leeson's photography
is essential to its political value and is what saves it from the earnestness
and substitutionalism of the muralist movement. For what the work
demonstrates in a practical fashion is how one of the most successful
ways of building cultural alliances between artists and workers is to
ally photographic practices with specific long-term political struggles.
Ideological and political skills are established within a framework of
shared values that will supply the basis for the transmission of similar
skills to others in similar circumstances. Moreover, by bringing the
skills and competences of many people into common focus, a raising
of the real political differences within the community is brought into
play. Dunn's and Leeson's work develops therefore, in classic socialist

democratic terms, organically from the constituency which it sets out to serve. This constitutes the materialist base of its realism. However, this is not to underestimate the determining input of Dunn and Leeson themselves. It is Dunn and Leeson who actually produce the images and who invariably set the agendas for discussion. Nor is it a case of inflating the potentiality of this model of intervention into yet another vaunted paradigm of 'socialist practice'. For clearly there are many problems with 'talking to many people' as a cognitive model for art. The necessity for independent aesthetic judgement can come into repeated conflict with the democratic decision-making processes of the project. It would be foolish therefore to talk about community photography, as many artists did in the 1970s, as the final 'resting' home of art's political effectivity. Such a means/end rationale is no less idealistic than the search for the Popular. Nevertheless, what remains instructive about Dunn's and Leeson's photography is that if consumerism destroys other knowledges, or rather the cultural spaces where they might be produced and exchanged, the active creation of a context where learning politically in the face of art might begin is genuinely progressive.

This use of photography as a pedagogic communal resource is also at the heart of Jo Spence's practice. Since the late 1970s Spence has been working on the possibility of what she calls an Alternative Family Album. This is based on the understanding that the genres of amateur photography (the portrait, self-portrait, landscape, holiday snap, etc.) play a large part in reproducing bourgeois relations through the family. The economic dominance of the symbolic under late capitalism produced a split in bourgeois culture between the family as a place where meanings are consumed, and political society where meanings are produced. Amateur photography is one of the principal sites of this split. Locked into a celebration of the picturesque as a realm where meanings can be created and relived outside any intrusion of politics, amateur photography acts as a kind of ideological self-monitoring of the family cell and its domestic rituals. With around 80 million films sold to 27 million people every year in Britain alone, this hegemony is not to be treated lightly.

In these terms Spence's work is concerned to show that popular photography is the product of certain restrictive ideological practices. Much of her photography therefore has been engaged with the production of a series of non-idealised genre images. These range in humour and pathos from her lounging fully naked on a divan in a pose

borrowed from a studio photograph of herself as a baby, to the harrowing documentation of her fight against breast cancer. By re-working the received genres of amateur and professional photography she opens up a symbolic space for another set of knowledges for the family photograph: a set of knowledges based not on the monitoring of family life as a succession of moments of concord and happiness but on the realities of class, gender and age. The recourse to such 'truth-telling' is of course not new to the realist claims of photography. However, what is important in this instance is that, becoming the object of scrutiny herself in the work, Spence offers an image of women openly and practically resisting the tyranny of ideal types. As such her photography has had considerable success with women's groups and photography classes. By actually producing images of her body in process, she offers a view of photography for the everyday user as something that can not only bring consensual pleasure (the family 'happy snap'), but can act as a therapeutic resource. As Spence has said in collaboration with Rosy Martin, constructing alternative images for the camera can provide the basis for forms of psychological 'unblocking'. We need to find 'new ways of perceiving the past so that we can change our activities now. Through the medium of visual reframing we can begin to see that images we hold of ourselves are often the embodiment of particular traumas, losses, hopes and fears.'[23] Using the camera for a dialogue with the self and others, we can 'de-censorize ourselves'.[24]

For Spence herself this process of self-therapy through photography has centred principally on her own traumatic struggle against breast cancer. Out of this struggle in the mid-1980s she produced a series of works 'The Picture of Health' 'documenting' her treatment, as a means of producing a narrative which could counter the orthodox medical treatment of breast cancer as something shameful and to be hidden. In two articles in Spare rib in 1986[25] she outlines the development of the project: 'It seemed to me that the breast itself can be seen as a metaphor for our struggles. The fact that we have to worry about its size and shape as young women, its ability to give food, when we become mothers, and its dispendability when we are past child bearing age, should be explored through visual representation, as well as with health care itself.'[26] It is this fragmentation of consciousness of the female body in the culture, of which orthodox treatment of breast cancer is a particular expression – the breast as a 'problem' for medicine divorced from the rest of the body – that lies at the heart

of the project. Thus in the series she contrasts images of her treatment under orthodox medicine with those of her undergoing traditional Chinese medicine. The holistic is juxtaposed with the instrumental. However, the series isn't simply a compare and contrast exercise. As subjectively present in the work, the image of the patient in struggle serves as part of a general project of consciousness raising on the question of women's (and men's) passivity in the face of the medical profession.

In this respect there is a conscious political/redemptive aspect to a number of the images in the series, in particular *Victim or heroine?* In fact in this staged image of herself baring her scars to the camera and wearing a crash helmet, she echoes the *ostentatio vulnerum* (the showing forth of wounds) of the devotional painting of the Renaissance.[27] In Renaissance painting the showing forth of the wounds of Christ was offered as physical evidence of the Scriptures; the images were in a sense visual 'proof' of Christ's corporeality on earth. In Spence's images though, the display of her wounds acts not to reinforce a prevailing set of texts but actually to subvert them, dominant readings of women's bodies as sexually supplicant. For example: women with a mastectomy have no right to a visible sexuality; the passivity of the female cancer patient; the 'good' feminine self-portrait. The result is an image of female 'triumph' and a provocative transgression of capitalism's sexual infantilisation of the female body. However, for Spence such self-display is not about women wearing their 'scars with pride'.[28] Rather, the images are a way of 'not disavowing what had been done to me, because the only way I can begin to come to terms with it and take control of my own life was by being able to look at what *had been done to me*'.[29]

Spence's work is regularly criticised as being self-indulgent and ghoulish. This couldn't be further from the truth. For by placing herself confessionally in the image, she encourages us to link photography and self-representation beyond the antinomies of private and public. Which is not to say of course that the construction of an Alternative Family Album alone can shift the economic dominance of the symbolic under capitalism, or that Alternative Family Albums should contain images of unrelieved pain, but that photography might be used in ways that it is currently not, to ask questions about the social conditions of our subjectivity. In this sense Spence has talked about her understanding of realism as being linked to an awareness of herself and others as 'subjects in struggle'.[30]

I want to construct images that cause a rift in how people perceive 'the real', but I don't want to leave the real behind. Thus when I say I am dealing with fantasy I am simply dealing with that which is suppressed in visual representation, that which is not normally shown. What I want to do is create images that people see in galleries or books that will stay in their minds as seeds so that when they look at their own photographs they will think 'My God! I never thought of that before'. By letting loose these seeding ideas into the world one hopes that other people will see that the dark side of their lives has a validity in coming to understand who they are. And not afraid to show it and discuss it. New activity can then flow from that.[31]

Another artist who has made a considerable contribution in the 1980s to the development of a new pedagogic role for photography is Peter Kennard. Kennard's photomontages and staged images are inseparable from much of the British left's public identity in this period. In fact, throughout the 1980s Kennard has had an unprecedented public role on the left. His work with the Campaign for Nuclear Disarmament (CND) and the Greater London Council (GLC), his widespread contribution to left magazines, books and to national newspapers, have given him a political platform few other artists in recent times have matched. Kennard's relationship to the organised left, though, has been a fraught one and as such provides something of an index of the conditions under which artists working on a campaigning basis have to work. For despite all the intellectual ratification from the left (a 'gifted artist' to quote E. P. Thompson)[32] Kennard has repeatedly come up against the Realpolitik posturing of those in the Labour movement who see no enabling connection between the representation of politics and the constructed image.

The Labour movement is not interested in ideas that can't be assimilated straight away. What they want, or are satisfied with, is an iconography that idealizes a sense of community. And of course the world of political fine art simply reinforces this by its general critical absence from the Labour movement. Artists see it as either irrelevant or too difficult to make inroads into the Labour movement and change their relations or production.[33]

In his work for CND Kennard was consistently faced with the arguments of those who wanted sun-gilded images of post-nuclear harmony. Nevertheless, despite these problems, Kennard's long-term consistency as a public artist of and for the left has done much to expose the nullities of Labourist anti-modernism. By using studio-constructed imagery and photomontage in conjunction with short, sharp captions he has over the years produced a varied, and more importantly, modern, armoury of oppositional iconography.

The idea of political effectivity is, as I have argued, a common fantasy on the cultural left, no more so than in the area of the public poster and hoarding. Kennard's posters and hoardings would seem therefore to offer the perfect technologist answer to problems of political access – mass distribution on the streets and through the media. There is an element of truth in this. Mechanical reproduction does guarantee a qualitative change in the level of distribution. However, what happens of course when socialist images and messages attempt to compete with advertising within the public sphere is the enforcement of state censorship. The public sphere – the site where *classes* interact – is the place for the circulation of commodities and not for the free exchange of counter-hegemonic instruction. This is why although the public successes of Kennard's campaign for CND and the GLC were real enough, without the economic and administrative support of the left-dominated Labour councils of the mid-1980s, he would not have received the support that he did. The Tories' attack on local government was essentially an attack on the possibility of the public sphere being used for socialist education in the way that the GLC attempted throughout its Labour control. Discussions of the political effectivity of posters and hoardings then are flawed right from the start without a recognition of the coercive and exclusionary powers of the state, which is why all those high hopes the municipal left had in the 1980s in Britain were rudely awakened by the class nature of Thatcher's attack on local government. There is nothing to suggest either that Labour in government would 'free' the public sphere for socialist education.

The effectiveness of Kennard's campaigns in many ways lies outside of what images might deliver directly on the street. For the success of Kennard's work for CND lay not just in terms of getting an anti-nuclear message across but in terms of building an alternative *visualisation* of the world of nuclear war and the permanent arms economy. This of course is an accumulative and long-range project, in which the construction of an image-repertoire around the issue becomes the priority. Thus the collaged cruise missile hitching a ride on Constable's *Haywain*, the orbital view of the British Isles under a fall-out cloud, the skelton reading the risible government pamphlet *Protect and survive* and many others, are images that have insinuated themselves to such an extent into the British collective visualisation of the prospect of nuclear war that they are now actually identifiable with Britons' imaginary expectations of such an outcome. In this respect they have

practically become an autonomous symbolic resource in themselves. This is borne out by how extensively these images or fragments of them have been used by anti-nuclear activists in their own visual productions, particularly banners. The appropriation of imagery from a common image-repertoire is of course highly familiar within mass culture. In relation to imagery which 'serves' the left, though, this is rare. What this points to, and makes Kennard's work of particular significance, is the potential power the vivid political poster or hoarding can have in symbolically *sustaining* certain interventions within capitalist culture. Dispersed across a thousand bedroom walls, offices and meeting rooms, the oppositional poster gives a visuality to political agendas. Naturally the enduring reality of war gives Kennard's anti-nuclear images a longer imaginative life than other issues but nonetheless, long-term or short-term, the public-issue-based image stands potentially as a symbolic resource not wholly determined by the interests of the capitalist public sphere.

The realism of Dunn's, Leeson's and Spence's work lies specifically in the part photography is asked to play in the creation of a wider alliance between cultural activism and political intervention. What makes this interface of substantial interest is that the process of making photographic images itself forms the main part of its political content: the enablement of others. *How* images are constructed, what interests they serve, serves to focus the understanding that subjects and the structures that cross and contain them, are also capable of being changed, being worked on. Although there is no comparable collaborative base to Kennard's production, a similar act of political reclamation is evoked in his photographs: the recovery of a primary understanding of ourselves as active, social subjects.

In their advocacy of staged imagery Dunn, Leeson, Spence and Kennard represent the postmodernisation of the documentary/interventionist tradition. The idea therefore that they are doing 'political photography', rather than asking questions of art through photography, makes little sense. This re-ordering of the conceptual distinction between photography and art is something that has also characterised those artists working with photography 'within' the art world in the 1980s. In fact one of the dominant characteristics of art in the 1980s was its general disregard for formal hierarchies and distinctions. This points to a profound critical transformation of art's relationship to its resources. Once photography and art are seen as forms of representational activity on the signifying materials of the

culture, the mechanical (objective)/manual (imaginative) distinction that has upheld the polarisation between political photography and 'the aesthetic' collapses. Defining postmodernism as a 'combinatorial logic'[34] then is much more than a formal issue. It is directly a political one, for it means breaking with those binary oppositions of bourgeois modernism and left populism that would retain the political in the mechanical and the aesthetic in the manual. This is why, invoking the political modernist tradition, Peter Wollen can say in his conclusion to *Readings and writings*: 'The way out of the ghetto and beyond the fragments can only be by crossover, hybridization and interzoning.'[35]

Hybridisation and interzoning have of course been a central issue for women artists in the 1980s. Breaking out of the ghetto of male definitions of female authorship has been an explicit act of aesthetic deregulation (see chapter 7). This is why photography has been so important to women artists. For it has allowed women artists to expose those binary oppositions of bourgeois humanism and left populism as oppositions that subordinated women's self-representation. Like Mary Kelly, Susan Hiller has used mechanically reproduced imagery with text and assemblage as a means of opening up the relationship between aesthetics and politics, art and photography for women. It is on the basis of this 'extended' use of photography that I now discuss Hiller's work as a further contribution to the extension of the political modernist urban tradition into the construction of a politicised postmodernism in Britain in the 1980s.

4.2 Dream mapping

What has been central to Susan Hiller's work since the mid-1970s is a clear understanding that formal hybridisation, recontextualisation and the collision of unfamiliars is the most adequate means of generating new content spaces for the mediation of women's subjectivity. In this respect her emphasis upon a combinatory aesthetic owes, more than the other work just discussed, to that appropriative and redemptive side of the political modernist tradition. Benjamin's defence of political modernism in terms of the 'dialecticisation' of the sign chartered and elaborated the role of the radical artist under consumer capitalism as essentially that of the *bricoleur* or 'ragman': the collector and transformer of the unwanted and discarded. Hiller's strategies of recontextualisation and appropriation are the direct

political descendants of this moment. However, having said this, it would be a mistake to assume that her work can fit unproblematically into this tradition of the appropriated image. For to talk here of the dialecticisation of the sign or cultural artefact is to talk first and foremost about the dialecticisation of women's subordination. Consequently what concerns Hiller is not just the status of the sign or cultural artefact as an expression of commodity relations, but its unconscious expression of sexual difference.

Since the mid-1970s Hiller has been engaged, through the combination of various media – adulterated and staged photographs, xeroxes, drawings and texts – with the underlying way that sexual difference is encoded in the most 'innocent' or familiar cultural material. The act of appropriation and recontextualisation for Hiller though is more than a simple 'putting into view' of women's history and experience. Rather it stands as a metaphor for the construction of meaning itself. For there is a consistent sense throughout her work that the process of drawing disparate fragments together is the basis upon which we make sense of the world. Furthermore, this is particularly pertinent to how women have made sense of the world. Subjected to subordinating definitions of their experience, women have in a sense had a 'privileged' access to the realities of fragmentation and division. The reclamation and recontextualisation of the found image or artefact is therefore very much an interrruptive act for Hiller. As a unit of meaning 'outside' a prevailing or received order of knowledge, the fragment becomes the didactic expression of what it means to reject the 'totalising' claims of a given discourse.

Hiller's work from the early 1970s can be divided into two main groups: works which are anthropological in their procedures, symbols and materials (the systemic work such as the 'Rough sea' postcard series 'Dedicated to the unknown artist' (1976)[36] and those works which are engaged in an unfolding project of self-description (the photo-booth self-portraits which incorporate automatic writing). The former are quasi-sociological, installation-based and discursive, the latter predominantly two-dimensional, pictorial and decorative in format. Although this is something of an arbitrary distinction to make, it does point to a strong formal division in her practice between work which uses photographically derived images as part of a dialogue with the conventions of sculpture and work which is closer to the two-dimensional conventions of painting.

Despite the formal differences though, what links both areas is a

conscious relinquishment of a singular or stable point of entry for the spectator. In the installation-based work this is generated through the interaction of photographic imagery, texts, drawn elements and occasionally sound; in the two-dimensional work through the displacement of Hiller's self-image into fragments. Both sets of work in their refusal, as she says, to manipulate source material into 'new wholes',[37] foreground the impossibility of representation ever being unitary in its claims to the real. However, what concerns Hiller here is not a post-structuralist-type deconstruction of the limits of representation, but rather, how an aesthetic of the fragment as a relinquishing of an 'objective', authoritative voice might offer women a degree of aesthetic autonomy, and therefore subversive power, in representing themselves freely to themselves. As she said in an interview with Roszika Parker in 1985: 'I want to show how one can claim a position of *speaking* from the side of darkness, the side of the unknown, while not reducing oneself to darkness and the unknowable.'[38]

Thus if Hiller's endorsement of hybridisation and discursiveness skirts very close to conservative notions of *écriture féminine*, her emphasis upon the critical and 'dialectical'[39] side of this process, as she herself has called it, owes nothing to the celebration of women as essentially 'unrepresentable' (see chapter 7). Rather, by relinquishing an 'objective' voice, she courts a kind of 'fruitful incoherence'[40] as the means by which a critical language adequate to the divisions women experience can take shape: a realist language – 'Women who are struggling with their own incoherence tell me they identify with this work. They feel they recognise the signs. . . what can I say? . . . these ineffable signs, because don't forget that at one level the world is constantly presenting us with signs that we as women have to deny or translate.'[41]

Central to the pursuit of an aesthetic of 'fruitful incoherence' has been Hiller's increasing interest in and use of automatic writing as an intellectual and formal component of her manipulation of photographs and texts. What attracted her to its use was its conventional status as 'feminine' and 'irrational' and therefore a potential metaphor for the suppression of female speech. In this sense she is not asking us to decipher her ineffable scripts, as in such works as *Sometimes I think I'm a verb instead of a noun* (1982),[42] or making any revised claim that automatic writing, as André Breton wrote, would free us from the tyranny of waking life.[43] Rather, the luminous scripts offer us a vision

in which the marginal and 'irrational' take on a positive and prophetic beauty. This is revealed with particular poignancy in the series of enlarged photo-booth self-portraits *Midnight, Baker Street* (1982).[44] Here Hiller has worked the automatic writing over her face, creating a tension between the bad faith of being 'written-in' by alien representations, and a vision of female identity as yet 'un-written'. This creates a dreamlike imagery in which human identities are projected as open to change.

The imagery and processes of dreaming are crucial to this series and to Hiller's political commitment to the fragment. For what Hiller unites here is the imaginative life of dreams with the desires of waking life; a dialectic which is inadmissible from any politics which counts itself as socialist. For just as it is the untoward and subtended in dreams where significance lies, it is within the boundaries of the marginal and unassimilable where revolutionary politics has its prophetic power. Thus, as a woman artist who has a political interest in the prefigurative power of the margins, what Hiller captures in 'Midnight, Baker Street' is a sense that the process of being an artist and a woman, doing politics, and 'coming to self-representation', are part of the same emancipatory order, the mapping out of fragments *as* cognitively significant. This is perhaps now the inescapable terrain of the postmodernist artist's political commitment to intertextuality. Pushed to the margins of the culture, the postmodernist artist works over, in Freud's phrase, the 'worthless fragments'[45] of our collective psychic and political life.

This process is particularly vivid in the video and photographic installation *Belshazzar's feast/the writing on the wall* (1983–84).[46] It consists of a video taken on Super 8 film of a bonfire on Guy Fawkes night. Over the flickering red/orange image is a voice-over from Hiller chanting an improvised 'nonsense' language and her son Gabriel attempting to describe the legend of Belshazzar as painted by Rembrandt. Surrounding the video are a series of photo-booth self-portraits similar to the ones already described. The basis for the piece was a number of newspaper articles Hiller had read on people who had seen ghost images on the televison screen after transmission had finished. Seeing this reading-in of images as a kind of electronic substitute for the reveries of fire-gazing she was led to the view that such 'misseeing' was in fact the unconscious workings of creative political resistance. In the work she goes one step further and locates these revelations of 'foretelling' within a tradition of prophecy itself,

hence the retelling in the tape of Belshazzar's feast in which Daniel calls his soothsayer to decipher the sudden appearance of mysterious runes on the palace wall: 'Mene, mene, tekel, upharsin'. However, in Hiller's work the ambiguities and omissions of her son's description of the Rembrandt painting displaces any notion of the retelling being retributive as in the legend itself. (Daniel fails to heed the signs and is killed.) Rather, what is conveyed is a sense that as in the television readings something that has the appearance of incoherence might in effect be undoing what is repressed: 'Signs of that which is always and already destroying the kingdom of the law'.[47] That 'always and already' of Hiller's is important, because what the watching of the flickering flames on the video-screen envisions is how human creativity is always resisting and escaping the confines of bourgeois consumption. As Hiller has put it:

My use of the primitive or incoherent utterances – signs and sounds – is like remembering the fragments of a language for which we've forgotten the rules. I'm reviving the audience's recognition that they aren't separated from these kinds of feelings and experiences, but simply that they've been re-pressed. Because the phenomena occur socially as messages, usually messages of doom, it's as though there's a very long history of individuals sharing insights into the kind of lack of health of themselves and their culture.[48]

Thus as in her other works which have incorporated ideologically 'fringe' material, for example Elan (1982-83),[49] which uses the 'voice of the dead' experiments of Constantin Raudive, Hiller doesn't just deconstruct the pretensions of those who find coherence in the incoherent. On the contrary she recodes such motivations as evidence of women and men in the most attentuated of circumstances or with the most implausible or impoverished material and intellectual re-sources actively trying to make sense of their culture. This is the abiding strength of Hiller's 'redemptive' vision. By drawing together fragments of discourses, narratives, photographs and artefacts into new configurations she releases those unspoken assumptions and desires 'imprisoned' in events and materials into a critically account-able form.

It is no surprise therefore that the key impression of Hiller's work as a whole is a sense of the marginalised voices of history speaking with common and prophetic voice in the present. This is particularly empathetic in Monument (1981).[50] Monument consists of forty-one colour photographs of memorial plaques Hiller found in a cemetery in the East End of London. Each one represents an individual act of heroism

by Victorian working-class men and women. In front of the plaques, which were arranged in a loose diamond shape on the gallery wall, stands a park bench on which the spectator can sit and listen to a fragmentary tape by Hiller on the relationship between death and representation. Thus, as in *Fragments*, which reclaimed the shards of pots made by Pueblo Indian women as a metaphor of women's entry into representation, in *Monument* we are immediately aware of absent lives, lives that are in a position of subalternity as regards their control over that process of entry. For *Monument* is principally concerned with how the containment of class, gender and morality determine the limits of women's and men's entry into representation. Thus for Hiller what is sacrificed in the commemorative plaques is not simply lives but the individual's powers of self-representation, insofar as the dead speak here through inscriptions that are not of their own making but of the dominant culture under which they lived. As a history lesson in false consciousness, the pathos of these lives lies in the fact that in death they were appropriated to ruling-class notions of honour and good citizenship, yet as workers were living under social conditions where self-sacrifice was a daily matter of self-survival and the survival of others. In effect Hiller has produced a model of how representation works in a class and gender-divided society. But as in all her work, her metaphors of exclusion are subject to a process of dialectical interference. Secreted at the bottom of the plaques is a piece of found graffiti from the 'other side' of ethical conduct: 'Strive to be your own hero', a punk motto of the late 1970s. If this 'unofficial' message represents the same kind of tyranny as the official ones, nonetheless Hiller's concern for the fragmented signs of desire shows that the drive for self-representation is continually making its voice felt. To return to the issue of realism and Hiller's renunciation of 'objectivity'. Her explicit use of material which has passed out of cultural circulation is not based upon a desire to comment on events, but is the means whereby the unassimilated or fogotten might speak of a disunited past and present and a possible democratically differentiated future.

The pursuit of a redemptive intertextual aesthetic has also characterised large changes in the production of sculpture in Britain during the 1980s. Heavily influenced by the de-hierarchising of aesthetic categories in conceptualism, a number of sculptors began to reclaim an expressly political function for sculpture. In fact, just as hybridisation and interzoning became key strategies in photography's and painting's move against social realism and late modernism, sculpture

began to theorise the extension of its resources through the second-order reworking of the semiotic status of the mass-produced objects and materials of consumer culture.

4.3 Mapping out the commodity

In 1981 at the Institute of Contemporary Arts in London a group of young sculptors were launched as part of a growing wave of disenchantment with the formalist proprieties of American-type late modernist sculpture and its Caroesque peers in Britain. A revived spirit of extemporisation, appropriation and the metaphoric was shown to be in the air. As the organisers put it: 'approaches have become more eclectic, there are moments of a certain anarchic humour and many of the statements are personal and direct'.[51] One of the major contributors to this exhibition was Bill Woodrow who, since the late 1970s, along with Tony Cragg, has helped to establish a critical context for this aesthetic shift.

One of the key debates in late-modernist sculptural theory in the mid-1960s was the issue of 'sculptural presence'. Much of the discussion at the time centred on Michael Fried's influential essay on minimalism 'Art and objecthood' (1967).[52] In this Fried looks at what he calls the overt theatricality of minimalist sculpture: the fact that basic to minimalism is the self-conscious acknowledgement of the interaction between the body of the spectator and the space in which the object or installation is presented. For Fried this represents the very degeneration of sculpture into life, and therefore capitalist spectacle. As he argues at the end of the essay: 'we are all literalists most or all of our lives. Presentness is grace.'[53] For Fried, like Greenberg, criticality lies in the *non-pictorial* intractability of the sculptural object; quality lies with the resistance of the object to literary or metaphoric association. Extending sculpture into the interactive spaces of the 'theatrical' could only weaken this.

It is therefore no surprise that theatricality became so strongly associated, after minimalism, with the early theorisation of postmodernism. As Douglas Davis says in his 1977 book *Art-culture essays on the post-modern*: 'We live at a moment when artworks veer from one extremity of scale to another, without concern of style or genre.'[54] What minimalism locates, and what Fried has mistaken for entertainment, is an irrevocable break with the idea of the 'truth' of sculpture

being at its most compelling in the 'expressive' freestanding con-
structed object. The idea that sculptural value might also be contained
in the manipulation of the representational content of objects,
materials and 'real-time' acts (the *Gesamtkunstwerk*, performance, assem-
blage and text) is simply beyond Fried's Greenbergian high-modernist
appeal to a continuity in sculptural 'technique' and 'quality'.

However, this is not to treat the link between theatricality in recent
sculpture and postmodernism on purely morphological grounds. The-
atricality is not to be identified as postmodernist simply because it
refuses a certain 'purism' in art. Minimalism was no less 'purist' in
its way than the constructed abstract steel sculpture it opposed. Rather,
theatricality needs to be seen as further evidence of that emergent
understanding across disciplines in the early 1970s, that art is
principally a conceptual and semiotic act. This is why Bill Woodrow's
and Tony Cragg's semiotic encounters with the object-world of
capitalism involve more than a 'new plural language' for sculpture or
a return to Pop Art.

Like their immediate predecessors, Woodrow and Cragg have
focussed on the modern condition of sculpture as a necessarily
conceptual one. But whereas minimalism and its extension into land
art (the work of Robert Morris, Barry Le Va, Carl Andre, and Robert
Smithson) are concerned with extending what might be called the
feasible formal limits of this understanding, Woodrow and Cragg have
been concerned with the relationship between the sculptural object
and its conceptual setting as a source of social knowledge. After the
formal exhaustion of late modernism, sculpture is returned to its
rightful place as the mediator of public meanings. By manipulating
found consumer durables and industrial materials into new objects
and configurations, Woodrow and Cragg use the devices of metaphor
and metonomy to re-stage the commodity as something which exists
in coded form as part of a wider set of economic, social and political
relations. Metaphor and metonomy (and narrative and parody) are
used to link the object imaginatively to its social conditions of
production and consumption. And this is why their work, along with
Susan Hiller's, is more profitably discussed within the terms of
Benjamin's dialectic of 'reconstruction and recuperation'.[55] For, as
with Benjamin's Baudelarian enthralment with things inorganic, their
reclamation and revisioning of the commodity form clearly maps on
to a world of values hidden from, or disfigured by, such forms.

In Benjamin's writing this sense of loss was rooted in the very

repetition of the commodity itself, in as much as the constant turnover and consumption of trivial and unwanted goods both acknowledged and prevented the realisation of a world beyond such effects. In Woodrow's and Cragg's work, the re-presentation of industrial 'remains' in the form of installations and tableaux (Woodrow) and wall-motifs and three-dimensional topographies (Cragg) project a similar kind of displacement. However, if their strategies of recycling look to a world beyond the instrumental uses of technology, their art does not celebrate a world before capital. Their 'ecological' vision is not the product of a forlorn remembrance of a more equitable, 'natural' past. On the contrary, by creating the new from the old, by reworking that which has been consumed or discarded into new objects of delight, humour and pathos, the products of a passive relationship to consumption are transformed into acts of conspicuous self-determination and self-sufficiency. From out of the world of decay and exhaustion is prefigured a set of social relations in which human beings are seen to have some collective control over what they produce and consume. Woodrow and Cragg are therefore criticising not consumerism as such but the division of labour under conditions of capital accumulation. This refusal to moralise gives their work its conceptual and aesthetic value, insofar as their means (recycling, scavenging, appropriation) match their ends (their anti-accumulative vision). By offering us metaphors of the practical remaking of our industrialised culture, they give imaginative life back to the dead world of the commodity.

These are big claims, particularly in the light of the varied quality of their work in the 1980s, and the fact that Cragg in particular has travelled quite far from the world of metaphors and metonomies he created in the early 1980s. Nevertheless, the initial thinking behind their work that established their positions has had a profound influence on a whole new generation of British and European sculptors in the wake of the crisis of late modernism.[56] The production of a social, anthropologically based sculpture has broken decisively with late modernism and its recently conspicuous conservative counter-tra- dition: traditional carving and casting. The revival of the latter in Britain in the 1980s, under the aegis of Peter Fuller's writing, has been based on both a distaste for the 'purism' of late modernism and the heterogeneity of the New Sculpture. In fact Bill Woodrow has been regularly singled out by Fuller as the very nadir of what is awful about the New Art.[57] As in his critique of recent transformations in painting,

Fuller and friends have dismissed the work of Woodrow and Cragg on the grounds that it lacks 'skill' and solid 'craft-values': that it is merely gimmick art (a position, incidently that Charles Harrison has not been adverse to applying in his criticism of Woodrow).[58] All this is predicated of course, as in Fuller's writing on painting, on the view that the crisis of late modernism can be solved by a return to traditional craft skills unproblematised by any link between technique and social knowledge. The virtue of Woodrow and Cragg, schooled as they are in the scepticism of conceptualism, is that they recognise this, and consequently incorporate it into the material processes of the work itself. As such there is no way we can separate the significance of their art from the novelties of its production. However formulaic such methods may have become does not alter the fact that the moves they made at the beginnning of the 1980s offered the maximum aesthetic and cognitive mobility for questioning the status of sculpture.

In Woodrow's work though, given its wider range of technical and semiotic interests, this dialectic takes on a far broader set of references. The cutting out of the imaginative object or objects from the functional object or objects allows him to open up the semiotic content of the 'host' and 'parasite' objects to a wide range of issues.

This is at its most effective and elaborate in some of the early ethnographic-style tableaux, in which the artefacts of pre-capitalist cultures are reconstructed out of the 'host' objects as new forms of Western cultural capital. One of the most vivid of these and perhaps one of the best works Woodrow has produced is *Car door, ironing board, twintub and North American Indian head-dress* (1981).[59] A North American head-dress as an archetypal symbol of exoticised ethnicity is recycled and objectified as one more domesticated consumerable. Here is the logic of exchange value writ large. The head-dress has become reified. Colonised by the expansion of capitalism, North American Indians are now recolonised as the Romantic Other. Thus North American Indians may be 'integrated' into North American capitalism, but their public identity and status still resides within the exoticised margins of the racial stereotype. Moreover, and this is what makes the work so compelling and saves it from sentiment, this Other-ness is staged as the basis upon which modern North American Indians actually continue to establish an autonomous cultural identity for themselves. Hence the sculpture doesn't just enact a loss of identity through economic exchange, on the contrary it shows it to be trans-formed under changed social conditions. Thus whilst the great-grandson of

a warrior-chief may now be an executive for IBM the accoutrements of the warrier-chief stand as a symbol of resistance to cultural imperialism. It is Woodrow's recognition of this dialectic which gives the work its candour. The head-dress has been produced as a symbol of resistance by the very conditions that sought to repress it.

In other works the cutting into the 'host' consumer durable offers a more explicit economic reading of Woodrow's appropriative aesthetic. In the early *Tricycle and tank* (1981),[60] in which a tank scaled down to toy size has been cut out of the top of a child's tricycle, the relationship between alienated labour and non-alienated labour is clearly visualised as an economic asymmetry (even though in this instance, for reasons of practicality, it is an image of alienated labour which has been extracted from an object of free-play). Consequently what makes Woodrow's work politically resonant is that not only do the sculptures stand as a metaphor for the transformation of consumerist values, but in a number of works the contraditions of capitalist production find a visual correspondence in the form of an ironic or anomalous juxtaposition.

The attempt to link the reclaimed and extracted objects to an objective set of social relations is also a concern of Cragg's early works, which recycle a colourful array of found plastic objects and shards into wall emblems and figures. In *Britain seen from the North* (1981), which shows a life-size figure of a man looking at a large map of Britain turned on its side, *Soldier* (1981), an almost double life-size image of a soldier on the streets of Northern Ireland and *Submarine* (1981)[61] a large schematic image of a nuclear submarine, the banality of the images, and the infinitely reproducible materials they are produced from, are drawn together as part of the same process of stereotypical repetition. However, if Cragg is saying that images in our culture are now subject to the same laws of obsolescence as commodities, he is also arguing, as the codifier of the detritus of industrial production, that the products of modern industry now form the contours of a new aesthetic/cultural experience. Technology has not only mimicked and surpassed nature in its powers of reproducibility but it has also surpassed it in its powers of visual differentiation. The colours that now dominate our technological life-world and that dominate Cragg's art have no correspondence in nature. Cragg uses this expansion of the products of technological and scientific innovation in a sense to quantify the distance between nature and modern art. By using discarded plastic artefacts and shards as a 'natural' resource, nature as

the traditional site of art's aspiration to authenticity is parodied. Nature is revealed no longer to be the 'spiritual home' of art; the place where the artist might find sanctuary from the modern world. Consequently, as the classifier of the minutiae of the urban landscape, Cragg confers on the mass-produced for the artist the universality of nature itself.

As with Woodrow, the strength of Cragg's early work lies in the way the 'double-life' of the found artefact or fragment – its simultaneous functional status and sign-value – *spatialises* our reading out from the micro to the macro, the cultural to the economic and back again. The result in fact is a constant critical tension between production and consumption as 'moments of a single act',[62] as Marx put it: 'Without production no consumption; without consumption no production'.[63]

It is no surprise therefore that an art that should deal so evocatively with economic issues should emerge in Britain in the 1980s. The decline of Britains's manufacturing base since the First World War and the Tories' attempts to stave off this continuing crisis by the creation of a would-be new 'leisure/service' industry, have clearly provided the material conditions for Cragg's and Woodrow's interventions. In this sense a British context is indispensable in a reading of the work's pathos. This is not to say that their sculpture begins from the economic realities of Thatcherism, but that a national perspective is invaluable in determining why both sculptors made the aesthetic moves they did.

Clearly Woodrow's and Cragg's work is open to other readings, readings which emphasise the visual punning as surrealistic acts of 'making strange', just as some of the work that both artists have produced throughout the 1980s can be cited as contradicting my overt political reading of their acts of reclamation and recontextualisation. But nevertheless all readings which remain predominantly within art-historical pattern-recognition will persistently misrepresent the causal conditions of their work's production: the fact that the work I have discussed possesses a definable and consistent moral vision in how it is put together. Woodrow has been explicit about this: 'How can you distinguish between [politics and aesthetics].'[64] Thus the recycling and appropriation are not decorative or picturesque asides but the actual means whereby a critically semiotic encounter with the status of objects might be embedded formally in the work. This constitutes the sculpture's realism. This is why it is important to locate Woodrow's and Cragg's art as an extension of the political modernist tradition. For to weaken this historical connection is to deracinate not only what

makes their novelties of production cognitively significant but their links as urban artists to other artists who may be working outside of sculpture but towards similar postmodernist ends: an art that derives its points of reference from the 'clash of classes, ideologies and forms of control'.[65]

The failure of much postmodernist theory in Britain in the 1980s to deal adequately with their work (and Susan Hiller's) from this position is a reflection generally of the resilience of conventional aesthetic categories, particularly in relation to sculpture. Woodrow and Cragg then, when they have not been slighted as 'tricksters', have been accused of being marginal to the real sculptural traditions of recent times, either modern or traditional. However, what their work has recognised is that there is no real sculptural tradition to call on post the demolition jobs of conceptualism. Despite his antipathy towards Woodrow and to a lesser extent Cragg, Harrison has been one of the few British writers to recognise the problems of making sculpture in the wake of this crisis of self-definition:

It may be that the problems of development of 'three-dimensional work' are still in their infancy. It may also be, on the other hand, that there is little real substance to the idea of a category of modern practice which is neither painting nor sculpture but which is positively not performance or photography either. We need some change of terms, however, if we are to think fruitfully about sculpture as modern art. The practice is still relatively well insulated against a potentially chill wind. Critical fashion may now be with what happened in the sixties, but there is little sign yet of relevant and adequate revision in the conceptual basis – the language – of criticism. . It may be that commitment to the practical and conceptual integrity of 'sculpture' is now inhibiting: that it serves to obscure some important lesson which might otherwise be learnable from the recent history of art.[66]

Absolutely – and exactly the historical lesson Woodrow, Cragg (and others) have learnt.

It is of course easy to impute self-conscious radical transformations in practice by a highly selective account of 'best moments'. Nevertheless, the practice and writing discussed in this chapter signals in my estimation that theoretical revision of conceptual categories across practices that Harrison and others have consistently called for since the early 1970s. That such changes continue to suffer at the hands of conservative modernist *ressentiment* and left populist retrenchment should in no sense weaken their claims to what now stands historically as the way forward for the talking about and making of art. The

materialist theorisation of postmodernism is yet to be written in Britain and elsewhere.

Illustrations pages 118–124

1 Pete Dunn and Lorraine Leeson, Docklands Community Poster, photo-mural, black and white with applied colours,1980 (Docklands Community Poster Project)
2 Jo Spence and Terry Dennett, Victim or heroine?, from the Picture of Health exhibition, 1986
3 Peter Kennard, Protect and survive, photomontage,1981 (© Peter Kennard 1981)
4 Susan Hiller, Monument, 41 colour photographs/audio tape/bench, 1980–1
5 Bill Woodrow, Car door/ironing board, twin-tub with North American Indian head-dress, mixed media, 1981 (Trustees of the Tate Gallery)
6 Tony Cragg, Britain seen from the north, mixed media,1981
7 Terry Atkinson, Narrative Dispute: the New Zealand Hat – three minutes after this moment the hat fell off the branch! (No that isn't true!) Well, O.K., three to four minutes then (No, that's not true either) . . . A narrative anecdotal index of 'being' a British artist (1980). Auckland infantryman watching 'working class' (1917) – 'bourgeois' (1958) infantryman of the Bedfordshire Regiment march by. Early summer evening, Somme area, summer 1917. Conté and gouache on paper,1979
8 Art & Language, Index: incident in a museum IV, oil and alogram on canvas,1985
9 Avis Newman, This . . . the dream's navel (two-part piece), mixed media on canvas, 1983–4 (Lisson Gallery, London)
10 Sue Atkinson, Landlocked Air America plane flies over Home Office washing line: on its way to Libya. Pegged to the line: hand made tie and dye dress picked up at Greenham, T-shirt picked up at Wapping, hat picked up in Northern Ireland. There is Tide in the sky and Tide on the clothes. Tide mixed gasoline makes napalm. Washing your dirty linen in private. Down comes a blackbird, mixed media, 1985–6
11 Sonia Boyce, Missionary position I, pastel and conté on paper,1985
12 Rasheed Araeen, Green painting, nine panels, mixed media, 1985–9 (Arts Council of Great Britain)

3

2

4

5

6

7

9

10

11

12

Postmodernism and representation

Imaging history: the history painting of Terry Atkinson

The next two chapters on Terry Atkinson and Art & Language and chapter 7 on painting and sexual difference deal explicitly with the critical possibilities of painting in the wake of the debates around representation that have already been mapped out. In this respect what follows is a further clarification of the notion of a second-order approach to practice today.

As argued, the eager denunciation or celebration of painting has been less the result of any internal crisis of the medium than the result of the tasks it has had to perform under post-1950s social realist and late-modernist closures. We can see the weaknesses of the 'Art and society' legacy very much in terms of a failure to think beyond these closures. As such, to risk an historical generalisation here, since the early 1960s painting has suffered massively from what Adorno called the schizophrenic function of art under capitalism – the conflict between a demand for utility and a respect for 'autonomy'. The Berger/Heron debate is a perfect example of this tension. Weakened theoretically by its particular vulnerability to commodification, painting became locked into a polarised conflict between the claims of aesthetic redemption and political effectivity. The result was a kind of succession of 'partial moments' or 'half-victories' for painting. This is not to say that all painting after the apex of American modernism was prey to woeful naivety and academicism, but rather that the split between a disinterested and contemplative model of learning through art in late modernism and a conventionalised political one in social realism, *and* the critique of painting itself in the 1960s and 1970s continually undermined what painting has been best at: history. Or rather, it undermined the understanding that certain pictures might stand in a position to generate historical knowledge discursively. The comings and goings of post-1950s painting, all the populisms and for-malisms, have been the product of the *reification* of the split between utility and 'autonomy'. Thus the issue is not that there hasn't been

important work being done during this period (some of Philip Guston's work for example), but that after the crisis of late modernism and social realism we can see why the closures around these practices took the form that they did.

Of central importance therefore for a critique of this split has been the need to recall painting back into some overall historical perspective, as a means to resocialise and repoliticise its resources. T. J. Clark's historical project on nineteenth-century French painting is the most obvious and major contribution to this. His work on Courbet in the early 1970s is an attempt to draw painting back into a perspective which took painting to be historically linked to the claims of art's second-order critical status. For Clark, Courbet's vividness and greatness lay in his sensitivity to those 'signs which are already present, fighting for room – meanings rooted in actual forms of life; repressed meanings, the meanings of the dominated'.[1] As Clark says in his description of Courbet's disjunctive use of popular nineteenth-century French iconographic material:

It was this disjunction that Courbet exploited in his usual instinctive fashion. Popular imagery has always developed – in other words, carried new information – by a series of transformations, reversals of terms, exaggeration and distortion of detail. . . He tried to use this system of changes and inversion, and stay within the understanding of mass audience – to forge images with a dual public, and a double meaning. In The Meeting he took a detail of a legend [The Wandering Jew] and retained faithfully the visual form of the orignal; he retained the bourgeois, but gave their presence a new significance; retained the landscape, outside town, outide time; transformed the outcast and his attitude towards the people he meets.[2]

This intertextuality should clearly not be confused with the intertextual demands on painting today. Courbet's organic class link to the peasantry and painting's function generally within the culture, presents a very different set of social conditions under which the 'reversal' and 'transformation' of signifying material might occur. But nevertheless Clark is making an important historical point. What Courbet's work offers us is a root back to painting's primary (if occluded) modern status as a parodic and appropriative activity, i.e., as an activity that is of necessity inside representation as a shared cultural act.

Intertextuality of course has become central to a good deal of painting produced in the 1980s, under painting's massive market revival. In fact it has been principally within the area of painting where

the closures of social realism and late modernism have been attacked most vigorously. Since the late 1970s there has been a general turn within European and American painting to understanding that painting is in a position to renew itself only through parody and pastiche. Reclaiming painting's traditional resources has been constitutive of the critique of the idea that novelty in painting is still possible. The result of this has been essentially twofold: on the one hand, a form of historicism (Julian Schnabel, Francesco Clemente) in which art-historical styles and formats are cannibalised as an act of spiritual 'regeneration', and on the other, a form of painting which uses painting against itself, so to speak. Taking its cue from post-structuralism, the appropriation of disparate images and signs – usually from both contemporary mass cultural sources and art-historical ones – becomes a purposeful rejection of the possibility of determinate meaning. As in David Salle's work, a 'poetry' of fragments draws a sceptical veil over any stable social function for art. This is Salle from an early statement, 'The paintings are dead': 'I am interested in the elevation of the arbitrary and contrived to the level of the ineluctable; not ineluctable in the sense of some higher purpose, but just arbitrary and inevitable at the same time.'[3] For some critics and writers this celebration of indeterminacy represents a political stance. As Tom Lawson argues in his essay 'Last exit: painting' in Artforum in October 1981, which was influential in its drawing together of this new work: 'By resorting to subterfuge, using an unsuspecting vehicle as camouflage, the radical artist can manipulate the viewer's faith to dislodge his or her certainty'.[4] Whether dislodging certainty can generate a discursively adequate engagement with the world is another matter. In many ways, despite all the talk about Salle's appropriative techniques, Salle's work and work like it harks back to that central aleatory component of the American modernist tradition (Pollock, Johns, Cage).[5] Such scepticism over means and ends is thus miles away from any 'reversal', 'exaggeration and distortion of detail' within the 'clash of classes, ideologies and forms of control', to use Clark's phrases. In fact under the dominance of either conservative or post-structuralist 'post-critical' readings of postmodernism, the eclecticism of reference in much of the new painting has openly contested the possibility of any discursive historical function for painting. As Michael Phillipson, British painter and critic, has said in Painting, language and modernity, which in many ways represents the most sophisticated defence of this position, the new painting's emphasis on parody and

pastiche is essentially a question of mourning and loss.[6] 'Painting is the other of power, it offers a passive subversion, puts itself aside from the positivities of information. It reminds us of "lost things".'[7]

The intention here is quite obvious: to separate art's relationship to language from any active grounding in social knowledge. But what of those 'lost things' that might be registered through the positivities of information? For registering loss is a question not just of redemption but of social transformation. Thus for example, the possibility of women entering painting as a site of socially constructed meanings, a space in which they are neither absent as models nor neutralised as the same or other, is a form not just of passive resistance but of active intervention. Moreover, this act is a massive practical one, given women's historical marginalisation within the Western painting tradition.

It is therefore with the spirit of the critical and historical recovery of 'lost things' that the discussion below concerns itself. I deal first with Terry Atkinson, who provides a focus for many of the claims made so far in this book. Atkinson was born in 1939 and was one of the first generation of working-class students to attend art college in Britain.

Terry Atkinson's work addresses some of the most pressing problems that face the production of art under late capitalism. In this respect his art goes to the heart of what it might mean to practise within the framework of historical materialism. For Atkinson's work may be made contingently out of the divisions of British life and culture, but it is set theoretically within a global political perspective. Thus, Atkinson's engagement with the realities of state violence across various continents is first and foremost an attempt to come to terms with capitalism as an integrated world order. The daily violence between capital and labour, imperialism and its subjugated peoples, is visualised not as an aberation of social reproduction but its symptomatic logic. This involves two interrelated responsibilities: first Atkinson sees his position as an English socialist as being tied to exposing the place of British imperialism and its contemporary reflexes within the world order; and secondly, as an artist dealing with the problem of 'doing' politics in art, he sees his own work at all times as being shaped, and cut across, by struggles outside his own immediate experience. However, in no sense does this mean that Atkinson has an itinerary of political scenarios he 'ticks off', but that despite all the shifts in his practice over the years he sees his work as

being linked inextricably to an historically accountable view of his own agency as an artist. The complex issue of producers being both *bearers* as well as would-be transformers of cultural values is central to this. For Atkinson politics is not just the material of his art but that space of conflicting signs through which a counterfactual vision of capitalism can be carried forward, irrespective of the success or failure of art's political effects.

5.1 Historicising the image

Atkinson left Art & Language in 1975 after a period of eight years. The reasons for leaving the group were complex and manifold. Nevertheless in terms of his work he felt he wanted to develop a more direct and interventionist relationship between art and politics. Whatever the political virtue of Art & Language, they did not look upon their art as being organically connected to any existing socialist culture or public, in fact on the whole they saw themselves as antagonists of much of the sentimentality and earnestness of those who were constantly wishing one into existence. If Atkinson took this realism with him, nonetheless he wanted a practice that stood 'against the grain' in more popular ways, that remained within that orbit of understanding which saw art as a constant problem of conceptual definition, but all the same sought to locate that within a realm of sharable meanings. This is why Atkinson in a sense returned to his early student and post-student concerns: the amalgam of pop motifs with social caricature. However, this wasn't a longing for the lost world of social realism. Rather, Atkinson saw that the closures of late modernism were based on the collapse of the relationship between doing and knowing.It had been the strength of Art & Language that they saw and theorised this crisis in the late 1960s, when provincial modernism was on the rampage in Britain, teeming as the country was with a whole generation of artists desperate to be thought of as modern in American terms. Art & Language's attack on American modernist culture though was not just an attack on anti-intellectualism and political timidity but on the morphological status of art; that the normative grounds of art as a form of object-making were open to dispute. Hence the centrality of textual production in the group at this time.

To say Atkinson gradually became sceptical of this position would be too simplistic, as if Art & Language were not sceptical of the terms

they had set themselves. Still, there came a point where the downgrading of the 'old' pictorial skills looked like too much of an imposition. Atkinson's break with the group then was very much on the terms of a reassessment of traditional pictorial skills as the basis for linking doing and knowing. His show at Robert Self in 1976 of paintings and drawings based on the First World War was the first codification of this. Clearly, intervening into a cultural climate which judged all figurative painting as ideologically adaptive, Atkinson's show argued that traditional skills were not in themselves reactionary but were to be valued according to the conceptual framework under which they were produced. Atkinson's paintings and drawings of First World War soldiers in the trenches were therefore less to do with a 'return to figuration' than an extension of Art & Language's second-order or interpretative approach. The work *referenced* the First World War, but through various textual strategies sought to make the issue of historical transmission through images a problematic one. It was precisely the epistemological status of the images as truthful representations that was the basis of the work. Pictorial skills were used to say something about how discursive structures govern the meaning of images. However, this is not to argue that this was a formulistic exercise in deconstruction, or that Atkinson is only marginally interested in painting – a position he would sometimes like us to believe. Rather, by using pictorial skills and formats as the *pre-ordered* means of expression, he prised painting and politics away from a reflectionist theory of representation.

These concerns culminated in Atkinson's first major exhibition, at the Whitechapel Gallery in 1983. Six years on though and the question of a politics of representation had become the fully fledged base for a new history painting. The show consisted not only of the First World War paintings and drawings but work on Stalinism, the Vietnam War, and the politics of the third world/west divide.

5.2 'Seeing-as'

In broad terms Art & Language's project from the late 1960s onwards has been a critique of empiricism and expressionism in art theory. Atkinson's Whitechapel show extends this debate to a critique of historical representation.

The attack on empiricism in the philosophy of history and science

acknowledging that claims to the adequate representation of the world are discursively linked to a struggle for the *better argument*. A good example of what I am defending here is Isaiah Berlin's well-known list of propositions about Nazi Germany.[12] Under Nazi rule was it the case that (a) the country was depopulated, (b) millions of people died, (c) millions of people were killed, or (d) millions of people were massacred? All the propositions could be said to be true, however, it is (d) that is obviously the most adequate. As Roy Bhaskar has said in a commentary on Berlin, all the other propositions create the wrong *perlocutionary* force.[13] This point to me seems essential. For whether it is social scientists or artists 'doing' history, history, is not just *about* a subject, but for an audience, as Bhaskar rightly says. That is, if we are to maximise our understanding of phenomena then we need to see phenomena as the product of competing value systems.

In this respect there is a distinct denial in the series of the artificial distinction between 'fact' and 'value'; the slaughtering of millions of working-class soldiers is not a 'fact' of the tragedy of war, but the result of a particular chain of causal links that turned trade war

rests on the view that its methodology of 'true to the facts' ignores the fundamental part theoretical models play in historical construction. All observation is inescapably value laden, involves a process of 'seeing-as'. Conventionalist critics of empiricism then resolve these contradictions by exposing empiricism's ideological interests. But if all observation involves a process of 'seeing-as', on what grounds is one model to be preferred over another? Conventionalists tend to weaken criteria of rational assessment therefore by treating epistemological questions in terms of incommensurably competing theories.[8] As I argued in my earlier discussion of realism and post-structuralism, on these grounds 'truth claims' operate relative to discourse. One of the obvious consequences of this is the idea of history as a literary discourse, a hermeneutic space of enquiry, as for example in the historical writings of Foucault. By assuming that events exist only under some description and that descriptions belong with opposed and mutually exclusive theories, conventionalists see historical representation in terms of the absence of the object from propositional knowledge.[9] However, this does not mean that conventionalists do not believe in the existence of reality but that reality is only identifiable within re-

eventually into actual war. The conflict Atkinson deals with is a war of *capitalisms*. Moreover, it is a war that engendered the October revolution and crippled the German one. Each of Atkinson's drawings and paintings in this series then forms a structured whole in which the victims and agents of the war are shown as part of a process that is *teleologically* intelligible. Quite simply, by 'narrativising' fragments of social conflicts as a series of violent or incipiently violent images, Atkinson seeks to disclose the larger 'narrative' and violence of capital. As such Atkinson's intervention into the debates on history and representation is not an academic one, as if he was 'doing' the philosophy of history through art. On the contrary, it is a practical and political one. For what is being asked here is: how might history be pictured in a way that is adequate to its real human complexity?

To 'do' history as a socialist is in essence to reclaim it from the clutches of myth, decorum and pageant. This is why we need to look at Atkinson's various strategies of textual and visual adulteration as specifically acts of defamiliarisation. By introducing the unexpected, uncanny or anachronistic into the historical image, and by extending the critical function of the caption, historical memory is destabilised, pushed out of kilter. The intention is of course, to locate the contradictions and uneven development of the historical process that the continuist perspectives of bourgeois history nullify. The continuum of history is blown apart, to paraphrase Benjamin. Thus in *In rock 'n' roll consumership 'working class' is a null class. . . Private Caprichos no. 73-Face, Vietcong, South Vietnamese Rangers, Private Buddy Holly-Face, Vietcong, South Vietnamese Rangers, the Plain of Reeds, 1972 (1979)*[14] a work from the Vietnam series, Atkinson uses the face of Buddy Holly for the face of a South Vietnamese Ranger as evidence of one of the more macabre contradictions of the Vietnam war: that American imperialism was accompanied by the strains of rock 'n' roll and the argot of working-class counter-culture. The principle issue around the use of the anomalous then is that the historical image does not simply service an affirmative anti-bourgeois historiography. The working class is not *opposed* to the bourgeoisie as a set of positive character-types, as in social or socialist realism, but acts as the focus through which the realities of class history can be exposed. This, however, is not to say that projective socialist readings are not available from Atkinson's work. But whether he represents 'from below' (as in the First World War and Vietnam series) or attacks 'from above', the memory of class betrayals and the sheer violence of the historical process outweighs

any easy affirmation of class solidarity. To 'do' history as a socialist in the West is inevitably to step across the void between affirmation and disaffirmation, between mourning for 'lost opportunities', as late capitalism restructures in its relentless way, and the necessity continually to bridge the socialist project with its past, to reclaim those fractured contours of resistance into new patterns of solidarity. It is this tension between reconstruction and deconstruction that Atkinson works out of. This is why there is no false promissory tone to Atkinson's critique, only a relentless commitment to the view that political art practice has to face up to the full powers of ruling-class exploitation and negligence this century if it is to have any perlocutionary force.

Beginning with the First World War is therefore of primary importance. For it was with the end of the First World War and the entry of the Russian revolution on to the world historical stage that the parameters of politics this century come into focus. It is no surprise then that the next period Atkinson should deal with is the 1930s and the rise of Stalinism. Although it is easy to talk about political betrayals, the failure of the German revolution in 1923, out of the ruins of German defeat, was a disastrous blow for the international working class. The vacillations of Stalin and Zinoviev about the nature of the revolutionary situation (Trotsky was prevented from travelling to organise amongst the workers) allowed a bourgeoisie severely weakened by war to eventually regroup politically. This exacerbated the economic pressure on the Soviet Union, whose working class had been decimated by the Civil War. The view that the gradualist delusions of the SPD and the left/right zigzagging of the KPD paved the way for the pogroms of the Nazis and Stalin should not be taken lightly. For it was the prolonged isolation of the Soviet revolution that produced the 'pragmatism' of Stalinism and its ideology of 'socialism in one country'.

Atkinson's work on Stalinism and Trotsky in the series entitled 'The Trotsky postcards' (1981–83) thus continues to explore the 'narrative' of history's combined and uneven development. Utilising the conventions of the postcard Atkinson addresses a series of political messages from Trotsky to various conservative and demagogic figures (Churchill, Verwoerd, Stalin himself, Svetlana Stalin) as a metaphor for the exile of the real revolutionary socialist tradition from the evaluations of those who would judge the future of socialism from Stalinism and social democracy alone. It is the legacy of Trotsky that has sustained

a vision of human flourishing in opposition to the reductions of Stalinists and social democrats alike. As Atkinson has said: 'The whole Eastern bloc lives in fear of Trotsky's cultural ghost'.[15]

In contrast to the First World War pictures though, Atkinson employs a range of techniques that markedly open out his practice. In a number of pieces pictorial space is broken up in the interests of ideological and aesthetic mobility. Combining collage with a compartmentalised picture space and captions that now take on the interpretative range of 'stories', Atkinson creates a kind of historical patchwork in which various historical images and facts collide and intersect. As Atkinson states: 'The choice of the "postcard" device in the "Trotsky Postcards" was by way of seeking for an opening into a "field" whereby text would conventionally articulate picture and vice versa (the postcard is conventionally visual on one side, text on the other) as integral and mutually dependent instrumentalities developing a genre to convey "Modern Politics" as subject'.[16] Furthermore, this process in a number of large works, in particular Ideologically battered postcard from Trotsky in Coyoacan to Stalin in Moscow (1981–82) takes on a hysterically mordant tone. The adulterated surfaces and fragmented spaces of these pieces are not just "botched" but violently despoiled. This points to the central conceptual issue of Atkinson's art. How does the history painter represent Stalinism or the legacy of Trotsky, for example, in a way that carries the right perlocutionary force? How does the painter represent, to quote Atkinson, the 'visual of the non-visible'.[17] Clearly, the dissonance of the surfaces of a number of these works is a way of trying to find that right formal correlation for the politics. The argument then for the history painter is never simply a question of getting political content into art but of finding the most adequate means of representation to match or contain the content.

What is at stake here is what has been at stake all through the preceding discussion of art and politics: that the aesthetic and cognitive skills of the artist are to be viewed a part of a continuing process of learning grounded in the contingent problems of pictorial organisation, and not the conventionalised product of any received powers of political commitment. For Atkinson this process is explicitly one of observing historical materialism as a methodological principle of constructing pictures. As he said in an early essay 'Materialism, by Jove!':

by historical materialist work, I mean work which affirms the primacy of social activity itself on our conception of knowledge. These assertions themselves rest on an acknowledgement, that a defensible art theory/practice must hold art out be an attempt to *gain* knowledge, i.e. that this theory/practice must be locatable in the practical problem of knowledge; the work must be up for 'disconfirmability', not reification. There must be no entrenchment of a proprietary idea. By this I mean that work which attempts to reify a 'great lineage in art' is not locatable in an active model of knowledge. It proscribes and fixes art practice on the epistemological map. The primary convention of such a map is that knowledge is already achieved – the matter of 'learning' art is unproblematic.[18]

Representing politics turns on the very issue of cognitive and aesthetic mobility. The repetitition of 'socialist content' merely leads the way to the sentimentalised postures of the politically aware artist. Political awareness is relatively cheap, moral concern even cheaper, the realisation of new forms to contain new content spaces somewhat harder to find.

5.3 The politics of parody

Despite Atkinson's critique of modernism, the above clearly reveals how acutely aware he has been of what modernism recognised as determining on practice and what remains determining on any adequate practice today: that art defines itself as much against other art as against the world. Although we may no longer be able to speak of the future of painting, or pictorial art in general, as participating in extending that 'great lineage of art' we call the Western avant-garde, nevertheless painting remains attached to the accumulated truths of that lineage. To gain knowledge in painting therefore is to place in view the necessity of limits and boundaries, of what is and what is not possible, in order to continue to practise. The problem for painting today, after the idealised transgressions of American modernism, is how does the artist work within these formal limits and yet remain committed to gaining new knowledge? The answer of course, as Atkinson implies, is by working on representaton as part of the world. Thus we might say that the rules of representation impose necessary limits upon the number of expressively novel acts painting can perform but they do not determine the future content governed by those rules. For meaning is not something that is created solely out of inter-artistic resources but is linked to non-discursive forces and

struggles. Consequently the whole question of getting new knowledge into art needs to be grounded in an understanding that art's manipulation of signs and conventions is both a product of, and response to, the structural divisions of social and historical life.

Broadly speaking, Atkinson's painting and writing promises a post-modernist intertextual practice. However, the formal specificities of such a move have played little part in his writing. This is unexpected, for Atkinson's whole break with late-modernist theories of expression and with reflectionist theories of realism is based on what has been central to a good deal of recent discussion of intertextuality: the importance of parody as a source of art's critical renewal.

As Linda Hutcheon says in her *Theory of parody* (1985),[19] parody is not just the allusive variation or nostalgic transcription of other images or texts, but a form of 'extended repetition with critical difference'.[20] Parody's principal function is not to ridicule or satirise but to *recast*. Defining parody along these more narrow lines allows us therefore to 'flesh out' an historical materialist account of representation, insofar as it makes clear in precise formal terms what the real aesthetic options are for the modern artist confronted with the exhaustion of modernism's supercessive logic and yet the need to 'go on'. The link between the creation of meaning and recontextualisation becomes integral not just to art that explicitily references other art but to any art that might claim a cognitively and aesthetically adequate engagement with the world in the wake of the crisis of late modernism and conventional realism.

One of the critical aspects of parody's capacity to free the background text from its inherited meanings is that it can say two opposed things at once. This is expressly what Atkinson does in the First World War series and the 'Trotsky postcards'. By reworking the genres of war painting (soldiers at rest, soldiers in combat, soldiers eating), he presents the appropriated academic realist tradition as incapable of matching the class realities of the Great War; and yet at the same time acknowledges that many of the conventions of the tradition remain capable of being reused to retrace history in an active and interventionist way. Similarly, in the Trotsky series the idea of the postcard as a space of consumerist misrepresentation comes to signify the spectacularisd nature of the bourgeois political process itself, whilst offering as the pleasures of popular identification. What connects these two series is what Hutcheon refers to as the 'parodox of parody',[21] or rather its bi-textual function. In recasting the background

image or text critically (i.e., through the inflexions of irony or satire) parody incorporates the image or genre deferentially. Thus Atkinson ironises both the claims of official war painting and the idealisations of the postcard, at the same time as utilising their inherited intelligibility as popular forms of representation. 'Parodic art both deviates from an aesthetic norm and includes that norm within itself as background material.'[22]

Parody then, in its emphasis upon recasting and recontextualisation, should be kept distinct from those post-structuralist theories of intertextuality which assert the free play of the signifier. For in tying the production and interpretation of artworks to a 'restricted' focus, the idea of the spectator being able to associate meaning *freely* is self-consciously resisted. In fact the 'restriction' of focus first and foremost implies a theory of *reference*. As Hutcheon says: 'While all artistic communication can take place only by virtue of tacit contractual agreements between encoder and decoder it is part of the particular strategy of both parody and irony that their acts of communication cannot be considered completed unless the precise encoding intention is realised in the recognition of the receiver.'[23] This implies a certain kind of spectator competence – an awareness of aesthetic and cultural norms and recognition of their transformation. Now, such a position could be said to have obvious conservative implications. Parody is no stranger to opaque self-reflexiveness. However, such a process may also create a complex and participatory form of spectatorship in which pleasure is associated directly with learning. In this sense parody should be thought of as an aesthetic extension of the politics of defamiliarisation. By recasting signs and convention in another light, the gap between official ideologies and a real world of agencies and structures can be foregrounded. Moreover, by defining parody as repetititon with critical distance we avoid all those conflations of politics in art with figurative resemblance: the question of critical recasting can apply to any background text or image.

5.4 'Bunkerism'

The mixing of genres and the reworking of inherited conventions is explored further in the work Atkinson did immediately after the Whitechapel show: 'Art from the bunker', which travelled around England and Ireland,[24] and 'Brit art', which travelled from London to

Switzerland.[25] If the work prior to the Whitechapel show was concerned with mapping out global historical and political relations in order to put in place the character of Atkinson's socialism and the nature of what has brought us to where we are politically, the work immediately after shifted to an assessment of issues that affected Atkinson more directly: the prospect of nuclear war and the war in Ireland. In fact, both political scenarios are played off each other in the form of a dialogue between state violence and revolutionary violence. More generally though, the change of focus brought into sharper definition his own understanding of what it is to be an English socialist faced with the entrenched legacy of British imperialism and the rise of a new conservative English nationalism. The work of this period is very much an attempt to take the argument for a new history painting to contemporary English politics and culture. In this, as with a whole generation of socialists and socialist historiography, he addresses himself to the peculiarities of English class rule, a culture of containment that has violently suppressed the rich republican and revolutionary traditions of England. The marginalisation of the radical democratic tradition of the Levellers is a case in point.[26]

Much recent theoretical work, spearheaded to a large extent by E. P. Thompson, has been directed towards the possibility of reclaiming an English nationalism from an explicit socialist/republican position. The counter-hegemonic possibilities of this approach though seem minimal, when they are not downright reactionary. Nevertheless, the sheer historical amnesia perpetrated by the British state and its offices on its inhabitants is not something to be easily dismissed or ignored, as I outlined in chapter 3. Whether the British state is 'exceptional' or not with regard to other Western bourgeois democracies, we cannot dismiss the fact that there is a massive alliance between the bourgeoisie and the ruling class and large sections of the working class around the inviolability of a British monarchical constitutionalism, which daily curtails and dams up Britain's variegated republican and revolutionary past. Atkinson's historical project, armed with what little art might have to offer, steps into this process of amnesia.

This is why Ireland has played such a large part in his recent work. Ireland is that structural absence in the British, and in particular English, political imagination that perhaps more than any other issue points to how deep this process of 'forgetting' has advanced within British politics. However, this is not to say that Atkinson sees Ireland as the issue for socialists, as Marx and Engel did in the 1860s. The

economic importance of Ireland for Britain has declined dramatically
since the Second World War, removing the worst aspects of the eco-
nomic exploitation of a colonialist situation, but that the British
presence in Ireland (for strategic reasons) continues to brutalise and
distort the relationship between the English and Irish working classes.
Atkinson's work then is an attack on that British form of bipartisanship
that would demonise and silence the Irish struggle simultaneously, that
would prefer censorship and increased military expenditure rather
than a political solution on Irish terms. Neil Kinnock's condemnation
of the IRA as abject 'cowards' and Thatcher's revealing assertion that
they 'should be wiped off the face of the civilized world. They must
never win' disclose the depth of the British imperialist reflex
irrespective of political beliefs.

It is not surprising therefore that the question of Ireland has
generally been absent from the work of British artists. To engage with
it is to take on board both a complex historical map and the morality
of armed struggle. This is why Atkinson's work has been important,
because the issue has been dealt with in a way that reveals the artist
actually knows his history. Naturally, this is not to say that knowing
history will produce interesting art, but it will at least prevent the artist
turning to Ireland as a form of political spectacle, in which women
and men are pictured as martyrs against an intolerable and unresovable
background of religious conflict, as in the sentimental pathos of
Richard Hamilton's The Citizen (1981).[27] To engage with Atkinson's
work on Ireland is to engage with a history that is both complex and
real, that is rooted in the contradictions of the daily struggles of its
combatants. History here is sticky. It hurts and rebounds if it isn't
treated with respect.

As with the First World War paintings and drawings and 'Trotsky
postcards', the Irish series places a premium on texts that do a lot of
historical locating. Names, facts, references accumulate to produce a
strong sense that a large amount of formalised knowledge is being
transmitted. Clearly, as Atkinson is quick to acknowledge himself, this
would be flat and arduous if the pictures themselves weren't doing
some work. And this is why, as with the First World War series and
the 'Trotsky postcards', Atkinson looks to the way that the Irish
struggle and Ireland itself has been, and continues to be, represented
in British and Irish culture, as the basis for opening up a second-order
and allegorical space for the production of images. Thus one of the
key background texts to the work is the familiar notion of Ireland as

a green and pleasant land in which a continuity of culture and community through landscape is the dominant aspect. In this sense Atkinson parodies an Irish tourist board, Gaelic Romanticist view of Ireland as an idealised background to the real struggles that inhabit the landscape. This produces what I have called in connection with the 'Trotsky postcards' an 'aberrant picturesqueness', in which the ideology of the pastoral, so central to the self-image of so many European ruling classes, is placed up against the effects and instruments of war.[28] However, by concentrating on this 'paradox of land and people',[29] Atkinson has far from produced a set of atrocity pictures. This perhaps says something about how certain genres of war painting are more easily usable from a safe historical distance. Rather, in a number of the works he politicises the landscape by treating the war as a series of hidden presences. One of the main devices he uses to reinforce this is the metaphor of the ghost: republicanism as a spectral, haunting and in a sense unassailable presence within the orbit of British history and affairs. In other works this absence of images of direct conflict is filled by the recasting of another picturesque genre in a 'corrective' light; the still life. Combining still lives out of a grotesque array of British army equipment or by placing actual pots of flowers up against the head and shoulders of republican combatants, he indexes a play on the phrase *nature morte* to a play on the idea of the booby trap; Ireland the land of sombre beauty that keeps blowing up in Britain's face. This attempt at allegorising the Irish situation by critically reworking the notion of republicanism as a permanent absent presence is extended through the metaphor which holds the whole series together: the image of the bunker. Many of the still lives are morbidly contained in black cabinet spaces. The image of the bunker serves then to figure the intractability of British imperialism. But perhaps more pointedly, the intractability of Irish republicanism; historically republicanism is dug in deep. In this respect Atkinson has been accused of romanticising Irish republicanism; but this misses the point. For what remains vivid about the Irish work is the way it uncovers and frames a history and culture that daily resists an 'engulfing slurry of . . . monarchist media performance'[30] in England. The contours of a deeply entrenched revolutionary republicanism are shown, paradoxically, to lie at the heart of British society. The historical irony of this is something that Atkinson shares with Tom Paulin; that it should be an ostensibly Catholic tradition that serves notice on a reactionary protestantism. The prot-

estant imagination as the home of the English revolution and the crucible of secularism[31] has become the servile home of ruling-class ideology. Tom Paulin puts it beautifully;

I see a plain Presbyterian grace sour, then harden
As a free strenuous spirit changes
To a servile defiance that whines and shrieks
For the bondage of the letter. ('Desertmartin')[32]

'Bunkerism' on a far larger scale is dealt with in the companion series to the Irish work, the bunker of nuclear preparation. In this regard both series represent two separate orders of violence; violence against the state and violence by, or threatened by, the state. The prospect of nuclear war is a form of state violence that knows no parallels in history. To defend an anti-nuclear position therefore is to be vehemently and unswervingly against State violence; there are no 'just' nuclear wars. However, one of the obvious consequences of this, reflected in the politics of CND, is a tendency to turn towards pacifism as a political solution. But to call for peace under capitalism is to call for something that capitalism can never deliver, because capitalism creates the conditions for the perpetration of violence. This is why Atkinson places his work on Northern Ireland quite stridently up against the anti-nuclear work. In doing so he sets in play a moral dilemma for socialists faced with the reality of this perpetration. Atkinson does not romanticise republican violence, rather he shows it to be internal to capitalist logic itself: that capitalism in order to maintain its interests will continually and quite cynically produce the conditions where it will flourish. In these terms to 'do' history is always to 'do' a history of state violence, which is why Atkinson at times refers to himself as a contemporary war artist, and why he consistently deals with political 'hot spots'. 'Art from the bunker' confronts the reality of two wars – one actual and one in preparation – as evidence of a system that, contrary to bourgeois myth, has remained permanently at war this century, and in other centuries.

But how does the artist begin to represent an enormous issue such as nuclear warfare? How does the artist represent what is in many ways unrepresentable? What kind of critical and aesthetic interest can painting generate in the face of the films *Threads* and *The war game* or the photographs of the victims of Nagasaki and Hiroshima? Obviously another set of resources have to be brought into play; ones that do not attempt to reproduce the horrors of such destruction but nevertheless

bear witness to its reality. Atkinson achieves this by introducing a very different kind of perlocutionary force into his parodic strategies. Instead of being confronted by a sense of anger through aesthetic adulteration, we are confronted by a sense of mourning. By adopting the conventions of the holiday snapshot he transforms the received notion of the family album as a site of harmony and concord into an archive of historical pathos. In some of the paintings Atkinson's wife, the artist Sue Atkinson, and their two daughters Ruby and Amber, are shown in settings indexed to the barbaric results of pre-nuclear imperialism, the cemeteries of First World War German, French and British soldiers in France. In others he represents his daughters at play on the beach which doubles variously as a war zone. However, if these images serve to create an 'aberrant picturesqueness' through reversal and distortion (Atkinson again uglifies his images in order to carry a sense of moral and political breakdown), in an accompanying set of images which show his daughters in secure domestic settings, the sense of anomaly is the result of irony's most basic function: repetitition without commentary. Reworking in a flat, almost banal way the conventions of the happy family snapshot, he, as he says, attempts to 'sieve a history of "sweet" imagery' into the reality of a 'nuclear high-tec poisoning environment'.[33]

The pictorial strategies of these works are much indebted therefore to the deferential side of parody. For in recasting the conventions of the family snapshot, by placing his family in the historical firing line so to speak, he mobilises an image of continuity to stand in as a vision of what we all stand to lose. Atkinson has been criticised for the patriarchal assumptions of his use of the family album, but I think these criticisms miss the point as well. For first and foremost, there is a play on the phrase nuclear family here; if capitalism celebrates and policies the family (in order to secure the reproduction of labour power), it is also the first economic system that stands to destroy familiar relations altogether. Atkinson is not defending the nuclear family, but generational continuity.

Atkinson's use of irony and parody and various other forms of reversal and adulteration point to an understanding on his part for a language that is essentially pathologised in its perlocutionary force. As Atkinson has said: 'the possibility of making an affirmative culture today seems to be . . . absurd'.[34] This pursuit of a 'critical non-affirmative'[35] subject, though, takes a different kind of turn in the work done after 'Art from the bunker', revealing quite clearly the

dialogic base of Atkinson's practice as a whole. In fact what 'Brit art' (1987) previews is a transformation of the pathological away from its relative 'stable' base in forms of figurative resemblance to the 'non-representational'. In this he returns to the spectre of late modernism as an ideology of 'not meaning' as the source for a new aesthetic of the grotesque. In 'breaking' with a political practice grounded in figurative resemblance he outlines what is to become the second-order concern of the new painting: that meaning in art cannot be reduced to a matter of what things look like, or rather, that a theory of reference is not necessarily synonymous with a theory of resemblance (see chapters 1 and 3). The codes of abstraction are as equally available for recasting, for parodic repetition, as any other set of visual conventions. Furthermore, they have particular grotesque qualities that make them eminently suitable for a language of disaffirmation.

In short 'Brit art' was an attempt to extend the allegorical range of Atkinson's 'new genre of Modern Politics'. Thus, although the terms of the process of cognitive mapping undergo alteration, its parodic function remains the same. Using certain conventions of abstraction (aleatory marks, colour fields, 'non-art' materials), he produces a map of Anglo-Irish relations as a map of ruins. The opacity and intractability of the Irish situation for the British finds its formal equivalent in the opacity of late modernist painting. Consequently there is a bitter irony to these paintings, insofar as they take the ruin of representation to be the most adequate way of locating the aspect-blindness of the British engagement with Ireland. However, 'Brit art's' cultivation of an aesthetic of disaffirmation which mimics the 'incoherences' of abstraction, suggests a broader political reading of ruins. In many respects 'Brit art' points to a change in how Atkinson frames the politics of what he is doing that leaves him open to attack for indulging in tragedianism. 'Brit art' is subtitled the 'Goya series'. As such it plays on the assumption that each of the canvases functions as part of a political grotesquerie. As he says in the accompanying essay: 'The metaphorical black hole vis-à-vis the black ground/surface of the Irish and Goya series is . . . an attempt to gain a representation of an historical pit in which cultural vertigo and historical closure is the typical condition. It is at these points in the mapping that the 'black' is mapped into the black of Goya's *Quinta del Sordo*, into the "black" of the *Desastres* and *Caprichos*.'[35] Ruins, closure, historical pits, the link between Goya's Spain and Ireland, all create a strong sense that structure has engulfed human agency. This is reiterated in the writing by the

powerful presence of Adorno and his notion of a fully administered society: 'Our modern societies . . . increasingly out of control and quite impossible to map on any set of old ethical reference points'.[37] This is a very different Atkinson to the one found in 'Materialism, by Jove!'. In 'Brit art' we find a catastrophism that is quite out of keeping within the materialism of the rest of the work. Thus the idea that our culture is one of ruin may be plausibly and rightly defended; but within a context where the metaphors of the void and vertigo dominate it becomes a weary existential platitude. In effect, by linking the history of Irish politics for the British with a history of modernism as opaque ideologies, the Irish struggle is left dispairingly in the realms of 'blackness'.

Whether we can judge such arguments as a position though needs to be treated with some scepticism. Atkinson tends to work through a process of subterfuge, as a means of breaking with received expectations. This is particularly the case in the 'abstact' painting that he produced after 'Brit art'. This work, shown initially in Copenhagen and Basle, continues to use the conventions of abstraction to create a map of capitalist grotesqueries, but in this instance as a direct attack on certain kinds of political art. Thus if 'Brit art' was an attempt to open up the co-ordinates of a process of cognitive mapping in art to a generalised notion of ruin and breakdown, 'Mute I' and 'Mute II' (1988 –89) use the codes of abstraction to beat on the door of a certain left visual culture. Essentially the new work continues the dialogue around the issue that meaning in art is fundamentally a question of conceptual definition; and for Atkinson this turns, in the final analysis, on strategies of negation. The reworking of various abstract modes recasts the original trajectory of modernism as a culture of refusal, as a form of commentary on an area of conceptual and aesthetic predicament that a good deal of political art has forsworn: that a critique of capitalist relations has to be embedded formally in the work.

'Mute I' and 'Mute II' then are not defences of abstract art but part of continuing second-order argument within Atkinson's work about the predicament of continuing to practise. This is why the refusal to be 'intelligible' in this series, seeks, through the negative, to open up the status of painting for discussion and analysis. The target of the show is a comfortable kind of political practice that would suppress the problems of locating meaning in the problems of pictorial organisation, through a defence of moral urgency alone. By mimicking acts

of modernist non-conformity – for example, by using grease as a conventionally unstable material in a number of pieces – Atkinson stresses through exaggeration that verisimilitude and technical profiency is not enough. But why go to all the bother of making artworks to say this? Aren't these issues best left in the pages of art books? I believe Atkinson has produced his critique in the form of objects because it is only when arguments become grounded in works, and therefore enter a process of economic exchange, that such arguments can act as a basis for dialogue through the *artist* rather than the critic. Arguments have in a sense to become events. The idea that we might judge these abstractions in any 'fruitfully' formal way is to be resisted. On the contrary, in much the same way as his early work commented directly on the conceptual categories and value systems of art, this work uses painting in order to comment on the problems that face the political in painting as such. Atkinson's critique of complacent forms of political art, as for example the work in 'State of the nation', should not be taken therefore as signalling the absolute corrigibility of figurative reference. Rather, the absence of the figurative social referent in this work problematises the very basis of political reference itself.

5.5 Identity, meaning and audience

Atkinson's commitment to the necessary but non-sufficient relationship between figuration and political practice, his resistance to easy solutions, points to a view of the politics of representation that owes little to the received convictions of the 'Art and society' legacy. In this respect the presence of Adorno, as the critic of identitary thinking and the scourge of the early Brecht and of Lukács downgrading of the necessary illusionistic basis of art, stands behind Atkinson's art. Atkinson's dialogic and parodic strategies are strongly indebted to Adorno's notion of ironic reversal: the setting up of antitheses.

Adorno saw antimonial thinking as being at the heart of bourgeois culture because bourgeois culture was incapable of resolving social problems directly; only historical materialism, as the 'logic of aporia', could expose such antinomies. In relation to art we might describe this process as the drawing out of the antinomies in aesthetics in order to show that such antinomies have a social base. Implicit in this of course is the understanding that the distortions/misrepresentations/asym-

metries of our culture have to be acknowledged in the form (or pictorial organistion in relation to painting) of the work itself. This was Adorno's objection to the early Brecht and to Lukács and to theories of expressionism: all three were torn halves of an attempt to embed social critique in the form of the work. Brecht and Lukács (though Adorno was always highly ambiguous about Brecht as a cursory reading of *Aesthetic theory* reveals)[38] tended at their most propagandist to collapse art into functionalism; and expressionism tended to collapse it into mere subjectivity.

In Adorno the relation between art and society is presented as a continual problem of the form of the work and not simply a question of the stated content. Style then becomes of central importance. Style is not fixed and promoted over the material which it constitutes but stands, as Gillian Rose says in her book on Adorno, *The melancholy science*, for a 'continual vigilance to the mode in which [it] is presented, thereby recasting the relation between theory and praxis'[39] In essence Adorno's critique of identitary thinking challenges attempts to make theory in art an instrument of univocality. Thus for example his criticism in the 1930s of Benjamin's valorisation of technology as the basis for a new social practice in art was predicated on the fact that Benjamin underestimated the residual appeal of the singular aesthetic object. The task of 'doing' theory in art therefore lies in recasting as a form of praxis without overstating the claims of theory as such. For Adorno this approach was quite simply the 'morality of thinking'.[40]

All the same, in Adorno this 'morality of thinking' as a critique of 'standardisation' and 'reification' of content was pushed to the point where he saw no possibility of any popular forms being politically invigorating under the administered culture of late capitalism. Adorno was so insistent on looking at the form of artistic production, and not the reception, of works of art that he failed to differentiate between different responses of different forms of cultural production. The refusal to adapt to the prevalent modes of exchange and reception in art became reified in itself; Adorno had little sense of an audience.

Adorno's writing has its roots in Nietzsche's refusal of 'complicity with the world'. To affirm life under capitalism is to affirm capitalism itself. In this Atkinson is in absolute agreement. However, Atkinson's practice does not endorse the anti-epistemological implications of Adorno's negative dialectic. Atkinson's art may follow a melancholic, disaffirmative path, but this does not weaken its moral and political basis in a revolutionary socialist analysis. Rather, the

melancholy and disaffirmation are attached to a particular sense of the failure of *political art* in the face of the world, at the same time as recognising the need for the political artist to find ways of continuing to practise that are aesthetically vivid and intellectually strenuous. Atkinson's work is self-consciously at the centre of what it means to practise art as a marginal activity under late capitalism: on the one hand, the necessity for art to be grounded in a cognitively adequate engagement with the world; and yet, on the other hand, a respect for art's 'relative autonomy', that art is at no point a substitute for politics. This is an important distinction because it actually allows us to dispense with that dummy debate between social realism and modernism, 'political effectivity' and formal interest, that has dominated the high-cultural ground over the last fifty years. It also allows us to link up that fragmented culture of left aesthetics this century that has resisted this binarism – an anti-Stalinist and anti-Labourist cultural politics. For Atkinson's critique of People's Art is rooted not only in Trotsky's attack on Proletkultism and the Popular Front and Adorno's critique of identitary thinking but in Valentin Voloshinov's contextualist theory of the sign. It was Adorno who in many ways kept alive the theoretical implications of the critical legacies of Trotsky and Voloshinov in the 1950s and 1960s. (Voloshinov was another victim of Stalin's purges in the late 1920s). Reflectionist aesthetics and theory though have remained a potent pole of attraction for the left, particularly in Britain, as outlined in chapter 3. The dominance of Stalinism and Labourism on the left should not be underestimated in drawing those who would not normally support their political ramifications to their functionalist cultural politics. The 'cultural attachés' of the now defunct GLC are a good example.

Essentially Atkinson (along with Art & Language) represents a continuation of the claims of that early theoretical modernist political legacy that fought a rearguard action againt notions of 'pure signality' in art, be it from an expressionist or social realist position. This is why an understanding of the relationship between art and language has been fundamental to the critical projects of both Atkinson and Art & Language. For what was at stake was the attempt to show that art was not just a matter of what or how, but *what, how and where*. The combination of Wittgenstein and Trotsky in Atkinson's early writing then was an attempt to secure a political culture for art that was open and self-critical, that refused the closures and blandishments of both social realism and bourgeois defences of modernism.[41] In this regard

at least, Atkinson's project also overlaps with certain themes of the post-structuralists. Those artists influenced by post-structuralism have likewise presented a vigorous critique of the autonomous creative subject and reflectionist aesthetics. However, the importance of Atkinson's contribution to this debate is that, in addressing these issues specifically through Wittgenstein and Trotsky, the general anti-Marxist implications of this debate could be avoided. And this is why Voloshinov as the great 'forgotten' theorist of modernism and representation is so important within this context.

In many respects Voloshinov 'sorted out' the problems that have beset questions around representation in the West since the 1960s without collapsing such problems into an anti-Marxist setting. In fact, his work prefigures in an uncanny synthesis all the major theoretical motifs and themes that an anti-Stalinist and anti-bourgeois modernist left has articulated over the last thirty years: that signs do not simply reflect reality but structure our reception of it; that class interests do not coincide with a given set of signs; that meaning is a dialogical process and a product of concrete situations; that there is no expression outside of its embodiment in signs. In various ways the projects of Benjamin, Gramsci, Wittgenstein himself, Raymond Williams, Habermas and even Donald Davidson find their echo in Voloshinov's *Marxism and the philosophy of language* (1929).[42] As Raymond Williams has said in his essay, 'The uses of cultural theory',[43] which deals with the legacy of that extraordinary moment within the study of signs and language in the Soviet Union in the 1920s which produced not only Voloshinov but Bakhtin and Medvedev, Voloshinov's work is a 'lost moment'[44] of some magnitude, a moment that 'could have saved many wasted years'[45] (Voloshinov was translated only in 1973). This of course is not to argue that Atkinson could have saved many wasted years if he had read Voloshinov earlier, but rather that by placing Voloshinov in the foreground of our analysis, rather than Wittgenstein and Trotsky, we can get a clear picture of a continuity in alternative debate around art and politics this century. In short we can begin to discern what is the *real*, though subtended, progressive critical tradition this century: the political-modernist tradition. For we are talking about a theoretical tradition that has been in permanent opposition since Trotsky's and Voloshinov's deaths, a tradition which has constantly emphasised the necessary but non-sufficient relationship between politics and value in art in the face of the reductions of both the bourgeoisie and Stalinists. Voloshinov makes a devasting critique of the aesthetic positions

implied by both political positions in *Marxism and the philosophy of language*. Criticising those semioticians and linguists who would reduce expression either to free utterance ('individual subjectivism') or objective system ('abstract objectivism'), he argues that communication is not the product of stable, transparent signals, but an 'interindividual' process which is precisely the product of a reciprocal relationship between a given context, the addresser and addressee. The task of understanding then for Voloshinov does not

amount to recognising the form used, but rather to understanding it in a particular concrete situation, to understanding its meaning in a particular utterance, i.e. it amounts to understanding its novelty and not recognizing its identity.[46]

Every sign . . . is a construct between socially organised persons in the process of their interaction. *Therefore, the forms of signs are conditioned above all by the social organization of the participants involved and also by the immediate conditions of their interaction.* When these forms change, so does the sign. And it should be one of the tasks of the study of ideologies to trace this social life of the sign.[47]

If the sign is a creation between individuals then meaning can be generated only through an interindividual process. In other words, as he says, 'only that which has acquired social value can enter the world of ideology, take shape, and establish itself there'.[48] Reality then is *refracted*, as Voloshinov calls it, through the sign. And this is determined by an intersecting of differently oriented social interests, i.e., the class struggle. It is this notion of the sign as the *site* of class struggle that became the basis of Gramsci's and Benjamin's critique of the bloc-theory of art's class function in the 1930s. What Voloshinov makes clear therefore is that class interests do not coincide with a given set of signs: 'various classes will use one and the same language, as a result, differently orientated accents intersect in every ideological sign. Sign becomes an area of the class struggle'.[49] Take for example the 'green imagery' – so ubiquitious today – that is associated with both the left and right of the ecology movement. Voloshinov calls this instability 'multiaccentuality'.[50] However, what remains important about Voloshinov's theory of the sign is that the world is not collapsed *into* text, Voloshinov neither substitutes struggle over the sign for revolutionary politics nor assumes that words can be substituted for things and experiences.

It is ultimately impossible to convey a musical composition or pictorial image adequately in words. Words cannot wholly substitute for a religious ritual;

nor is there any really adequate verbal substitute for even the simplest gesture in human behaviour. To deny this would lead to the most banal rationalism and simplisticism. Nonetheless, at the very same time, every single one of these ideological signs, though not supplantable by words, has support in and is accompanied by words, just as is the case with singing and its musical accompaniment.[51]

Voloshinov's insights into how communication actually works could be said to be the suppressed slogan of a politicised modernism this century: that reclaiming meaning from art is fundamentally a question of *understanding* and not just an act of recognition. Its fortunes, however, as I have indicated, have fluctuated enormously. If the tradition has produced Benjamin, Trotsky and recently the insights of conceptualism and feminist criticism, it has also produced more ambiguously and culturally more powerful Greenberg and Michael Fried. Adorno in fact is perhaps the only major post-war theorist who took on the implications of such a theory of the sign. Because there is no satisfactory theory of the historical development of capitalism and the state in his writing (power to command rather than the profit system becomes the basis of Adorno's analysis), he was not able to open his own version of a contextualist theory of representation to any practical and projective socialist analysis. Nevertheless, he remains a key figure in extending the anti-reflectionist tenets of this tradition, although to my knowledge he was not aware of Voloshinov's writing. For in concentrating on cultural forms as real objects in themselves, as Voloshinov, Bakhtin and Medvedev did, and not simply as reflections of society, he gave valuable space to an understanding of the artwork as giving form to the experience of social reality.

These issues about identity, meaning, language and communication are at the centre of artistic practice today. Without a critique of both expressionism and reflectionism the specificities of artistic production and reception are lost to neo-Romantic notions of 'withdrawal', poetics or protestation. Thus, what the political modernist tradition has emphasised in its fragmented way is that artworks acquire their meanings contingently from the social and political relations in which they operate. Thus the concrete nature of meaning can only be grasped through an understanding of the *performative* dimension of all practices, that the relationship between artwork and spectator is discursively constructed through those critical interests that intercede on its part. These interests in turn will be mediated through the social interventions of institutions. For example, Atkin-

son's exhibition of his Irish work in Derry in 1988 brought his work and ideas into dialogical relationship with forms of political consciousness that had no immediate connections with art. Now this is not to over inflate the political effects of such an intervention, or to claim that the meanings of Atkinson's art changes radically from one context to another, but rather that the insertion of a given set of cultural materials here sensitive to the context in which they are shown brought about the possibility of dialogue and exchange of ideas around art. This is why the exhibition space as a place where art is simply deposited fails to acknowledge that exhibitions are in themselves nodal points in a network of communicative exchange within the public sphere. In many ways this has been the whole point of exhibition catlogues since the late 1960s – the catalogue as theoretical extension and analogue of the work. However, what has happened of course is that the catalogue has invariably become a commodity itself, a promotional adjunct to the reified notion of the exhibition space as shop window. (If we are to talk about a dramatic *volte face* in the critical relationship between the artist, the gallery system and the public sphere since the late 1960s and early 1970s this is where we'll find it.) Galleries have again become blocked off from the wider culture of which they represent and are a part. These changes of course can be traced to those economic and political transformations in the Western democracies already mapped out. The reinforcement of the state, particularly in a country like Britain, has brought with it a heightened understanding of bourgeois democracy's powers of ideological exclusion. Nevertheless, there are important transitional struggles that artists and institutions might participate in. This process turns principally on changing the terms under which art gets discussed and consumed. The crucial issue in a way is not about getting more people in front of art on the grounds of making art more popular but of bringing *people together* in front of art to discuss it on a popular basis.[52] This is a question of education and politics and can only be solved by wider changes outside of what artists, writers and galleries might do individually. For clearly one of the reasons why art does remain opaque to masses of working-class people (and section of the middle class) is that for education under capitalism to espouse that one might *learn* from art would be to testify to a realm of experience and cognitive value that lies outside, or in blatant contradiction to the interests of popular capitalist entertainment. Winning people over to an acceptance of this is as hard as winning over people at the moment to the

F

idea that socialism might be a higher form of democracy. Which is in a sense why a defence of one today remains intimatedly bound up with the other. As Ken Hirschkop has said:

Cultural forms are democratic not when discourse is set free from overt political constraint or when they enjoy mass participation but by virtue of the specific kind of 'communicative action' they enjoin. In discourse, as in all else, the contrast between democracy and oppression is a distinction between forms of social organization, not degrees of it. In this respect Habermas is entirely right to argue that the criterion of democracy applies to *procedures rather than specific ideas. This would refer not to a set of rules for the conduct of discussion but to actual political relations conditioned by and produced in discourse itself.* (my italics).[53]

In effect this involves artists, writers and those who work in art institutions politicising their relationship to the social process in order to create new relationships between audience and text. As Atkinson says, one of the immediate and practical ways of achieving this is by artists trying to win positions for themselves, and their ideas, on working-class platforms.[54] With the downturn in the class struggle this may seem highly optimistic at the moment. Thus I am not advocating as a general principle the privileging of 'non-art' contexts above 'art' contexts. This is voluntarism of the worst kind. But all the same, this argument at least states what the real historical stakes are, and threfore where new democratic relationships between audience and text might be won. In this regard Terry Atkinson's painting is exemplary. For Atkinson's work has sought above all else, as the ideal horizon of art's discursive powers, to bring art up against living history and lived political relationships.

Realism, painting, dialectics:
Art & Language's museum series

In the mid-1980s Art & Language (Michael Baldwin and Mel Ramsden) shifted from painting art's site of production (the studio) to painting its principal place of distribution (superventive quasi-production). Both as a paradigm of the economic and ideological power of such a site, and as an architectural model, they chose the Whitney Museum of American Art, an institution whose development has been in many ways central to the rise of American modernism. Founded by the sculptor and patron Gertrude Vanderbilt Whitney in 1931, the Whitney's first home was in her converted studio space in Greenwich Village. In 1954 it moved up-town to West 54th Street near the Museum of Modern Art and in 1966 to Madison Avenue and 75th Street where a new building was designed by Marcel Breuer. The design, which broke with traditional ideas of museum architecture, was said by Breuer to bring the 'vitality of the streets to the museum's structure'.[1] The bay window looking out on to the street, the large department-store-type foyer and interconnecting stairs between floors gave the building the secular aspect of a shopping precinct. Restricted solely to the acquisition of American art, every two years it holds an invitational survey of American artists.

Adopting the conventions of perspectival painting Art & Language have produced a series of interior shots of their own work, or fragments and ciphers of their work, hanging within the museum space, the irony being of course that such a hanging is historical impossibility. However, as an ideological interdiction, their uninvited exhibition is not simply a disquisition on American cultural imperialism – as if by putting their works into view they were 'righting' some wrong – but rather as a focus for the role the museum plays generally in our culture as the guardian and proprietor of liberal values. Museums are the 'voice' of bourgeois democracy insofar as their vaunted pluralism and self-enlightenment denies the relations of class subordination upon which their power rests. Their post-war

expansion has been built upon an anomalous sense of civic virtue. As products and reifiers of class division their dissemination of art's meanings to the 'people' flows one way, to one constituency, with one end in view; the edification of the middle class.

It is of course fashionable after Foucault and culturalist readings of Gramsci to entertain a particularist view of the radical artist's interventions within the dominant art institutions of our culture. Working within such bureaucratic structures the artist confronts their managerial power by exposing their would-be ideological impartiality. Central to this is the notion of getting counter-meanings on to walls and into heads as a means of linking the 'art world' and the 'real world'. As Hans Haacke has put it: 'the galleries' promotional resources should be used without hesitation for a critique of the dominant system of beliefs while employing the very mechanisms of that system'.[2] In short, art's subordination to bourgeois institutions becomes a site of social struggle.

There is much to be said for this position. As I said in the last chapter, social readings of artworks can only be generated through institutional spaces. However, as I also argued earlier, the idealisation of ideological struggle through art tends to envisage cultural transformation solely as a discursive problem. The result is the separation of cultural struggle from those objective non-discursive material interests that are in a structural (though obviously not teleological) position to transform the institutions of bourgeois democracy – the interests of the working class – and a downgrading of art's formal problems.

The historical strength of Art & Language as a group has been its resistance to such idealisations. Thus the museum paintings may mark a political intervention into the day-to-day business of bourgeois culture, but their fictionality as images also encapsulates a moment of prefiguration, insofar as their complex ironies point to a world where the culture of art is not 'held in' by class subordination. To say these paintings are anti-museum paintings therefore is to say very little. Rather, by adopting certain disruptive aesthetic strategies (anachronism, parody, pathos) they imaginatively disalienate the museum's bureaucratic structures as transitive and conjunctural. This sounds optimistic and grand of course, as if Art & Language were offering us allegories of revolutionary socialism, moments from beyond the 'river of fire'. In fact, the 'reading-in' of such content is not to be judged separately from the real limits on popular democracy of which they are directly the product. However, if we are to stick with the spirit

of the paintings, their fictionality nonetheless makes some imaginative claim upon the future; offers some utopian glimpse, if you like. And this is where Art & Language's 'avant-gardism' – their project of 'no-saying' to bourgeois culture – meets their politics. As artists who have pursued a political 'second-order' practice, who have at all times sought to include as a central part of their work a critique of the cognitive style of contemporary arts management, they have had no interest in those forms of interventionist practice that would simply *dramatise* political contents or offer some positivist deconstructive reading of 'dominant ideology'. Such practices, they say, inflate the political role of art and enable the prevailing system by submitting art to the meanings of the dominating, or rather to their manipulative barbarities.[3] In essence Art & Language abjure any form of cultural politics which would valorise the political effects of art by refusing the 'puzzles' of its autonomy, or which would, in fine, separate out class subordination from economic relations. They therefore refuse a view of art as a formation internal to a gradualist process of social change.

To assert this, however, is not to invest their fictional disturbance of the integrity of the modern museum with any abstract political virtue. Rather, it is to begin to investigate why the works look the way they do. Of course it is in the act of stressing why the works look the way they do, and how certain aesthetic and cognitive skills are demonstrated by the way they look, that criticism comes to exercise its distinctive competences. It is in relation to the critical issues of realism – in terms of the meeting between a certain set of political and philosophical interests and the display of certain aesthetic and cognitive skills – that I discuss Art & Language's museum paintings.

The crisis of late modernism has been described in this book as a crisis in the evaluation and demonstration of skill or competence. By celebrating the vagaries of touch and formal coherence at the expense of questions of reference and cognitive value, late-modernist abstraction and expressionist figuration deracinated the claims of representation to be an intentioned, knowledge-dependent activity. The question that looms larger than most then in our critique of late modernism is: can we talk about a return to a 'classical' view of representation? Can the 'good' and 'real' of art be judged according to a rational set of standards? In Renaissance aesthetics, embodied as they were in the tenets of classical literary criticism (wholeness, appropriateness), such a question was the basis of *any* adequate estimation of the worth of works of art.

Critiques of expressionist theories of representation are usually couched in terms of 'relevance' and 'performance'. As Hilary Putnam has argued: 'It is not the phenomena themselves that constitute understanding [or worth] but rather the ability of the thinker [or artist] to employ these phenomena, to produce the right phenomena in the right circumstances.'[4] But of course if representing 'well' or with any degree of competence involves some acknowledgement of criteria of relevance, we should ask 'relevance to what'? For Putnam, criteria of relevance are 'true' or 'rational' or 'real' or 'good' because they confront the necessary issues. However, this does not mean we are forced to defend a prescriptive hierarchy of contents but that certain claims to relevance might be more defensible than others given the nature of an objective world. Thus as far as art goes we might say that such notions as 'democratic communication', the 'critical examination of the social world' (or some part of it), 'aesthetic pleasure' are goals that are in the interests of the 'true', the 'rational', the 'real' and the 'good' of art, precisely because 'democratic communication', the 'critical examination of the social world' and 'aesthetic pleasure' are distorted and fragmented in our culture.

This is essentially a classic Enlightenment view of art in the face of capitalism's unreason. That is, because art's pleasures and functions are distorted and fragmented by the injuries of capitalist modernity – the split between art's specialisation and generalisable social interests – the predicates available for such pleasures and functions, the 'true', the 'rational', the 'real' and the 'good' of art, are of necessity refracted through that split. As outlined in chapter 1, all the major post-war aesthetic theories – Adorno, Benjamin, Greenberg and Trotsky – were attempts to deal with this consequence. All were attempts at assessing projectively what the 'true', the 'rational', the 'real' and 'good' of art might be. This is why modernism as a culture remains determining. For irrespective of the 'solutions' of these writers art is still tied to the structural division between autonomy and use-value that defined their terms of engagement.

This is why the cognitive interests of Art & Language's project could be said to operate self-consciously between these two poles: between the modernist avant-garde's defence of aesthetic autonomy and the exigencies of producing a political, didactic practice. It is consistent with such interests therefore that the practice of painting should be chosen as the redemptive site where this split between autonomy and politics continues to be played out in our culture. In an interview in

1987 Baldwin and Ramsden talked about their shift from purely theoretical work in the 1970s to painting in the 1980s as a shift away from an area of practice where virtue − critical autonomy − had become too easy.

Conceptual art became Wagnerianly neurotic − the outdoing of oneself was so trivial and yet seemingly so important. A xerox, a dictionary, a postal system, an advertisement, a photograph: the identity of the work always existed in the form of these neurotic presentations and fixations, in other words distributor categories. As such one had to revert in some sense or another to a category so soaked in sin as to permit the discussion of virtue.[5]

This, however, is not to say that painting for the group has become virtuous in and of itself, or that (for example) photography in the light of its overdetermined democratic function should be spurned, but that painting offers a calculable aesthetic excess and distance from media values that cannot be reduced simply to one form of communication amongst others, along with advertisements and bus tickets. It is this tension then between the claims for a defence of art as art, and the demand for art to do something, to make some critical purchase on the world, that forms the intellectual basis of Art & Language's engagement with painting. This was vividly realised in their earlier *Portraits of V. I. Lenin in the style of Jackson Pollock* (1979-80)[6] which presented a collision, or *détente* to use their own word, between the claims of aesthetic autonomy and use-value.

A 'return' to painting for Art & Language therefore has nothing to do with a retreat into 'Art and society'-type defences of social 'subject matter'. In an essay on the museum series Charles Harrison deals with this issue in detail. The critical issue on which the museum paintings hang, he says, resides not simply in their content (if it did reside, it would suggest that this content had been 'prescribed and organised'[7]) but in the means of their execution. He recognises that the use of an expressive, agitated surface to pull the references away from mere illustration is continuous with certain of the investments of modernism. As Harrison says: 'The 'meaning' of a work of art is not to be equated with the novelty of its imagery but rather with that quality in modes of inclusion and exclusion, of emulation, quotation, paraphrase and critique of representational resources which newly characterizes learning in the face of the real.'[8]

This is what I mean by a 'return' to a 'classical' model of representation for painting. For Art & Language's 'modes of inclusion or exclusion' reconnect the 'true', the 'rational', the 'real' and the

'good' of painting to its traditional 'deep resources' (perspective, mimeticism, parody, image and text). However, there is of course a fundamental qualitative difference in such a reconnection. The use of such resources is made not in the name of confirmation and celebration (as if the artists were reviving an interest in the techniques of Quattrocento painting) but in the name of irony, dissimulation and adulteration. Art & Language's paintings are 'classical' in construction therefore in as much as the resources of 'classical' representation are engaged with as part of an ongoing historical materialist project of enquiry. Or rather, Art & Language do not appropriate the 'deep resources' of painting – in the fashionable terminology of the 1980s – they use them, reshape and destabilise them. And this is why we might refer to the museum paintings as adopting an allegorical or postmodernist/realist mode, insofar as the gap between reference and formal interests is neither foreclosed as in descriptive realism nor ignored as in late modernism. In short they revivify the rhetorical base of art – the assertion that art is language – on the terrain of a realist political practice; the assertion that there are certain sets of asymmetries, interests, manipulative structures that determine what have been the prevailing criteria of validity and reference for modern art. Realism for Art & Language, as for Terry Atkinson, Susan Hiller, Bill Woodrow and Tony Cragg, is less a descriptive category than a practical and philosophical commitment to the notion that both the means and references of art should acknowledge the disfigurements of our culture.

Their decision to paint on the grounds of painting's lack of virtue – its hysterical commodification in the 1980s – could therefore be said to have a realist justification. To paint today is to 'get one's hands dirty' within the culture. This is where their critical meeting between means and references finds its political register. For in deciding to paint the modern museum, they in a sense acknowledge the museum as the late capitalist 'home' of art – a 'home' whose comforts they directly benefit from. The contradictions of their position in fact find their direct embodiment in the development of the museum series itself. In a certain sense the early paintings blocked off their own ideological investment in the process they were criticising. It looked as if they were simply taking a sideswipe at American cultural imperialism from a position of relative security. As the reworked images and fragments of images began to assert themselves as the modus operandi of the museum's functional destabilisation, the museum gradually began to

'drop off the edge',[9] to quote the group. In a way the first works were all distributory space, whereas the later works – which involve a critical reassertion of aesthetic autonomy – make only partial or oblique reference to the architecture of the museum. In fact as the work progresses this process of displacement and fragmentation eventually leads – as in the earlier Studio series (1982–83) – to a kind of critical implosion, in which the re-presentation of earlier Art & Language material, in this instance Art & Language texts, forms the black pigment for a black museum interior. There is then a certain deconstructive logic to the series, a progressive cancelling or compression of the museum as a space of 'pluralism', 'self-enlightenment' and 'democratic communication'. The content of the series shifts its allegorical focus from the museum as a space of provisional democracy to a space where art is made quite literally incoherent. In their work included in the Turner Prize exhibition at the Tate Gallery (November 1986) this shift of focus is given a grievously ironical emphasis. The only way we can view the museum interior is through scattered holes drilled into sheets of plywood attached an inch above the surface. These sheets are organised in the pattern of the exterior cladding of the Whitney museum.

The museum series then uses various shifts in scale and reductions in legibility to inflict a certain damage on the ideological integrity of the museum space. As such, the display of technical skill (the competent reproduction of previous Art & Language works, the use of deep perspective, the illusionism and optical tricks) do not simply illustrate the collapse of legibility, they actually embody it. This is important in further acknowledging what realism might mean in relation to Art & Language's painting. For by the limiting of Art & Language's representational world to the world of their own intellectual and artistic production, fragmented and compressed within the museum space, a necessary connection is established between reference (to the museum's fragmenting and distorting of the culture of art) and the means of expression employed. The pictures are the fragmented subject of what they make reference to.

What is at stake in Art & Language's indexical regeneration of their work is the demonstration of some real causal link between what gets into pictures and the lives of artists. However, this does not mean that all art works that demonstrate some 'sincere' causal interaction with their subject (pace Aristotle's and Horace's insistence on the authority of experience) are more 'real' or 'truthful' than others. Rather, given

the nature of our interpretative culture – the idle forms of commendation and celebration that are brought to bear on works irrespective of their causality – the necessity for some control over reference becomes a priority. Now this is not an attempt to close off the play of meaning – an obvious impossibility anyway – but a recognition that if references are to be seen to be meaningfully caused then they must be seen to be the product of certain cognitive controls. We might generalise here and say that realism in art for Art & Language involves the dialectical grounding of the necessity for some control over meaning at the point of production. Thus the self-presentation of the intellectual and artistic development of Art & Language functions both as a history of their developing interests and as the very material of their critique of the misrepresentations of our culture. They use themselves to expose what is done to art and its meanings *at the same time as working on the culture itself*. This dialectic between criticism and self-criticism can best be described as a process in which theory fuses into practice as the transformation and extension of antecedent cognitive and aesthetic material. This material is then mediated by further theorising which is in turn transformed into new practices, and so on, in a kind of self-critical expansion of interests. As the group say:

Essentially you have to work in an open system of inquiry to sort out [the problems of 'going on'] ; and if you don't do the work the aesthetic predicates end up being substituted for that work quite frequently. They substitute or close off the possibility of that work arbitrarily. This isn't some sort of moralism, in the sense of saying that artists have to live clean lives in order to paint clean pictures, to paint paintings about clean lives, not at all. But rather, that even at that limit that question might be raised. You must not hide what you cannot choose.[10]

In other words the socialist artist must avoid the collapse of self-criticism as a consequence of the operation of his or her own critique. A good example of such a collapse, they argue, was the inflated rhetoric around Peter de Francia's *African gaol* in the 'Forgotten fifties' show.

The work is seems to me has a lot to do with the practical road to socialism or realism, if you like, in art. It is art without a sense of its own political marginality. In other words it is idealistic, and it stands to encourage the practice of idealism in one's judgement in respect of what might or might not have this or that social tendency. The work exists if you like to discount, or rather, refuse the other routes one might take to discover the content of the work. It is painting without moral strenuousness or self-disgrace. It

proclaims a method of interpretation for itself, it refuses others; and if you bring those others to bear it disappears. There are other questions as well. Where does it stand in relation to other art? Where does it stand in relation as a representation of other art? These are both causal and non-causal questions. It is not far away fom the question of paintings of important subjects somehow being important paintings. Thus who is to say that a painting of the Spanish Civil War is more important than a bowl of pansies etc. Such a painting closes off all the routes one might use to investigate it. I don't mean it literally closes it off. It isn't there unless it is closed off. Rather if you are going to take it to be an important socialist work then you are going to have to close off all the ways that something might be substantially dealt with as an important socialist work.[11]

The fundamental issue for Art & Language, then, is that if art is about learning through practices within open systems of enquiry, then critical references have to be seen to be the product of continuing intellectual work. However, this is not to say that intellectual performance in art, contrary to Walter Benjamin's valorisation of use-value, is a corollary of aesthetic interest or worth — far from it; rather that by doing 'theory in art' those meanings available to art in pursuit of aesthetic interest are clarified.

And this is why the resources of fiction-making in painting have become so important in Art & Language's practice as a whole. For if conventional social realism blocks learning in art under its reification of the world of appearances and political stereotypes, and deconstruction-as-pedagogic-intervention subsumes questions of aesthetic interest under a functionalism of ideological 'laying bare', then the relationship between means and reference becomes an unavoidably unstable business. If signs are deferred — do not go directly to the real — then the resources of representation are in a sense released into the fictive, into the gap between sign and signifier. This gap of course, as explained earlier, has become a central theoretical concern of the new postmodernist painting. The fragmentary convocation of signs, usually purloined from mass media and art historical sources, is presented as a kind of allegory on the 'impossibility' of determinate meaning. But there is intertextuality and there is intertextuality.

On the one hand there's a nostalgic desire for digging up images without memory or responsibility and on the other there is the intertextuality, pace Paul de Man, of a Stendhal, where intertextuality is a form of displacement. David Salle may displace his sources, but they are so shallow that they are certainly not an allegorical form of displacement. His work is Pop art under another form. But the possibility of intertextuality as a form of vertigo — the

symbolized symbol of the symbolized symbol – is another matter altogether.[12]

Thus, if Art & Language allegorise representation as a series of ruins or fragments in the face of the real, they do not wallow there 'without memory or responsibility' as eclectic *bricoleurs*. On the contrary they 'malinger'[13] as the producers of the ironically discrepant. They do not collapse the referent into the indeterminate, obliterating the ideological in the process, they in a sense re-imagine or re-order it. The history of the referent is retained *at the same time* as it is ideologically exposed.

In these terms the museum paintings acknowledge that there must be a moment of 'correspondence' in representation before (or perhaps more interestingly *while*) the play of other meanings is distributed. Thus what these paintings acknowledge in their meeting between modernism (the refusal of any identification of knowledge with appearances) and descriptive or conventional realism (the conflation of knowledge with appearances) is the necessity for a dialectical theory of knowledge. Although there is an element of interpretation in all knowledge it does not follow that our theories are therefore incapable of matching how the world actually is. For if truth claims were simply the product of signification there could never ever be any contradictions between knowledge and reality (see chapters 1 and 4). Consequently, although we participate in the making of the world, we need not assume that we are blocked off from an objective understanding of it. What makes the museum paintings' fictional disturbance of the museum real for *us* is that they actually map on to a real contradiction: the gap between the museum's claims to liberalism and the realities of class society. Now, this is not to say that value goes automatically to those artworks that map, in the spirit of realism, on to such contradictions. But that the 'moment' of 'matching' in representation needs to be acknowledged in any evaluation of those fictional 'modes of inclusion and exclusion' that make references in art worth talking about. We can give due recognition to representation having an active role in the construction of meanings without abandoning a realist theory of knowledge. We therefore do not have to lay claim to a social realist aesthetic in order to defend the idea that some artworks are more successful at 'matching' reality than others.

To say that Art & Language demonstrate the dialectical theory of knowledge in their painting is however fallacious. Rather, their paintings are the products of what is significantly historical materialist work, and the outcomes of interests consonant with such work. In

defending a dialectical theory of knowledge I do not propose that these paintings are *about* dialectics (*about* the meeting between the claims of modernism and those of conventional realism), but that a dialectical theory of knowledge is the most adequate means of determining why that meeting of interests should be at the centre of their work, and therefore why the paintings look the way they do.

Painting and sexual difference

This chapter is concerned with painting and sexual difference. For reasons of space it concentrates on a British context. However, the debates around painting and sexual difference in Britain have implications far beyond a local context. Given the amount of time and energy sections of the women's movement in Britain have devoted to questions of representation from the early 1970s onwards, there has developed an advanced critical culture around the image that needs addressing in general.

There could currently be said to be three dominant feminist discourses around the question of painting and sexual difference:

(1) the anti-painting argument, which sees the 'ambiguities' of 'positivism' of painting (in its late-modernist and social-realist variants) as a double obstacle to the *specifities* of the representation of gender;

(2) the anti-functionalist argument, which sees painting in a wholly positive light; painting stands as a source of radical difference for women, a way of linking up women's bodily experience with a distinct female aesthetic or 'visual economy';

(3) the female-*centred* approach, which defends the descriptive powers of the figurative tradition as the basis for a feminist narrative or mythological painting.

A good deal of painting by women informed by the women's movement during the late 1970s and 1980s has implicitly or explicitly taken on these polarised positions. Thus 'Women's images of men' at the Institute of Contemporary Arts in 1980 was in many ways an attempt, in tandem with its critical engagement with the bodies of men, to reclaim the pictorialised female body for feminist practice against the post-painting critique of those who saw painting as the home and vehicle for the subjugation of women's bodies to the male gaze, whilst recent defences of the painting of British artists Therese Oulton and Avis Newman have emphasised a Kristevian-type position of anti-representation as a 'modality of feminist dissidence',[1] against both ideological critiques of painting and the sentiment of a female-centred figurative tradition.

Essentially what is at stake here is not just how and with what women artists speak but how the nature of women's subordination is conceptualised, and consequently how women artists conceive of their place and function within the culture. Each of these discourses is making a particular claim upon what might be more politically justifiable for women artists. Thus we need to see the first position as properly a textualist analysis, insofar as it locates art and feminist practice within a general theory of representation. Artworks, as with all forms of symbolic production, are the products of an antecedently coded system of economic, sexual and political exchange. Intervention within such a system can only be effected in any practical sense by women working on, and through, the dominant technological means which contain and reproduce bourgeois ideology: film and photography. The second position, by contrast, is radically 'non-participationist'. The possibility of a non-complicit 'autonomous' practice for women will only be found by working outside of a 'male-constructed' reality of which photography forms a major constitutive part. The third position is quite literally positivistic. Actual or imaginary representations of women – in all media – form part of a celebratory and positive female iconography which stands opposed to negative images of women in the culture. These are in some sense crude categorisations, but nonetheless they locate the broad areas of ideological dispute under which the expression of sexual difference is being played out.

Now, in respect of painting, what has tended to occur through these divisions is a split between painting and politics for women, reproducing in many ways the deeper split in our culture between the claims for the relative autonomy of art and the necessity for art to be grounded in some cognitively adequate engagement with the world. Consequently given that the textualist approach to the production of art in feminist discourse has been developed predominently outside the problems of painting,[2] painting for women has tended to be reclaimed in opposition to claims for art's cognitive significance. The result, in a number of instances, is women artists identifying their painting with a repressed, intuitive, feminine Other. In Alexis Hunter's contribution to the 'State of the art' series on Channel 4 in 1987, she said she returned to painting because it allowed her to speak outside the constraints of theory. A critique of theory as a critique of the fantasy of mastery is one thing, the equation between a lack of theoretical competence and female creativity is another; in sum, it is

to argue from a position of weakness. The consequence of this has been the general emergence within women's painting of what the philosopher Jean Grimshaw has referred to as 'self-validating female consciousness'.[3] The avoidance of questions on the adequacy and inadequacy of theories is defended on the grounds that objective knowledge is male subjectivity. It is no surprise then that post-structuralism has been a common ally in much recent writing by women on painting. A good example of this is Jean Fisher's essay on Avis Newman, *On the margins of forgetfulness* (1987).[4] 'Uncertainty. . . is grasped and given value'[5] as the superimpositions in scale reveal the 'limitations of vision'[6] and the impossibility of the 'viewer as a coherent subject of knowledge'.[7] Rejecting the Renaissance perspectival tradition for the heterogeneous spaces of the palimpsest, Newman's paintings release pictorial space for women from the 'tyranny of logic'.[8]

The work's space is one of fluidity, of swells and eddies, in which contours and volumes – now transparent, now opaque – gently turn and undulate in a movement that is both sinuous and sensuous . . . The figure is not more than a light contour embedded in an extensive but indeterminate opalescent field – a body without territorial boundaries or markers, simultaneously a fullness and a negativity whose excess negates purposeful action. We may understand now why the paint surface is structured in dabs rather than directional strokes. A heavy langour, felt rather than seen, pervades this figure, recalling the sensation of those suspended moments that precede time when the working process can begin again. It is the body surrendered to the opaque silence of language, the body subject to the wordless and incessant flow of desire.[9]

Now, to criticise such a defence of indeterminacy is not to co-opt painting back into the framework of a stable perspectivalism or to deny that Newman's distaste for the pictorialised 'positive' female figure is valid. Rather, it is a question of acknowledging that certain types of writing by women on painting avoid substantive questions over art's relationship to the development of cognitive skills. Little attention has been given to the fact that the attack on representation as mastery has pushed women's painting back into the history-less spaces of late modernism.

As such, even if there are a number of problems with a textualist account of the production and reception of artworks (the least of them being that the artwork as textual intervention abrogates the enigmas of subjectivity), the textual position has one clear advantage over its

competitors. To reiterate T. J. Clark, the pursuit of meaning in art, of conditions of critical contrast, is to be found not on the 'other' side of representation, or in any simple transcription of the referent but in transformational work on those signs, images, symbols, and ideologies active in the culture. If painting by men in the wake of the crisis of late modernism and social realism has barely begun to address these problems, painting by women on such terms is practially invisible.

In short, the question of painting for women today is how do women represent sexual difference across the discursive spaces of the social without essentialising difference, without turning the pursuit of a female 'visual economy' into the language of the Other? How and what might painting be made of for women today without it falling into a form of what Jacqueline Rose has called, in another context, 'hereditary transmission and style'?[10]

7.1 Genealogies

Clearly the issue of representation and difference turns on the nature of the means at the producer's disposal. It is no surprise then that painting as the site of various critical and historical investments in our culture should be so divided as a space of meaning for women. When Mary Kelly in 1981 called for a feminist practice of 'statements' (see chapter 1) against the ambiguities of painting, she was articulating a view long held by feminist artists that painting offered nothing for women, given its power as a site of male dominance.[11] The turn to 'alternative' media by women throughout the 1970s was a concerted attempt to win back some autonomous space in the face of the sheer weight of this history. The pursuit of a particular female language, or écriture féminine, and a collective space of opposition became grounded in the theorisation of painting and object-making as masculine regimes – practices that actively institutionalised the oppression and marginalisation of women. This is why photography, film and video were so important to women artists in the 1970s and early 1980s. Their means of production and distribution allowed women to construct and develop a set of resources and an active community of viewers outside of both the dominant nexus of institutional arrangements and the containments of an official art history that was beyond reclamation. For many women artists therefore who learnt their

history and politics in the early 1970s this involved nothing short of a moratorium on all inherited forms. There could be no backing away from the closures of American modernism and social realism as closures oppressive to women. There could be no feminism and agnosticism about form, no abstraction and conventional realism and critiques of women's subordination. In retrospect the profound pathos of the Berger/Heron debates was also a sexual political one. When women made it on to the political representational agenda for the social realist they were presented as either victims of damaged femininity or allegorical cyphers of future socialist munificence. Here was a tradition that grounded 'social action'[12] in the speech and power of men. As a consequence, the feminist displacement of the sexual apositionality of American modernism and social realism took the form, as with much other art of the time, of an explicit discursiveness. The production of statements on their own, or as a constitutive part of performances, or as a commentary on stereotypical media and advertising imagery, became the didactic means whereby women could open up the necessary self-sustaining distance from bourgeois culture. Extensity and density of *reading* therefore became an explicit form of resistance to the pictorial. What was at stake essentially was the gendering of new pleasures, insofar as if pleasure is linked to knowledge-claims, to what the spectator believes in and desires, then art's claims on aesthetic experience cannot be separated from the issue of who is speaking to whom, and on what terms.

This is the base line against which the new feminist/textualist photographic practice has pursued its commitment to the delegitimatising nature of the fragmentary in vision. As Jacqueline Rose has said, the chief drive of this kind of work is to 'expose the fixed nature of sexual identity as a fantasy and in the same gesture, to trouble, to breakup, or rupture the visual field before our eyes'.[13] Since the Godardian extension of Brecht's 'alienation' techniques into strategies of materialist anti-narrativity, the breakdown of the voyeurism inherent in spectatorship, the *absorptive* pleasures of looking, has been a central component of cognitive value in anti-capitalist aesthetics. To break down the narrative flow or coherence of vision was to involve the spectator immediately in the world of meaning-production itself; the relationship between object and subject is made uncomfortable and therefore reading problematised. The new feminist/textualist photography, video and performance continues to rework these basic assumptions, in so far as if painting is historically that place where

masculine pleasures have become voyeuristically fixed, then the only means of constructing other kinds of pleasure for women is outside of painting.

Thus Kelly sees the discursiveness of her *Post-partum document* as a way of controlling meaning.[14] This is what I take her to mean by the use of the word 'statement'.[15] Against the too 'easily attained'[16] reading of pictorial images of women as sexualised objects, the theoretical artistic text asserts an anti-spectacularised relation between looking and meaning. Hence the question of the work's feminism is not to be detached as a 'supplement' to the form. The replacement of the pictorial mother in *Post-partum document* with the enunciation of the mother's desire for the child in diaristic form is clearly an attempt to match the production of the work with the production of a point of entry for a female spectator. Or rather, by splitting of the representation of being a mother from representations of the mother, the fixed nature of sexual identity (mothers and fathers) is denied.

Openness, discursiveness, the 'non-hierarchical' use of materials and the elaboration of a 'stable' critical context for the reception of the work, have thus not only been central to much of post-1960s art's break with the painterly canons of American modernism and social realism, but the basis upon which feminism in art has constructed its sense of differentiality; a language of disruption and multiplicity that challenges via its anti-pictorialism, the power of dominant social relations to recoup women as image. The 'absent' woman in Kelly's work therefore is very much the necessarily 'unpresentable' woman of a feminist reading of Lacanian psychoanalytic theory. Because women speak from within 'patriarchal discourse', from within the Law of the Father, the pictorial visualisation of women can only reinforce that asymmetry. Or rather, because women are bound within 'patriarchal discourse' to become objects, never subjects, of their own desire, women's pleasure in self cannot be mediated through the experience of other images of women.

Kelly's Lacanianism then has had a powerful influence on the move against painting by women. For if images and symbols for women cannot be separated from images and symbols of women, the representation of identity cannot be divorced from how identity comes into play.

However, for a number of women artists this pursuit of an *écriture féminine* began to assume too heavy an ideological embargo on painting. The reduction of painting to the fixed categories of a self-

present pictorialism or genderless abstraction only confirmed women's 'lack' of speech and absence within the Western fine-art tradition, by conferring certain characteristics on women's art. In the necessary process of divesting women's practice from the oppressive contain-ments of this tradition, women artists saw their practices becoming overly identified with the area of not-painting. There has been a desire therefore on the part of a number of women artists, including a number who had been working in photography, video and perform-ance, to make contact with those aesthetic resources that had been left underdeveloped in the pursuit of difference. Essentially painting was reframed within a theory of sexual difference that sought to critique the idea of there being a practice or set of resources that was in the best interests of women, that was more combative of women's sub-ordination than another.[17] This could be said to rest on a contextu-alist view of art's relationship to language. If the meanings of art are produced through a process of discursive construction and negotiation then the idea of certain forms carrying 'anti-patriarchal' content is untenable. Painting therefore may be contingently in the interests of men (and capital) but its aesthetic resources are not identifiable with those interests. Sexist bias does not inhere in painting, but may be promoted given the social and political conditions of its emergence.

Central to this re-engagement with painting is the importance of a post-Lacanian feminism/psychoanalysis, in particular the writings of Julia Kristeva and Luce Irigaray. For Kristeva and Irigaray what is at stake is the direction of an understanding of women's entry into culture away from an all-encompassing negative perspective, away from notions of women receiving their place as Other under the dominance of Lacan's theory of the 'phallic divide'.

7.2 Lacan and the post-Lacanians

In Jacques Lacan's writing sexual difference operates as a law; individuals are divided between those who have the phallus and those who don't. This is not biological reductionism but a determinate biological fact, from which the structuring of sexual identity begins.[18]

However, for Lacan the woman is not the negative term because she is defined as not like men, but because she is transformed into an object of fantasy, of otherness, for the man. In being the imagined site of wholeness woman's otherness serves to secure for man his own

approach is perhaps at its most theoretically explicit. Thus Peter Gidal sees Oulton's shifting molten forms as disavowing any stable female identity. The paintings cannot be consumed, he says, as part of any spectacle of the female.[22] Likewise Rosa Lee in her essay 'Resisting amnesia; feminism, painting and postmodernism' in *Feminist review* (1987)[23] sees the refusal of determinate meaning in Oulton as freeing painting for women from the tyranny of 'any one fixed interpretation'.[24]

Oulton's work signifies a 'new, non-representational artistic language'.[25] Like Gidal and Fisher, Lee's arguments are based on a rejection of representation as positivistic:

The case against *representation* in painting . . . rests on the view that it relies on pre-given meanings and codes which have been ideologically determined. It is only through overthrowing dominant structures and forms of 'recognition' (in which are included the structures of representation) that the issues of sexual difference and existing power relations can be challenged and different meanings produced. Deconstruction provides no more than a *reinterpretation* of the structures and forms of recognition, producing what amounts only to the odd stylistic difference in any particular practice.'[25]

A 'female imaginary' then is best served by a concept of the feminine as outside the divisions of language and social life. Painting's actual escape from the analytic functions of textual intervention is a far more radical − non-complicit − means of resisting women's objectification and subordination. Setting aside the complacent equivalence between deconstruction and the fixture of meaning, the obvious consequence of such a position is the conceptualisation of femininity in the form of an absolute negation. 'Dephallicisation' simply becomes a reverse symbolic order in which the maternal as a form of unfixing serves as a kind of transcendental signifier. This is why this kind of thinking on representation (which Kristeva unlike Irigaray always holds back from in her theory of the semiotic) collapses the question of difference uneasily and ironically back into those modernist spaces that such theory sought to extract itself from. Thus in what sense does Therese Oulton's refusal of 'fixture' in representation offer a practical resistance to women's 'negative entry' into the culture? It would seem that the place of entry is reduced to the silent and absent, that very realm of 'non-mastery' as truth from which the stereotypes of femininity and the critical distantiation of bourgeois readings of modernism have been constructed. In effect Lee's and Gidal's defence of Oulton in terms of the radicality of non-representation recodes late

modernism under the auspices of radical feminism. Just as the former collapsed into managerial self-interest, the latter has led to a situation where for an individual to just name herself as a feminist artist is to claim a moral backing for her work and actions. As Michele Barratt has said of the implications of radical feminism, 'Men have one reality, women have another, and women's culture can be developed as a separate activity. To adopt this view is of course to abandon the project of transforming the world into a place less dominated by traditionally "masculine values".'[27]

The central problem therefore with the pursuit of a 'female imaginary' free of the dominant circuits of symbolic exchange between women and men is to render meaningless the social construction and reproduction of femininity and masculinity: how women and men variously experience their path to femininity and masculinity. The refusal to participate in this dominant circuit of exchange, far from being an act of resistance to meanings already in place, simply leaves them in place. This is what I mean about there being a clear conflation of interests between a would-be autonomous 'female imaginary' and the closures of late modernism. In separating 'self-expression' from any external and cognitive constraints, both divorce the representation of the body from its social figuration, from those determinants of class, race, nationality and sexual identity which give it communicable meaning.

7.3 Historicising the body

The political and aesthetic implications for women and painting are clearer − or somewhat clearer. There is no separate or subtended maternal imaginary or language to reclaim, no female 'modality of dissidence', that might sustain a realm of values outside of the material and symbolic divisions under which women and men actually experience gender under capitalism. There is only one space of struggle: history itself. This is why a number of women, critical of both non-representational and deconstructive-photographic practices, have sought to reposition women within painting as *historical* subjects. However, we should not confuse this with a kind of female-centred type of painting noted at the beginning, though there are convergent problems, as the rejection of non-representation has tended to license a retreat back into a conservative descriptive realism and 'positive

images'. Two British painters who have courted this conservatism precariously, but nonetheless point to a move beyond its strictures, are Rose Garrard and Sue Atkinson. Rose Garrard's early series of portraits of 'lost' women artists (Gentileschi, Vigée-Lebrun and Leyster) with its anomalous meeting between 'old master' conventions and feminist inscription, kitsch and painting-as-object, offers some kind of interrogative space for women's entry into representation. Working with representation (in this instance painting's possible continuity of resources for women) and on representation (painting as an historical exclusion zone for women), the series recovers, in an empirical sense, a set of expressive resources recently denied women artists. Yet at the same time though, the adulteration of these received conventions dismantles the idea that there is such a thing as a painting tradition for and by women that can be simply reclaimed, as argued for example in Germaine Greer's sentimental *Obstacle race*.[28] On the contrary the very act of copying the self-portraits suggests there is no possibility of the recovery of lost values, only the ceaseless reinscription/transformation of the antecedent in the pursuit of new meanings. The metaphor of the frame is a key component of the series. The frame of history, of painting, of women's subordination, is signified as a divided space that has to be negotiated in all its messiness, that has in a sense to be stepped outside of and worked within simultaneously.

Unfortunately the implications of this work have not been taken up by Garrard. Garrard has swapped an interrogative mode for the comforts of Women's Art. Nevertheless, the early work at least points to the possibility of thinking inside of painting as a source of publicly reclaimable meanings for women: a painting that is both conceptually and aesthetically complex. This approach also informs Sue Atkinson's work, although the majority of her painting so far has tended to present an unproblematic conversion of social/ist realism into feminist realism. In her series on Greenham Common (1985-87) with its sociological emphasis upon 'being there', she frames the contingent (gestures, discarded objects, debris from the occupation) as cyphers of a positive disruption of a colonised landscape.[29] The sense that women are being represented here as the political combatants of modernity rather than its victims is thus central to the value of the work and to Atkinson's painting as a whole. But all the same, the conventions of this series (the narrative and genre 'snapshot') are incapable of generating those signs that would aesthetically embody

this physical and symbolic 'decolonisation'. All we get is a documen-
tator's commitment to notation. In this respect the virtue of these
paintings is precisely diagnostic. For what they do in a highly succinct
way is foreground the very problems of how women might represent
their public relationship to the spaces of modernity. In effect how do
women represent the projective aspects of their entry into the culture
without the work falling into the sphere of 'positive images'?
(projective insofar as feminism as a cultural and political transforma-
tion of traditional 'masculine values' implies that men have to learn
from the experience of women). For paintings of female solidarity at
Greenham Common and elsewhere are no less susceptible to the con-
ventionalising of social critique than their People's Art counterparts
in the 'Art and society' legacy.

In work Atkinson completed in the late 1980s such criticisms seem
to have been taken on board in an attempt to break with the technical
academicism of the Greenham series. Thus in *Laundered Air America plane*
(1987) for example, Atkinson sets up a canvas of a sky with an
American bomber on its way to Libya against a line of clothes stiffened
by paste in front of the picture (a handmade tie and dye dress picked
up at Greenham, a tee-shirt picked up at Wapping during the printers'
dispute in 1987, and a hat picked up in Northern Ireland).[30] By placing
the signs of domesticity and the gender division of labour up against
the 'larger' public sphere of politics, with the accompanying sense that
is women who on the whole sustain practically the political culture
of men, the continuing expansion of women's critical participation in
the public sphere is given a kind of structural focus; private and public
are made coextensive.

Another British woman artist who has engaged with the problems
of representing the divisions of women's social identity is Sonia Boyce.
However, Boyce is in no strict sense a painter. In fact as a collagist/
drawer who uses painterly expressive marks, she has declared her
opposition to the prioritising of painting in the culture. This would
seem to exclude her from the argument at hand, but nevertheless she
provides some interesting pointers. Her interactive use of paint,
collage, drawing and xeroxes suggests, like Garrard and Atkinson, that
the category of painting for women might be best carried over and
away from any media-specific definition of its resources.

Drawing on various painting conventions (genre, narrative) that
like Garrard and Atkinson open up the female body to its social
placement, Boyce offers the possibility of new content spaces for

women's critical self-representation. Thus her highly developed sense of patterning, derived in part from the interior of her own black working-class family home, allows her to place the black female body in a setting that is vivid in historical and local detail and not just anecdotal. By foregrounding the decorative she creates a convincing metaphoric space for images of her own path to feminism and black consciousness, insofar as the pleasures in solidarity taken from the representation of urban black working-class culture are confronted by their obverse: the signs of a kind of maternal religious claustrophobia (*Missionary positions*, 1985).[31] As she has said on her methodology:

The patterns. . . aren't simply there to decorate, but are there to give clues to the picture. Many of the images I produce are reminiscent of strip cartoons, snapshots etc, in that the image focuses, is edited down, to the essential information required. Rather than allowing the viewer into a pictorial/mirrored space, the created space is flattened, denying entry, yet often the figures depicted do invite entry. These contradictions between invitation, surface barrier and the sensuality of the pastels and crayons is only something I have realised recently.[32]

Collectively what is at stake here in the work of these women is the production of another set of artistic competences: a reclamation of those second-order cognitive and aesthetic skills (the parodic, iconographic, quotational, image and text) that both non-representational and female-centred social realism or mythological painting practices have excluded or devalued. This of course is to say no more than that feminist consciousness in painting is no less bound up with the determining conditions of modernity on representation than the work of men. Painting must find its conditions of critical contrast both out of the fictive and conventionalised animations of representation and the real itself, those real conditions of existence in which women and men find themselves.

Consequently the problems of painting that face women and men today are not to be divided across any separate or untranslatable scale of values: namely, criticism of Therese Oulton's non-representationality is unacceptable on the grounds that because women's experience is qualitively different to men's, therefore generalisable critical evaluations of such work cannot be made. Or, because women's entry into the public spaces of modernity of necessity invokes the pleasures of solidarity in difference, then criticism of the sociological representation of such solidarity is neither here nor there. Rather, the question is with what means is it possible for painting to map vividly on to a

real world of structures and agencies, of conditions of the production of subjectivity under capitalism, and remain aesthetically *mobile*? Clearly if such a question implies that value in art is to be secured in aesthetic performance, this rests in part, paradoxically, as I have continued to argue, *on* the modernist critique of representation, that references alone cannot secure interest in painting. The modernist link between anti-academicism and a rejection of the naturalistic rendering of the world of appearances still holds. Modernist painting's various commitments to strategies of 'awkwardness' – surface agitation, anomalies in scale and reference, the use of 'non-artistic' materials – remains the basis upon which aesthetic and cognitive mobility is to be secured. Thus it is not my intention to criticise Oulton's and Newman's work as attempted practices of *negation*. Oulton's and Newman's refusal to objectify the female body by pictorialising at least recognise the problems of thinking through feminist consciousness in art formally. There is then not an unbridgable conceptual gap between their work and the work of Garrard, Atkinson and Boyce. However, in Oulton's and Newman's hands such strategies tend to collapse into what T. J. Clark has called, in an essay on Greenberg's modernism, 'practices of purity'.[33] In pushing modernism's critique of representation into a critique of representation *as such* the social referent disappears in fear of its complicity with the dominant culture. 'Negation negates itself because it cannot help but posit the object it seeks to destroy', to quote Terry Eagleton.[34]

The need to recognise that without cognitive constraints disaffirmation in art inevitably collapses into forms of 'hereditary transmission and style' is thus central to the issue of painting's 'missing discourse' for women. For it is recognising that such constraints are in a sense gender-blind that allows women to *use* painting, to establish that 'double discourse' of criticism and self-criticism that Jane Gallop has argued is an absolute necessity if women are to signify beyond the antinomies of same and other. As Gallop has said:

Women need to reach 'the same', that is, be 'like men', able to represent themselves. But they also need to reach 'the same', 'the homo': their own homosexual economy, a female homosexuality that ratifies and glorifies female standards. The two 'sames' are inextricably linked. Female homosexuality, when raised to an ideology, tends to be either masculine (women that are 'like men') or essentialistic (based on ascertainable female identity). The latter is as phallic as the former for it reduces heterogeneity to a unified, rigid representation. But without a female homosexual economy, a female narcis-

sistic ego a way to represent herself, a woman in a heterosexual encounter will always be engulfed by the male homosexual economy, will not be able to represent her difference. Woman must demand the 'same', 'the homo' and then not settle for it, not fall into the trap of thinking a female 'homo' is necessarily any closer to representation of otherness, an opening for the other.[35]

The idea of women reclaiming an historical/critical mastery within painting then is not to be identified with any would-be category of women's history painting but with the reconstitution of painting for women outside the polar identitary logic of 'abstraction' and 'figuration'. The attempt to 'tell the truth' of women in representation as a negative 'female imaginary' or a positive sociology falls prey to the very 'phallic logic' it seeks to depose.

Essentially, if we are to break out of such binary thinking we need a theory of subjectivity that takes account of what women and men share at the same time as acknowledging what divides us. The problem with Lacanian and anti-structuralist theories of the subject (though Kristeva is a partial exception) is that by positing gender as constituted in and through relations to the Other, the intersubjective constitution of subjectivity is denied, resulting in the absurdity, pace Irigaray, that women and men inhabit different worlds. The Irigarian choice between identity and non-identity for women fails to take account of subjectivity as an interlocking interplay of sameness and difference.[36] Genuine difference, as Gallop intimates, is inseparable from a notion of relationality, the need to think and deny identity simultaneously.[37] This is another way of saying, of course, that women's articulation of difference in painting can only figure itself through the problems that constitute painting's pursuit of reference and aesthetic vividness in the culture as a whole.

Postmodernism and the critique of ethnicity: the work of Rasheed Araeen

The emergence of art history in the nineteenth century as a supercessive logic of 'stylistic progress' points vividly to the imperialist attitudinising that has underlain the construction of the Western fine-art tradition. Defining the conditions of a culture's evolution – theorising and matching the 'primitive' against the 'sophisticated' – became the central historiographical concern of art historians in their discussion between classical European art and the 'newly' discoverd art of the East. This emphasis on placing and positioning can in general terms be linked to the growth of empiricism in the sciences. In relation to the development of art history though, we also need to acknowledge the far-reaching influence of Hegel's metaphysics. Hegel's distinction between 'historic' and 'non-historic' nations gave specific shape to the containments and distortions of imperialist discourse by providing a supposedly normative basis for judging the development of different cultures. Aesthetic evaluations came to be extrapolated from an essentialist account of the so-called national characteristics of a nation.[1] Thus, for example, in Hegel's opinion Indian art was held to be monstrous, pathological and unformed, because of the philosophical irrationality of the Hindu religion. Invoking classicism as the measure of balanced aesthetic value, Hegel attacks the fantastical forms of Indian art as humanly 'inadequate', as disregarding the world of ordinary experiences. 'As we enter for the first time the world of Persian, Indian or Egyptian figures and imaginative conceptions we experience a certain feeling of uncanniness, we wander at any rate into a world of problems. These fantastic images do not at once respond to our world; we are neither pleased nor satisfied with the immediate impression they produce on us'.[2]

As Partha Mitter says in *Much maligned monsters* (1977) Hegel created a new myth about India, the 'monster myth'.[3] In measuring Indian

art against the classical canon of beauty, Indian art was seen as languishing in what Hegel called the 'forecourt of art'.[4] Symbolic art may have begun in India but for Hegel it didn't represent true symbolism; it was a transitional, denatured phase.

However, if Hegel saw the art of India, Persia and Egypt as obscurantist and unreflective, the East as a whole remained that imaginative and intellectual landscape through which a rapidly industrialising nineteenth-century Europe began to articulate its cultural and political self-understanding. In fact discussion of the ancient art of India, Egypt, Persia and China was a means of measuring notions of both cultural progress and decline. In this regard, in the work of various post-Hegelian scholars and historians two oposing positions were taken up over the East: those who viewed it from within the classical paradigm and the rationalist terms of the Enlightenment, and those who visited the East in actuality or imagination as an escape from such rationalism. Thus, when a number of writers set out to 'reclaim' Indian and Egyptian art on the grounds that its aesthetic qualities could only be appreciated by first understanding the cultural context in which the work was produced, the foundations were being laid for Romanticism's cult of the Orient: the celebration of the East as a repository of sensual and spiritual truths that Europe had abrogated in its pursuit of verisimilitude in art and logic in science since the Renaissance. One such writer was the German Romantic Friedrich Creuzer. Although a follower of Hegel in accepting the superiority of classical art, unlike Hegel Creuzer directly addressed himself to the problems of context and interpretation.[5] His theory of the symbol did much to shift the debates on Eastern art away from the simplicity/complexity opposition.

Under late Romanticism therefore the East became more than a source of casual interest for artists and writers in the West. Rather it became, as Edward Said has written in his path-breaking book Orientalism (1978) a 'great complimentary opposite',[6] a mythic source of desire, fantasy and fear. There was a 'virtual epidemic of Orientalia affecting every major poet, essayist, philosopher of this period'.[7] Consequently the Orient became a 'repetitious pseudo-incarnation of some great original',[8] or as Partha Mitter himself put it, speaking of India, 'the archaic homeland of mankind'.[9] However, as an anthropological process of Western 'self-exploration' and 'self-definition' dependent upon the early expansion of capitalism, such a 'dialogue' is obviously at its end. The West may still mystify the East, reduce its variegated peoples and cultures to the stereotypes of barbarity and

underdevelopment (as Said has cogently detailed), but it no longer, since the imperialist climax, stands as a site of the 'exotic' or 'primitive' for art. World capitalist development and nationalist and anti-imperialist struggles have shattered the conditions whereby the assimilation of the cultures of the East as fantasised places of paradisical escape or knowledge could offer a critique of, or corrective to, the West. The last point at which such knowledges were circulated *as* a critique – the discourses of Abstract Expressionism – was in fact the point where the *global* nature of capitalism under American hegemony was becoming largely visible. The New York School's emphasis upon the radicality of 'non-representation' owed a great deal to the anti-perspectival traditions of the East. By focusing modernism towards these traditions, Abstract Expressionism looked to the 'non-representational' as an act of resistance to the visual conformities of American mass culture.

Thus if the history of Western art and culture from the early nineteenth century onwards has been a history of shifting identifications with, and disavowals of, the cultures of the East, it has also been a history of absences and silences insofar as the art of the East has had no value or identity until it has been 'understood', mediated, transformed and circulated by the West. Modernism's assimilation of the 'primitive' from Gauguin to Abstract Expressionism certainly acknowledged the reality of cultural difference. But because of the nature of the process of assimilation – the idealised projection of non-Western cultures as free of the corruption of bourgeois rationalism – Hegel's hypostatisation of non-Western art as essentially undifferentiated in character was reproduced in a new form: the fetishisation of the exotic as Other. Moreover, assimilated to the imperialist ambitions of powerful and emergent Western fine-art institutions such as the Museum of Modern Art, New York, the appropriated cultural materials were subordinated to the universally defining powers of Western progress. In short, irrespective of how artists actually saw themselves utilising non-European sources, imperialism determined how such cultural relations would be used, what scale of values would be attached to such appropriations against their cultures of origin. It is therefore very much as a critical entry into these silent spaces of appropriation that a post-modernist project of historical redescription has recently been undertaken by a number of scholars, historians and artists, a project that has in a fundamental sense sought to decentre the imperialist and masculine assumptions of the Western tradition. As argued in chapter 1, postmodernism so constituted advances the

theoretical displacement of the Western fine-art tradition as the self-certifying domain of white men.

Imperialism and racism depend for their power on the positioning and fixing of the other. As I have said, though, such a process has changed dramatically since the post-war nationalist victories in Africa and Asia and the development of the Western bourgeois democratic state. The classic imperialist discourse of biological and cultural inferiority has been broken by anti-imperialist and working-class struggle. Positioning and fixing is now far more subtle a process of colonisation. Thus 'subject cultures' are no longer seen as inferior but as different; and therefore as something that should be preserved in all their distinctiveness. 'Racial difference' is used to survey and master non-Western culture from the standpoint of separate cultural development. In the West since the late 1960s this has come to be known as a theory of ethnicity. Essentially ethnicity is an inverted form of racism. It gives 'back' value to historically marginalised and suppressed traditional cultures at the same time as fixing non-Western peoples within their conservative orbit. Thus faced with this New Racism the struggle against racism in the West becomes more than simply an act of solidarity with traditional non-Western cultures, as the farrago around Salman Rushdie's Satanic verses has disastrously shown.[10] Rather what is at stake for a progressive anti-imperialist and anti-racist cultural politics is that the fixing of the identity of the subjugated subject be resisted and denied as such. This no more so than in the realm of art, where the recognition of difference as the coming to speech of others, is inseparable from the need for an independent place to speak from for non-European artists, and the need for independent and critical resources to speak with.

It is part of this resistance to the ideological containments of ethnicity and the continuing struggle for space and status for the black artist, that the Pakistani artist Rasheed Araeen has been engaged in Britain since the mid-1960s. Born in Karachi in 1935, Araeen left Pakistan for Paris in 1964 to try to establish himself as a modernist painter. In the following year he left for London, where he lives today, to pursue a career as a sculptor. However on arriving in London in the mid-1960s the possibilities of independent space and status for black artists were small if non-existent. Through the 1960s and the 1970s the black artist had two institutional positions open to her or him: to be either as seen not like white artists – an ethnic artist – or as like white artists but black – the modernist who happens to be black.

As such, ethnicity, and its corollary of token inclusion for black artists within the system, as black artists, became the central object of Araeen's writings and polemics against the British art world establishment in the late 1970s and 1980s. Ethnicity was merely a new cultural front for imperialism and racism: the idea that black people (both African and Asian), given their historical proximity to pre-capitalist formations, were at their most 'expressive' and 'autonomous' reworking traditional forms. As Araeen put it in *Making myself visible* (1984):

One's creative ability in the contemporary world is not necessarily determined by one's own origin. . . the ideology behind 'ethnic arts', or the anthropological view that Afro/Asian are nothing but merely the representations of their own traditional cultures, will not hold together if the reality is allowed to enter into or confront it. The purpose of the image being presented here (of ethnic arts) is therefore really to serve the dominant culture or ideology of this society, which by its inherent characteristics sees *other* people different from its own terms of their own creative abilities or functions.

Nobody is denying here that there do exist community based activities which are traditional and which clearly display sensibilities and values different from those of indigenous British; and I believe they should be recognized and supported. But to base the development of a multi-racial culture only on this difference does not look right, particularly when there is evidence that this difference has not been fundamental to most black artists in their attempts to come to terms with and express their own priorities within contemporary art practice.[11]

The paradox of ethnicity lies therefore in its reduction of difference to identity. Difference is remaindered *as* identity. The roots of this of course lie in the effects of racism itself. Defending traditional cultural identities becomes a means of fending off the incursions of racist denigration. But under the conditions of unequal exchange through which racism operates, such 'difference' always plays into the hands of racism and imperialism. As the South African Marxist Neville Alexander has argued, the ideology of ethnicity is principally a cultural cover for retaining black political aspirations within the old terminology of biological difference.[12] The distinct racial differences of a people must be protected from outside contamination. The question of cultural identity then in Araeen's writing and art is expressly twofold in analysis. How does one, as a black artist working in the West, reject the fixed identities of racial essentialism in order to enter the sphere of dominant Western discourses on art – in this instance the modernist/postmodernist power-bloc – and yet at the same time

retain the political need for an independent black cultural self-understanding *as* different, as not-white? The answer of course is as both defender *and* critic of Western modernity.

It was the attractions of modernity for a young artist in Pakistan that compelled Araeen to make his home in Europe in the mid-1960s. But if this Western acculturation gave him the confidence to break away from what he saw as the cultural parochialism of Pakistan it also in a familiar process of reversal displaced his received cultural identity as a Pakistani. Araeen's politicisation in the early 1970s then, like so many Afro/Asian artists and intellectuals who moved to the metropolitan centres after the colonial break, was a gradual process of unlearning, or rather relearning. Araeen came to London as an admirer of the 'New Generation' sculptors (Caro was at the height of his reputation). However, after a period of work as a minimalist sculptor, he began to realise that the higher echelons of modernist discourse and practice were not so susceptible to entry from a non-Western artist. 'I did not now that you have to be *eligible* for a heroic position to achieve. . . recognition. My eligibility, as I became a *black* person in the white society, posed a basic contradiction in the ideology of modernism'.[13] By the early 1970s Araeen realised that this lack of eligibility had nothing to do with a lack of knowledge or talent, but quite simply with the politics of race. Consequently, to continue to work as a black artist unproblematically within the 'genderless' and 'raceless' spaces of late modernism was increasingly to act in the interests of such misrepresentation. Yet as a modernist, as an artist who recognised the self-critical achievements and technical successes of modernist culture, Araeen was no friend of the traditionalists. If his politicisation recognised the impossibility of an independent voice for the black artist within modernism, his critique of ethnic cultural categories led him to see how the British artistic establishment could contain the demands of black artists *within* the realm of multiculturalism and threfore projectively outside the dominant and determining circuits of power. As Araeen was quick to point out, it matters considerably at what critical level the artist enters discourse. This is why in tandem with his art and writing has gone his work as an editor, first with *Black Phoenix* (1978-81) and recently *Third Text*.

As Araeen notes, under the institutional pressure of the New Racism, the ideology of ethnicity reproduces the Hegelian view of non-European art as the undifferentiated product of the mass, in a more 'benign' fashion. The specific concerns of the individual black

artist are reduced to the interests of the political collective or racial or national community. 'What is not fully realised, by either white or black people, is that ideas which are essential to the kind of multiculturalism which is being promoted today, come from (18th and 19th century) racial theories.'[14] This is why Araeen has also been a sharp critic of the Africanisation of radical black struggle within the Afro-Caribbean arts community. Rejecting modernism as eurocentric, this position would lay claim to a 'lost' black tradition and identity from which black artists were torn after the Diaspora. Or rather, because black revolutionary consciousness is the product of the whole historical experience of black people, and not merely the relations of production of colonialism or capitalist slavery, the black artist must become bound up with the recovery, to quote Richard Wright, of 'some nourishing culture'.[15] A good example of this 'black nationalism' is a statement published by the British artist Keith Piper to accompany his show 'Past imperfect, future tense', at the Black Art Gallery in London in 1984. Piper has changed his position, but nevertheless the sentiments expressed continue to find an echo in the black nationalist arts community, and therefore are worth quoting:

the forms which we use should be taken out of our traditions. We reject the Western concept of the 'avant-guard' [sic] with its constant demand for new trends to titillate bored 'trendies'. Instead we use, and re-use what they would call 'clichés', but what we know to be the symbolic building bricks of our struggle; The colours, Red, Gold, Green and Black; The image of Afrika – our common denominator; The five pointed star of the socialism which we advocate'.[16]

Traditions though are not fixed and available for recovery like monuments; they are in a continual process of transformation, fragmentation and decay. The idea of the possible integration of Afro or Asian cultures into a recoverable norm is simply nostalgic, when it's not a recipe for academicism. Just as feminism's use of psychoanalysis has exposed the notion of the monadic self, the black artist's relationship to her or his own cultural identity is made no more critically secure by being in struggle. In many ways this was the mistake the GLC made when it took over a number of the aspects of ethnicity in the mid-1980s. The GLC reinforced the notion of the black artist serving the interests of the black community, in the view that this best promoted anti-racism. Thus we might treat ethnic or holistic discourses on art as essentially fantasies, as a belief that there exist points of knowledge and certainty waiting to be occupied. Once we have

made 'a way of making works which is *exclusive* to us',[17]then things will be fine; identity will be restored.

Nevertheless, in reconstructing black experience and history, the need for a positive black historiography is absolutely paramount. As Araeen and Piper argue, there can be no advance for the black artist within the West outside this framework. The issue of a black identity frozen neither by loss of history nor by the fetishisation of tradition or blackness lies therefore exactly in exercising difference *and* criticising it. This is to say no more than was said in the last chapter about the problems that face women painters. Identity and non-identity have to be endorsed and denied simultaneously: a difficult process maybe, but one that is necessary if the status of the black artist in the West is to be placed and judged within a history of the modern itself. This is why, in a fundamental sense, Araeen sees his work as an extension of the modernist tradition (in the self-critical definition of the term), insofar as he defends the critical possibilities of the black artist, like any politicised artist, dialectically as work with and on the institutional forms, discourses, techniques and representations of the modern tradition.

Since the late 1970s Araeen has been involved in two different though related projects: the photographic sequences, performances and drawings (such as *Burning ties* (1976-79), '*Paki bastard*' (1976-79) and *Ethnic drawings* (1982)) which directly address the ideological distortions and silences of racist culture,[18] and the photography and assemblages of the mid-to-late 1980s which have engaged in a second-order redescription of Araeen's own modernist development as part of a reclamation of his own cultural and familiar background. This difference, which I want to concentrate on in relation to the foregoing discussion on identity, involves him in a more complex insertion of his own subjectivity into the histories of modernism and colonialism.

In the work of the mid-to-late 1980s Araeen reworks elements of both his own native culture and his 'adopted' one as a form of 'cross cultural mapping'. The purpose of this is twofold: on the one to hand, to undermine the racist link between ethnicity and the best interests of the black artist, and on the other hand, as an extension of this, to foreground the need of black artists to order their personal and collective experiences of race within the global divisions of modernity. As such these works refuse the 'schizophrenia' of cultural identity, as Sivanandan once put it, by consciously destabilising the would-be

conflicting ideological spaces of the 'traditional' or 'primitive' and the modern. As Araeen says:

There is no natural polarity between Western culture and Pakistani culture. They are different and I'm quite at ease with both of them. I don't feel suspended between them or suffer from a lack of particular cultural identity. Both have positive and negative aspects. And if there is a conflict between these two different cultures it is ideological – not formal – resulting from imperialist domination; and it is this understanding that underlies my recent work.[19]

Thus by presenting the slaughter of a goat (in commemoration of Abraham's sacrifice) in I love it, it loves I (1978–83)[20] as a performance for the camera, Araeen restores the modern to representation of non-Western experience by critically reworking the materials of his native culture. 'I no longer have to reject my own culture to be a modernist artist.'[21] For although the ritual enters 'Western representation' as a sign of anti-imperialist resistance it is also staged parodically for the Western viewer as a nostalgic fantasy of the pre-industrial 'collective experience'. Pakistan may have a large peasantry, but it is also a rapidly industrialising capitalist country with an emergent urban working class. This sense of the provisional nature of what we see is heightened by the 'reverse' reading we are forced to make of the piece. Reading the series of images from right to left, as in the reading of Urdu, Araeen literally enters his culture 'backwards', as if to suggest he was engaging in act of legerdemain or subterfuge. Simultaneously affirming and disaffirming cultural identity, it shows Araeen not so much oscillating between two stable identities – the ethnic and the modern – but consciously subverting them both.

The destabilisation of the imperialist opposition between the 'primitive' and modern is made even more explicit in Green painting (1985-86).[22] By placing a painted green panel in each corner of a cruciform of photographs of blood spilt from the ritual slaying of animals during the Muslim festival of Eid-ul-Azha, the 'barbarous' signs of the 'primitive' are organised into a late-modernist-style grid pattern. The result is a destabilisation of their respective orders of identification, or as Araeen himself says, the juxtaposition of their ideological spaces is turned upside down and dialecticised. 'The "primitive" periphery is cleared of all traces of expressionism (bloody ritual) which then is transferred to the central space (a cross/an Ad Reinhardt). The modernity of Minimalism is thus "restored" to where it came from, Islamic culture, which remains fragmented (four parts)

and occupies corners of the dominant culture.'[23] Hence far from producing a declarative opposition between these two orders of identification, he signifies their mutual, though historically obscured, relationship. Conjoining modernism (minimalism) with the 'primitive' (Muslim ritual) within the organisational spaces of modernity itself (the intertextual combination of various sign systems), he demonstrates his right to use elements of his own culture as components of an *international* art culture. Moreover, he demonstrates his right to criticise his native religion, for the inclusion of the four green panels is a provocative subversion of the hierarchies of Islam. As a holy colour and the colour of the Pakistani flag, the colour green remains outside permissible representation in Muslim countries.

In these terms *Green painting,* is perhaps *the* central work of Araeen's in coming to terms with his resistance to the ideological containments of ethnicity. For the complexities of *Green painting,* its ironies, inversions, and tropes criticise the binary opposition between the 'first world' and the 'third world' upon which the ideology of ethnicity is to a great extent based.

The theoretical status of the third world for sections of the left has rested on its function as would-be buffer zone against the world market. The result of this has been the absolutising of the difference between the 'first world' and 'third world'. As Nigel Harris has put it, third worldists tend to translate 'relationships of power and economy into those of geography, or physical space, and reduced to one single force market imperatives, competing capitals, and the institutions and policies of governments'.[24] To be developed was confused with economic independence. Consequently there has been a comparable tendency on the left to view the third world as a homogeneous area of anti-imperialist struggle outside the penetrations of capitalist cultural modernity itself. As Aijaz Ahmed has said in an excellent commentary on Frederic Jameson's essay 'Third world literature in the era of multinational capitalism',[25] 'the enormous cultural heterogeneity of social formations within the so-called Third World is submerged within a singular identity of experience'.[26] Third world countries have been 'assimilated into the global structure not as a single cultural ensemble but highly differentially, each establishing its own circuits of (unequal) exchange with the metropolis, each acquiring its very distinct class formations'.[27]

The debate between Ahmed and Jameson is an extraordinarily instructive one for our argument. For Jameson's insistence on the

'radical structural difference between the dynamics of third-world culture and those of first-world cultural tradition'[28] gives rise to that spectre of Hegelianism yet again: the suppression of difference in the name of the political collective. In fact Jameson could be rewriting Hegel's *Philosophy of art*. Western texts exhibit a radical split between private and public, the poetic and the political, third world texts, even those which appear private 'necessarily project a political dimension in the form of national allegory'.[29] The story of the individual is always an allegory of the powerlessness of third world culture. No wonder Ahmed is furious in his reply to Jameson. Jameson's weak economic analysis fails to locate the extensive cultural changes in the third world as a result of the profound structural changes in the world system. Thus the idea for Jameson that the divisions of modernity remain principally within the 'first world' has been shattered by the emergent Newly Industrialising Countries. Ahmed puts it very well:

if one argues that the third world is constituted by the 'experience of colonialism and imperialism', one must also recognise the two-pronged action of the colonial/imperialist dynamic: the forced transfer of value from the colonised/imperialist formations, and the intensification of capitalist relations within those formations. And if capitalism is not merely an externality but also a shaping force within those formations, then one must conclude also that the separation between the public and private, so characteristic of capitalism, has occurred there as well, at least in some degree and especially among the urban intelligentsia, which produces most of the written texts and is itself caught up in the world of capitalist commodities. With this bifurcation must have come, at least for some of the producers of texts, the individuation and personalisation of libidinal energies, the loss of access to 'concrete' experience, and the consequent experience of self as an isolated, alienated entity incapable of real, organic connection with any collectivity. There must be texts, perhaps numerous texts, that are grounded in this desolation, bereft of any capacity for the kind of allegorisation and organicity that Jameson demands of them. The logic of Jameson's own argument [i.e. that the third world is constituted by the 'experience of colonialism and imperialism'] leads necessarily to the conclusion that at least some of the writers of the third world itself must be producing texts characteristic not of the so-called tribal and Asiatic modes but of the capitalist era as such, much in the manner of the so-called first world. But Jameson does not draw this conclusion.[30]

In his reply to Ahmed, Jameson counters such criticisms in a familiar move. Difference can only be established within some larger pre-established identity. But what if that larger pre-established identity fails actually to match the material it purports to be synthesising? Jameson's search for a unitary determination for third world culture

simply reduces the 'third world' to a singular formation. Thus the issue isn't one of defending the 'third world' on the grounds that to do otherwise would collapse the distinctions between 'first world' and 'third world', as Jameson argues. 'There would be no great advantage gained by junking the category of "third-world" if the result is that [the West] then becomes the "same" as the subcontinent.'[31] But by weakening the third world's integration into the world market, Jameson's unitary theory actually de-historicises the *global* character of the effects of modernity and the struggle for socialism. 'By assimilating the enormous heterogeneities and productivities of our life into a single Hegelian metaphor of the master/slave relation [Jameson's] theory reduces us to an ideal type [nationalism] and demands that we narrate ourselves through a form [national allegory] commensurate with that ideal-type.'[32]

This is exactly what Araeen is opposing in *Green painting*. 'I do not speak only on behalf of the Third World or my own community because they are not separable from the world at large. My work is about the world we all live in and share today.'[33] *Green painting*, then, presents a view of the modern post-colonial or 'third world' artist's experience not as 'limited' to questions of race and imperialism as black issues, but as a constitutive part of a transformed sense of the global experience of modernity itself. And this is why we might declare that *Green painting* is not only a key work in Araeen's output as a whole but a key work in our general reading of postmodernism as initiating a new politics of representation. For in its disruption of the regulated spaces of East and West, ethnic and modern, it places the necessity for a new politics of reading securely and deliberately at the feet of the Western viewer. This is made particularly explicit by Araeen's use of Urdu texts. By including quotations from Pakistani newspapers on Benazir Bhutto's house arrest and Nixon's visit to Pakistan, the 'final' level of interpretation is left with the Urdu speaker. The Western viewer in a sense unlearns her or his unassumed eurocentredness. By mapping across cultures and representational systems in order to provide conditions of critical contrast, the positionality of both producer and consumer is foregrounded.

The question of the work's postmodernist status comes to rest therefore very much on its complex *spatial* treatment of the cognitive problems of political representation, the finding of conditions of critical contrast which will be adequate to the real, to the complex and hidden relations between subject and structure. However, this is not

to say that Araeen's work is 'deconstructive', with all of that concept's ugly, functionalist connotations. Rather, the concern with quotation, parody, paraphrase and inversion in Green painting and I love it, it loves I, points to Araeen's work as allegories of reading. Meaning is secured spatially through a movement across signs, from the micro to the macro, from the self to the collective, from descriptive cultural detail to historical framework. Whatever the weaknesses of Jameson's reading of postmodernism generally, this 'second-order' allegorisation of representation as the necessary basis of a politicised postmodernism today has been well described by Jameson as an aesthetic of cognitive mapping:

An aesthetic of cognitive mapping – a pedagogical political culture which seeks to endow the individual subject with some new heightened sense of its place in the global system – will necessarily have to respect this now enormously complex representational dialectic and to invent radically new forms to do it justice. This is not, then, clearly a call for a return to some older kind of machinery, some older and more transparent national space, or some more traditional and reassuring perspectival or mimetic enclave: the new political art – if it is indeed possible at all – will have to hold to the truth of postmodernism, that is to say, to its fundamental object – the world space of multinational capital – at the same time at which it achieves a breakthrough to some as yet unimaginable new move of representing this last, in which we may again begin to grasp our positioning as individual and collective subjects and regain a capacity to act and struggle which is at present neutralized by our spatial as well as our social confusion.[34]

Jameson's 'space of multinational capital' may not as yet in his estimation stretch to cultural production in the 'third world', but nevertheless an important point is being made here. In the wake of the world space of multinational capitalism, the idea of an aesthetic that protests (either through a refusal to represent or through social-realist variations on descriptive humanism) rather than locates is doomed to intellectual closure and cultural marginality. The usability of postmodernism as a second-order theory of representation for black artists such as Araeen lies therefore in the critical link it can make between the 'race-blindness' and 'first-order' crisis of late modernism and a critique of the conservative containments of ethnicity. For it is through a critique of both formations that the critical and self-critical resources needed to 'grasp our positioning as individual and collective subjects' will be developed.

Notes

Introduction

1 For one of the best discussions of neo-expressionism see Donald Kuspit's 'The new expressionism: art as damaged goods', *Artforum* (November 1981): 'Neo-expressionism, like the popular culture, is a reactionary attempt to possess the child's being, to appropriate it for ulterior motives . . . Under the mistaken assumption that it is a renewal of the basic, originative, life-giving spirit that was inherent in modern art, neo-expressionism artificially reproduces the child's perspective and thus dissolves the spirit of modern art'(p. 48). The revival of a neo-Romantic poetics in art in Britain in the eighties has been particularly conspicuous. A key expression of this was the Hayward Annual show 'Falls the shadow' organised by Jon Thompson and Barry Barker in April 1986. As Thompson says in his introduction 'Before and beyond the shadow': 'While it may appear that the artist is "willing" the work into being, nothing could be further from the truth' (p. 29).

2 Under the influence of Jean Baudrillard a theory of simulation in relation to art has taken many forms during the 1980s. See in particular the shows 'Simulacra – A new art from Britain' (Riverside Studios, London, November 1982), 'Close to the edge' (White Columns, New York, February 1983), 'Between here and nowhere' (Riverside Studios, London, October 1984) and 'Endgame – reference and simulation in recent painting and sculpture' (the Institute of Contemporary Arts, Boston, September 1986). One of the reasons that theories of simulation have become so influential is that they have allowed art to indulge its Romantic pessimistic side under the aura of radicality (we live in a world where the media destroys meaning, truth, sociality, at the same time as it claims to further it).

3 Hal Foster, ed., *The anti-aesthetic: essays on postmodern culture*, Washington, 1983.

4 Victor Burgin, *The end of art theory*, London, 1985.

5 Roszika Parker and Griselda Pollock, eds., *Framing feminism*, London, 1987.

6 'On the museum's ruins', *The anti-aesthetic: essays on postmodern culture*, ed. Hal Foster, Washington, 1987, p. 61.

7 *Ibid*, p. 61.

8 See Achille Bonito Oliva, ed., *Transavantgarde International*, Milan, 1983.

9 Karl Marx, *Grundrisse*, Harmondsworth, 1973, p. 100.

10 Imre Lakatos, *The methodology of scientific research programmes – philosophical papers volume 1*, Ed. John Worrall and Gregory Currie, Cambridge, 1978.

1 Modernism, realism, postmodernism

1 Jacques Bouvaresse, 'Why I am so very unFrench', *Modern French philosophy*, ed. A. Montefiore, Cambridge, 1983, p. 18.

2 Frederic Jameson, 'Postmodernism, or the cultural logic of late capitalism', *New left review*, no. 146, pp. 53-92.

3 Bouvaresse, 'Why I am so very unFrench', p. 31.

4 Perry Anderson, In the tracks of historical materialism, London, 1983.

5 Alex Callinicos, 'Postmodernism, post-structuralism, post-Marxism?', Theory, culture and society, vol. 2, no. 3 (1985), pp. 85-101.

6 Peter Dews, 'The nouvelle philosophie and Foucault', Economy and society, vol. 8, no. 2 (May 1979), and The logics of disintegration, London, 1987.

7 See Amin's Imperialism and unequal development, Brighton, 1977.

8 Jean-François Lyotard, The postmodern condition: a report on knowledge, Manchester, 1984.

9 Ibid., p. 75.

10 See 'Modernity – an incomplete project', The anti-aesthetic: essays on postmodern culture, ed. Hal Foster, Washington, 1983, pp. 9-22.

11 Paul Virilio and Sylvere Lotringer, Pure war, Foreign Agents Series, New York, 1984, p. 54.

12 Ibid., p. 47.

13 See Jean Baudrillard, In the shadow of the silent majorities, Foreign Agents Series, New York, 1984.

14 Stuart Sim, 'Lyotard and the politics of antifoundationalism', Radical philosophy, no., 44 (Autumn 1986), p. 8.

15 Lyotard, The postmodern condition, p. 38.

16 Michel Foucault, 'Two lectures', Power/knowledge, ed. Colin Gordon, Brighton, 1983, p. 83.

17 Ibid., p. 82.

18 Sim, 'Lyotard and the politics of antifoundationalism', p. 13.

19 Sean Sayers, Reality and reason: dialectic and the theory of knowledge, Oxford, 1985, p. 173.

20 Lyotard, The postmodern condition, p. 81.

21 Ibid., p. 77.

22 Ernest Mandel, Late capitalism, London, 1978.

23 Warren Montag, 'What is at stake in the debate on postmodernism?', Postmodernism and its discontents, ed. E. Ann Kaplan, London, 1988, p. 94.

24 See Perry Anderson, 'Modernity and revolution', New left review, no. 144 (1984), pp. 96-113.

25 Clement Greenberg, 'Modernist painting', Art and literature, no. 4 (Spring 1965), p. 193.

26 Ibid., p. 193.

27 Ibid., p. 193.

28 Ibid., p. 194.

29 Charles Harrison and Fred Orton, eds., Modernism, criticism, realism, London, 1984.

30 Ibid., p. xiv.

31 Leon Trotsky, Literature and revolution,ed.,Paul N. Siegal, New York, 1970.

32 Trotsky and Breton, 'Manifesto for an independent revolutionary art', reprinted in What is Surrealism? selected writings of André Breton, ed. Franklin Rosement, London, 1974, p. 183.

33 T. J. Clark, Modernism and modernity, Novia Scotia, 1981, p. 277.

34 Francis Frascina, ed., Pollock and after, London, 1985.

35 Walter Benjamin, 'The author as producer', Thinking photography, ed. Victor Burgin, London, 1982.

36 See Antonio Gramsci, Selections form prison notebooks, London, 1971.

37 Alex Callinicos, Is there a future for Marxism?, London, 1982, p. 56.

38 See in particular Benjamin's Charles Baudelaire: a lyric poet in the era of high capitalism, London, 1973.

39 Greenberg, 'Avant-garde and kitsch', Partisan review, vol. 6, no. 5 (Autumn 1939), pp. 34-49.

40 Ibid., p. 49.

41 I am indebted to Simon Frith for this phrasing. See 'Hearing secret harmonies', High theory/low culture: analysing popular television, ed. Colin McCabe, Manchester, 1986.

NOTES TO PAGES 25–36

NOTES TO PAGES 25–36

42 T. J. Clark, 'Preliminaries to a possible treatment of "Olympia" in 1865', Screen (Spring 1980), p. 40.
43 Charles Harrison, 'Present art and British art', Artscribe international, no. 55 (1985), p. 27.
44 Craig Owens, 'The discourse of others: feminists and postmodernism', The anti-aesthetic: essays on postmodern culture, ed. Hal Foster, Washington, 1987, p. 74.
45 Ibid., p. 71.
46 Ibid., p. 67.
47 Ibid., p. 71.
48 Ibid., p. 67.
49 Ibid., p. 70.
50 Alex Callinicos, Making history, Cambridge, 1987, p. 177.
51 Owens, 'The discourse of others', p. 75.
52 Ibid., p. 75.
53 Kelly, 'Re-viewing modernist criticism', Screen, vol. 22, no. 3 (1981), p. 74.
54 Victor Burgin, 'The absence of presence: conceptualism and postmodernisms', 1965-1972 – when attitudes became form, Kettle's Yard, Cambridge, 1984, p. 19. Reprinted in his The end of art theory.
55 Douglas Crimp, 'The end of painting', October, no 16 (Spring 1981), p. 74.
56 Nigel Harris, The end of the third world, Harmondsworth, 1986.
57 Ibid., p. 129.
58 Cedric J. Robinson, Black Marxism: the making of the black tradition, London, 1983, p. 97.
59 Raymond Williams, The politics of modernism: against the new conformists, ed. and introduced by Tony Pinkney, London, 1989.
60 David-Hillel Rubin, Marxism and materialism: a study in Marxist theory of knowledge, Brighton, 1977.
61 Ibid., p. 149.
62 Andrew Collier, 'Truth and practice', Radical philosophy reader, ed. Roy Edgely and Richard Osborne, London, 1985, pp. 201-2.
63 Hilary Putnam, 'Two philosophical perspectives', Reason, truth and history, Cambridge, 1981.
64 Ferdinand de Saussure, Course on general linguistics, London, 1974.
65 See for example Jacques Derrida, Writing and difference, London, 1978, and Jacques Lacan, 'Television', October, no. 40 (Spring 1987) (this issue was devoted to previously un-published material by Lacan).

Saussure's formula for the sign, s/S, recognises, uncontentiously, that signifier and signified have no 'natural' connection. Their connection, rather, is one of social convention. However, for Saussure, this does not mean that the sense of a given word in the development of a language may not change over time. This is what he meant by the 'sliding' of the signifier over the signified. In post-structuralism though this 'sliding' of the signifier is interpreted in a generally misleading way. The historical mutability of words becomes the radical mutability of meaning as such. As David Archard says in Consciousness and the unconscious (London, 1984), Lacan and others represent the bar in the Saussurean formula as a barrier dividing two parallel orders. 'Understanding the "shifting" of one with respect to the other as a dissolution of any necessary pairings of particular signifier and signified [they] "establish" the "primacy of the signifier".' For Lacan, we find the meaning of a word not by, as it were, going down below the bar to find its corresponding signified, but rather by proceeding along the line of remaining signifiers – in an utterance or indeed in the language as a whole – to discover what sense it has. And this sense is determinable only in relation to, by virtue of its specific difference from, all the rest. 'It is in the chain of the signifier that the meaning "insists" (insiste) but one of its elements "consists" (consiste) in the signification of which it is at the moment capable"' (p. 63).

Lacan's defence of the 'primacy of the signifier' is not just a misreading, but an

idealist distortion, of Saussure. Language, as a set of shifting signifiers 'creates' reality. Quite simply, such a view fails to address how meaning, linked to the material divisions of social and historical life, is actually produced and communicated.

66 Sollace Mitchell, 'Post-structuralism, empiricism and interpretation', *The need for interpretation*, ed. Sollace Mitchell and Michael Rosen, New York, 1983, p. 72.
67 Ibid., p. 80.
68 Clark, 'Preliminaries'.
69 Mitchell, 'Post-structuralism', p. 84.
70 Donald Davidson, *Inquiries into truth and interpretation*, Oxford, 1984, p. 43.
71 Charles Harrison, Michael Baldwin, Mel Ramsden, 'Manet's "Olympia" and contradiction (apropos T. J. Clark's and Peter Wollen's recent articles)', *Block* no. 5 (1981), p. 40.
72 Clark, 'Preliminaries'.
73 Griselda Pollock, 'Feminism and modernism', *Framing feminism*, ed. Roszika Parker and Griselda Pollock, London, 1987, pp. 92, 93.
74 Ernesto Laclau and Chantal Mouffe, *Hegemony and socialist strategy: towards a radical democratic politics*, London, 1985.
75 Hal Foster, *Re-codings*, Washington, 1985.
76 Stuart Hall, 'The hinterland of science: ideology and the "sociology of knowledge"', *On ideology*, series ed. Bill Schwarz, Birmingham, 1977, pp. 9-32.
77 Stuart Hall, 'Notes on deconstructing the "popular"' *People's history and socialist theory*, ed. Ralph Samuel, London (History Workshop Series), 1981, p. 239.
78 John Caughie, 'Popular culture: notes and revision', *High theory/low culture: analysing popular television*, ed. Colin McCabe, Manchester, 1986.
79 See for example N. Abercrombie, S. Hill and B. S. Turner, *The dominant ideology thesis*, London, 1980.
80 Conrad Lodziak, 'Dull compulsion of the economic: the dominant ideology and social reproduction', *Radical philosophy*, no. 49 (Summer 1988), pp. 10-17.
81 Ibid., p. 12.
82 Jürgen Habermas, 'Questions and counterquestions', *Habermas and modernity*, ed. Richard J. Bernstein, Cambridge, 1985, p. 201.
83 Imre Lakatos, *The methodology of scientific research programmes – philosophical papers volume 1*, ed. John Worrall and Gregory Currie, Cambridge, 1978.
84 See Allen Wood, *Karl Marx*, London, 1981 for an excellent discussion of teleology. See also Scott Meikle, *Essentialism in the thought of Karl Marx*, London, 1985.

2 Marxism, postmodernism and art

1 First published as *Das Wesen des Christentums*, Stuttgart, 1971.
2 Margaret Rose *Marx's lost aesthetic: Karl Marx and the visual arts*, Cambridge, 1984. Rose's return to the context in which Marx's scattered writings on art were produced is an attempt to relate those debates to Marx's fragmentary (and confused) legacy today. However, we have to dig deep in her book to uncover just where this reclamation might be situated in relation to contemporary visual art. What does emerge tentatively though, is a re-opening of those debates that various artists in the sixties extended from the Soviet modernist artists of the 1920s and their interdisciplinary aims. As Rose says in her conclusion: 'the emphasis on the opposition between "realism" and "modernism" found in most discussion of Marx's views, . . . has . . . led to the historical background to Marx's writing on and art patronage being looked at as a closed book' (p. 165).
3 Karl Marx, *Grundrisse*, Harmondsworth, 1973.
4 Marshall Berman, *All that is solid melts into air*, London, 1984.

5 Tony Fry, 'Late modernism v postmodernism', And magazine, no. 7, 1985, p. 13.
6 Perry Anderson, 'Modernity and revolution', New Left review, no. 144 (March/April 1984), pp. 96-113.
7 All that is solid melts into air, p. 89.
8 Ibid., p. 93.
9 Ibid., p. 15.
10 Ibid., p. 125.
11 'Modernity and revolution', p. 105.
12 'Utopia anti-utopia': surplus freedom in the corporate state', Artforum (May 1972): 'The American artist sees himself in freedom and free in space. For example earthworks and environmental art actions are further extensions of the artistic ego into those vast American reaches. The artist has a grasp equal to the extensions of the modern world. The artist is postulated to be a near-ultimate free being, unconstrained in following the open spaces of the modern world.'
13 All that is solid melts into air, p. 316.
14 Ibid., p. 316.
15 'Modernity and revolution', p. 109.
16 Ibid., p. 109.
17 Ibid., p. 113.
18 Berman 'The signs in the street: a response to Perry Anderson, New left review, no. 144, (March/April 1984).
19 'Modernity and revolution', p. 108.
20 Ibid., p. 112.
21 'Late modernism v postmodernism', Tony Fry, p. 13.
22 See Roy Bhaskar's The possibility of naturalism, Brighton, 1981. Also A realist theory of science, Brighton, 1978: 'It is only if we begin to see science in terms of moves and are not mesmerized by terminals that we can give an adequate account of science' (p. 147). The lessons for art from this task are obvious.
23 Raymond Williams, The politics of modernism: against the new conformists, ed. and introduced by Tony Pinkney, London, 1989.
24 Alasdair Macintyre, After virtue, London, 1981.
25 Ibid., p. 48.

3 Thatcherism and the visual arts 1

1 See for example Alex Callinicos, 'The politics of Marxism today', International socialism, no. 29 (Summer 1985), pp. 123-68 and Bob Jessop et al., 'Authoritarian/populism, two nations and Thatcherism', New left review, no. 147 (September/October 1984), pp. 32-60.
2 See for example Pete Green, 'British capitalism and the Thatcher years', International Socialism, no. 35 (Summer 1987), pp. 3-70.
3 'Authoritarian/populism: a reply to Jessop et al', New left review, no. 151 (May/June 1985), p. 119.
4 See the debates on art education in And magazine, in particular no. 8 (1986) and no. 13/14 (1987). 'The student would . . . seem, at present, to be a subject produced by disjunct discourses, one issuing – via government – from the (buyer-led) labour market articulating its demands, the other that of an archaically entrenched priesthood of the useless' (Brian Chadwick, 'Education through production', And, no. 13/14, p. 38). Market pressure on the fine arts is of course not new. In fact the ideological split between 'free creativity' and 'applied creativity' has been fundamental to the way the ideology of the fine arts has been developed and institutionalised in Britain since the

1830s. We see this clearly in the 1860s when the state sought to wrest control over art and design from the Royal Academy. Art and design education, it was argued, needed to be linked to the technical demands of production and economic competition. Under the guise of democratisation the art education that was to be on offer was to be technical and mechanical. 'Real' art was to remain the province of the elite trained artist. Thatcher's attempt to pull art (through design) under the sway of the market and the managers of industry is exactly the same process. Art education and higher education generally now operates as production system in which lecturers are 'operators' and students 'material' to be worked on, as Mike Cooley has put it (*Architect or bee?*, London, 1985).

5 'The uses of cultural theory', *New left review*, no. 158 (July/August 1986), p. 28.
6 See for example Robin Blackburn's contribution to *The forward march of Labour halted?*, London, 1981, pp. 159-64.
7 Brian Simon, *Does education matter?*, London, 1985, p. 27.
8 Perry Anderson, 'Components of the national culture', *New left review*, no. 50 (1968).
9 Martin Weiner, *English culture and the decline of the industrial spirit*, Cambridge, 1981).
10 See Nairn, *The break up of Britain*, London, 1977.
11 See for example Alex Callinicos, 'Exception or symptom? The British crisis and the world system', *New left review*, no. 169 (May/June 1988), pp. 97-106.
12 Serpentine Gallery, London.
13 Whitechapel Gallery, London.
14 Hayward Gallery, London.
15 Graves Gallery,Sheffield, Norwich Castle Museum, Herbert Art Gallery and Museum, Coventry, Camden Arts Centre, London.
16 Herbert Art Gallery and Museum, Coventry.
17 Nottingham Castle Museum, Edinburgh Arts Centre, Stirling Smith Art Gallery, Camden Arts Centre, London, Worcester Art Gallery, Winchester Gallery. See also 'Towards another picture' (1978), organised by Lynda Morris and Andrew Brighton for the Midland Group, Nottingham.
18 Richard Cork, 'Art for society's sake', *Art for society*, Whitechapel Art Gallery, London, 1978, p. 50.
19 *Ibid.*, p. 52.
20 *Ibid.*, p. 49.
21 'Art for whom?', *Art for whom?*, Serpentine Gallery, London, 1978, p. 6.
22 'Art and the social purpose of the Whitechapel Gallery', *Art for society*, Whitechapel Gallery, London, 1978, p. 8.
23 R. B. Kitaj, *The human clay*, Arts Council of Great Britain, London, not paginated.
24 *Ibid.*
25 *Ibid.*
26 John Berger, 'The Battle', *The new statesman*, 21 January 1955, pp. 70-1.
27 John Berger, 'The artist and modern society', *The twentieth century* (August 1955), p. 154.
28 Patrick Heron, 'Art is autonomous', *The twentieth century* (September 1955) p. 291.
29 Terry Eagleton, *Walter Benjamin or towards a revolutionary criticism*, London, 1981, p. 94.
30 Richard Cork, 'Fine art after modernism', *New left review*, no. 119 (January/February 1980), pp. 42-59.
31 *Ibid.*, p. 45.
32 *Ibid.*, p. 48.
33 Kitaj, *The human clay*.
34 Fuller, 'Fine art after modernism', p. 56.
35 *Ibid.*, p. 56.
36 *Ibid.*, p. 57.
37 *Ibid.*, p. 45.
38 Peter Fuller, *Beyond the crisis in art*, London, 1980.

39 Fuller, 'Fine art after modernism', p. 59.
40 For the best piece written on Fuller see 'Souvenir of 1979' by Art & Language in *Art-language*, vol. 5, no. 1 (October 1982), pp. 56-68. As they say, Fuller was saying things 'against a prevailing orthodoxy of ideological reductionists of his own invention' (p. 58).
41 Peter Fuller, 'The Hayward annual', *Artscribe*, no. 53 (July/August 1985), p. 55.
42 Peter Fuller, *Theoria*, London, 1988.
43 Fuller, 'The Hayward annual', p. 56.
44 In many ways Fuller's pastoralism aligns itself with the anti-modernist nationalism of the inter-war years, when many British artists returned to the landscape in search for a less dehumanised cultural order. See Ian Jeffrey, *The British landscape: 1920-1950*, London, 1984, for an overview of this period.
45 Patrick Wright, *On living in an old country*, London, 1985.
46 Fuller, 'Fine art after modernism', p. 44.
47 Marx and Engels, *The German ideology*, London, 1970. See the section on 'True' Socialism.
48 Berger, 'Looking forward', p. 46.
49 See Cherry and Steyn's 'The moment of realism', *Artscribe*, no. 35 (June 1982), pp. 44-9. This essay provided the initial context for 'The forgotten fifties' show. However, because of various differences with the director of the Graves Gallery, Julian Spalding, they were not involved directly in the organisation of the exhibition.
50 Brandon Taylor, *Modernism, postmodernism, realism*, Winchester, 1987, p. 89.
51 Lukács, 'Critical realism', *Critical realism*, Nottingham, 1987, p. 5.
52 Taylor, *Modernism, postmodernism, realism*, p. 138.
53 Ibid., p. 138.
54 Lukács, 'Critical realism', p. 5.
55 Raymond Williams, interview with Sue Aspinall, *Screen*, vol. 23, no. 3-4 (September/October 1982), pp. 144-52.
56 Trotsky,'Class and art', collected in *Literature and art*, ed. Paul N. Siegal, New York, 1970.
57 Ibid., p. 66.
58 Trotsky, 'Literature and revolution', collected in *Literature and art*, ed. Paul N. Siegal, New York, 1970, p. 37.
59 Trotsky, 'Class and art', p. 66.
60 Ibid., p. 66.
61 Trotsky, 'Literature and revolution', p. 37.
62 Ibid., p. 37.
63 Toni del Renzio, 'Art is modern, bourgeois, conceptual and marginal', *Art for society*, p. 26.
64 Ibid., p. 26.
65 Art & Language, *Art-language 1975-78*, Paris, 1979 p. 247.
66 Ibid., p. 246.
67 Taylor, *Modernism, postmodernism, realism*, p. 134.
68 Sara Selwood, *State of the nation*, Herbert Art Gallery publications, Coventry, p. 12.
69 Terry Atkinson and Sue Atkinson, 'British political art at Coventry', *Mute 1*, Galleri Prag, Copenhagen, 1988, p. 16.
70 Charles Harrison, 'Art & Language: some conditions and concerns of the first ten years', *Art & Language: the paintings*, Brussels, 1987, p. 12.
71 Quoted in Nicholas Pearson, *The state and the visual arts*, Milton Keynes, 1982, p. 6. The centrally controlled and exam-based National Diploma in Design was replaced in 1963 by the Diploma in Art and Design. Dip. A.D courses were given almost autonomy in the structure, teaching and assessment of courses. The basis of such courses was a liberal commitment to free expression. This legacy has contributed a great deal to the failure of art-school staff and management to defend their ground against the current economic restructuring. Faced with the ideology of free expression on one hand, and

a left critique of such an ideology in many art-school cultural/related studies departments as the only visible option on the other, the Tories have simply said: 'why not dump the lot?' Their 'centres of excellence' (predominantly London-based) are an attempt to weaken art education further as a place of critical independence. Art-school management has clearly colluded in this, the cuts offering them a perfect opportunity to get rid of all those bothersome left-liberals in the studios and related studies areas.

72 See for example Neil Bolton, *The psychology of thinking*, London, 1972.

73 Roy Bhaskar, *The possibility of naturalism*, Brighton, 1979, p. 104.

74 Art & Language, 'Portrait of V. I. Lenin', *Modernism, criticism, realism*, London, p. 168.

4 Thatcherism and the visual arts 2

1 Perry Anderson, *In the tracks of historical materialism*, London, 1984.

2 John Berger, *Ways of seeing*, Harmondsworth, 1972.

3 See for example Hall's 'Brave new world' in *Marxism today*, October 1988, a special issue on 'New Times', pp. 24-9.

4 Roy Bhaskar, *Reclaiming reality: a critical introduction to contemporary philosophy*, London, 1989, p. 3.

5 A. Rees and F. Borzello, eds., *The new art history*, London, 1986.

6 *Artscribe international*, no. 61 (January/February 1987), p. 89.

7 *Ibid.*, p. 89.

8 The transcripts of the debates were published in *Studio international*, vol. 194, no. 999 (1978), pp. 98-110.

9 *Ibid.*, p. 103.

10 *Ibid.*, p. 104.

11 Simon Watney, introduction to *Photographic practices: towards a different image*, ed. Stevie Bezancenet and Philip Corrigan, London, 1986, p. 3.

12 Clearly, though, there is a greater depth in historical writing on photography in the USA and France. The critical histories of British photography are yet to be written.

13 Victor Burgin, in *1965-1972 – when attitudes became form*, Kettle's Yard Gallery, Cambridge, 1984.

14 *Ibid.*, p. 20.

15 See for example Don Slater, 'The object of photography', *Camerawork*, no. 26 (1983): 'Photographs of the last century were nouns: they were about space, solidity, permanence, factness, about the continuity of a valued object achieved through its memorialisation . . The photograph today is a verb, it is about events, action, movement about the transportation of insubstantial realities across time' (p. 5).

16 Victor Burgin, ed., *Thinking photography*, London, 1982.

17 Peter Wollen, *Readings and writings*, London, 1982.

18 See in particular the catalogue for Hilliard's show at the Institute of Contemporary Arts, London in 1984: 'A real challenge would be to take the critical consciousness of Conceptual Art, the architectural awareness of Minimalism, the techniques and image sources of the mass media and articulate them with the visual flair of the Eighties' ('Extracts from an exchange of letters between John Hilliard and Michael Newman', not paginated).

19 See the catalogue *Fragments* for Stezaker's 1978 show at the Photographers' Gallery, London: 'Most photography tends to ignore or suppress the subjective relations involved in its production and thereby conceals the hold which the picture exerts in forming (giving space to) the imagination by emphasising the natural tie between the world and the photographic image. The contract between the photograph and external reality remains unchallenged as the core or authentication of the photographic act' (pp. 6-7).

20 Burgin, 'The absence of presence: conceptualism and postmodernisms', p. 20.
21 Victor Burgin, ed., introduction, Thinking photography, p. 9.
22 Owen Kelly, Community, art and the state, London, 1984.
23 Jo Spence and Rosy Martin, 'New portraits for old: the use of the camera in therapy', Feminist review, no. 19 (Spring 1985), p. 67.
24 Jo Spence, 'Forum on documentary', Creative camera, February 1986, p. 10.
25 Jo Spence, 'A picture of health?', Spare rib, no. 163, February 1986, pp. 19-24; 'A picture of health'? part 2', Spare rib, no. 165, April 1986, pp. 20-5. See also Spence's 'Body beautiful or body in crisis', Open mind, no. 21, June 1986, pp. 10-13. The exhibition 'Picture of health: alternative approaches to breast cancer' was first shown at the Cockpit Gallery, London, 1984.
26 Jo Spence, 'The picture of health?', Spare rib, no. 167, June 1986, p. 85.
27 See Leo Steinberg, 'The sexuality of Christ in Renaissance art and in modern oblivion', October, no. 25 (Summer 1983).
28 Jo Spence, unpublished interview with John Roberts, 1985.
29 Ibid.
30 Ibid.
31 Ibid.
32 Quoted by Thompson on the opening of the exhibition at County Hall, London, to inaugurate the Greater London Council Peace Year (14 January 1983).
33 Peter Kennard, unpublished interview with John Roberts, 1985.
34 See Christopher Butler, After the wake, Oxford, 1980.
35 Peter Wollen, Readings and writings, London, 1982, p. 214.
36 First shown at the Gardner Centre for the Arts, University of Sussex, 1976.
37 Susan Hiller, interview with Paul Buck, Centerfold, Toronto, October/November 1979, p. 39.
38 Susan Hiller, 'Looking at new work': an interview with Roszika Parker in Susan Hiller 1973-83: the muse my sister, Orchard Gallery, Derry, 1985, p. 26.
39 Ibid., p. 28.
40 Ibid., p. 22.
41 Ibid., p. 22.
42 First shown at Gimpel Fils Gallery, London, 1982.
43 In Breton's essay, 'The automatic message' (What is Surrealism? selected writings of André Breton, ed. Franklin Rosemont, London, 1974), automatic writing is celebrated as a triumph over 'rationalistic refinement' and as a 'vehicle for revelation'.
44 First shown at Gimpel Fils Gallery, London, 1983.
45 Sigmund Freud, The interpretation of dreams, Harmondsworth, 1976.
46 Belshazzar's feast was shown at the Tate Gallery, London, during the early summer of 1985. It was also televised on Channel 4 at 11.45 pm, 28 January 1986.
47 Susan Hiller, Tate new art/the artist's view, Susan Hiller Belshazzar's feast, interview with Catherine Lacy, Tate Gallery Publications, London, 1985, p. 7.
48 Ibid., introduction, p. 5.
49 First shown at 'A space', Toronto, 1981.
50 See Monument, Ikon Gallery Publications, Birmingham, 1981, for details of names on plaques.
51 Lewis Biggs, Iwona Blaszczyk and Sandy Nairne, Objects and sculpture, ICA Publications, London, 1981, p. 6.
52 Michael Fried, 'Art and objecthood', Artforum (June 1967), reprinted in Minimal art: a critical anthology, ed. Gregory Battock, New York, 1967, p. 28.
53 Ibid., p. 23.
54 Douglas Davis, Art-culture: essays on the postmodern, New York, 1977, p. 47.
55 Terry Eagleton, Walter Benjamin or towards a revolutionary criticism, London, 1981, p. 61.
56 For a discussion of the American connection, see for example Lynne Cooke, 'Object

lessons: just what is it about today's sculpture that makes it so different, so appealing?',
Artscribe international, no. 65 (September/October 1987), pp. 55-9.

57 See for example 'Onward Christian soldiers', Peter Fuller interviewed by Matthew
Collings, *Artscribe*, no. 52 (May/June 1985), pp. 40-5, Fuller's review of the 1985
Hayward Annual, *Artscribe*, no. 53 (July/August 1985), pp. 54-6, and his contribution
to 'Likely prospects: a British art questionnaire', *Artscribe*, no. 50 (January/February
1985), pp. 27-8. For Fuller's general position on sculpture see his 'Lee Grandjean and
Glynn Williams', *Art Monthly*, no. 51, November 1981, pp. 15-18, and 'Black cloud over
the Hayward', *Art Monthly*, no. 70, October 1983, pp. 12-13.

58 See for example 'Sculpture, design and three-dimensional work', *Artscribe international*, no.
58 (June/July 1986), pp. 60-4.

59 Tate Gallery collection, London.

60 Private collection.

61 All first shown at the Whitechapel Gallery, London, 1981.

62 Karl Marx, *Grundrisse*, Harmondsworth, 1973, p. 94.

63 *Ibid.*, p. 93.

64 Unpublished interview with John Roberts, 1981.

65 T. J. Clark, 'Preliminaries to a possible treatment of "Olympia" of 1865', *Screen* (Spring
1980), p. 40.

66 Harrison, 'Sculpture, design, three-dimensional work', p. 64.

5 Imaging history: the history painting of Terry Atkinson

1 T. J. Clark, 'Preliminaries to a possible treatment of "Olympia" in 1865', *Screen* (Spring
1980), p. 40.

2 T. J. Clark, *Image of the people: Gustave Courbet and the 1848 Revolution*, London, 1973, p. 158.

3 David Salle, 'The paintings are dead', *Cover*, Vol. 1, No. 1 p. 5, May 1979.

4 Tom Lawson, 'Last Exit: painting', *Art forum* (October 1981), p. 45.

5 Much of this thinking in fact can be traced back to Alfred Stieglitz's exhortation to the
American artist to think 'more about the actual relationships in the pictures and less
about the subject-matter as such'. See Bram Dijkstra, *Cubism, Stieglitz and the early poetry of
William Carlos Williams*, Princeton, 1969, for an overview of early American modernism.

6 Michael Phillipson, *Painting, language and modernity*, London, 1985.

7 *Ibid.*, pp. 176-7.

8 For an overview of the debates see Terry Lovell, *Pictures of reality*, British Film Institute,
London, 1980.

9 See Sollace Mitchell, 'Post-structuralism, empiricism and interpretation', *The need for inter-
pretation*, ed. Sollace Mitchell and Michael Rosen, London 1983.

10 See 'Remarks from hindsight' in *Terry Atkinson: work 1977–83*, Whitechapel Gallery,
London, 1983. The notion of 'botching' is fundamental to the early work. On
occasions, though, this putting of painting in 'quotation marks' suffers from too robust
strategies of 'de-skilling'. T. J. Clark also raises similar doubts about some of Atkinson's
strategies in a letter (unpublished) that he wrote to the artist after Atkinson's
Whitechapel show. He criticises the early First World War paintings and drawings for
their indirectness and recognises that the taking on of a 'hotter' idiom (see 'Politics
and the resources of expression', a discussion between Terry Atkinson and Jon Bird,
Art monthly, June 1983) was an attempt to remedy this. 'You've probably got to do
history painting hot, not to say torrid', but, he adds, without a 'leaven of irony'. He
describes Atkinson's refusal to 'take on paint' as 'overdetermined' – even if justified

in the circumstances, adding further that it is difficult not to let the 'botching' turn glib.

11 Gregor McLennan, *Marxism and the methodologies of history*, London, 1981, p. 73.

12 From Isaiah Berlin, *Vico and Herder*, London, 1976, quoted in Roy Bhaskar's *The possibility of naturalism*, Brighton, 1979.

13 *Ibid.*, p. 75.

14 First shown at the Whitechapel Gallery, London.

15 Terry Atkinson, *Cooking the books*, Air Gallery, London, 1987, p. 10.

16 Unpublished notes to Atkinson's exhibition at the Stedelijk van Abbemuseum, 1984 (not paginated).

17 Terry Atkinson, 'Art of the New Jerusalem', *Artscribe*, No. 52 (1985), p. 18.

18 Terry Atkinson, 'Materialism, by Jove!', *Block*, No. 1 (1979) p. 37.

19 Linda Hutcheon, *Theory of parody*, London, 1985.

20 *Ibid.*, p. 7.

21 *Ibid.*,: see chapter 4, 'The paradox of parody'.

22 *Ibid.*, p. 44.

23 *Ibid.*, p. 93.

24 1985–86.

25 1987.

26 H. N. Brailsford, *The Levellers and the English revolution*, ed. and prepared for publication by Christopher Hill, Nottingham, 1961.

27 Tate Gallery collection, London.

28 John Roberts, 'Terry Atkinson: postcards from the Front', *Parachute*, no. 35 (June/August 1984), p. 26.

29 John Roberts, 'Representing Ireland: an interview with Terry Atkinson', *Mute* 11, Orchard Gallery, 1989.

30 Atkinson, *Cooking the books*, p. 16.

31 Christopher Hill, *The Puritan revolution*, London, 1968.

32 Tom Paulin, *Liberty tree*, London, 1983, p. 16.

33 Unpublished notes to Atkinson's exhibition at the Stedelijk van Abbemuseum, 1984 (not paginated).

34 Terry Atkinson, 'Predicament' in *Brit Art*, London, 1987, p. 3.

35 *Ibid.*, p. 6.

36 Atkinson, 'The Goya series' in *Brit art*, p. 5.

37 *Ibid.*, p. 6.

38 Theodor Adorno, *Aesthetic theory*, London, 1984.

39 Gillian Rose, *The melancholy science: an introduction to the thought of Theodor W. Adorno*, London, 1978, p. 139.

40 Adorno, *Aesthetic theory*.

41 See for example 'Following a rule: from Russia with love', *Terry Atkinson: Work 1977–83*, and 'Late modernism v post modernism', *And* magazine, no. 7, 1985.

42 Voloshinov, *Marxism and philosophy of language*, first pub. 1929, Cambridge, Mass., 1986.

43 Raymond Williams, 'The uses of cultural theory', *New left review*, no. 158 (July/August 1986).

44 *Ibid.*, p. 26.

45 *Ibid.*, p.26.

46 *Ibid.*, p. 68.

47 *Ibid.*, p. 21.

48 *Ibid.*, p. 22.

49 *Ibid.*, p. 23.

50 *Ibid.*, p. 23.

51 *Ibid.*, p. 17.

52 *Ibid.*, p.17.

53 Ken Hirschkop, 'Bakhtin, discourse and democracy', *New left review*, no. 160 (November/December 1986), p. 111.

54 See Atkinson's 'Late modernism v post modernism': 'For [the politics of art] to have a cutting edge and its vanguardness to have credibility, future cultural organisations will have to reach a better exchange and interaction with the organised working class. This will mean being determined to get a voice on their platforms' (p. 9).

6 Realism, painting, dialectics: Art & Language's museum series

1 Marcel Breuer, Quoted in *The New York art review*, ed. Les Krantz, New York, 1982, p. 53.
2 'Radical attitudes to the gallery', *Studio international*, vol. 195, no. 990 (1980), p. 37.
3 Unpublished interview with Art & Language by Mike Archer and John Roberts, 1985.
4 Hilary Putnam, *Reason, truth and history*, Cambridge, 1981.
5 Unpublished interview with Art & Language by Mike Archer and John Roberts, 1985.
6 First exhibited at the Jan Sack Gallery, Antwerp.
7 Charles Harrison, 'Art & Language: incidents in a museum', *Confessions: incidents in a museum*, catalogue to Art & Language exhibition, Lisson Gallery Publications, London, 1986, p. 11.
8 *Ibid.*, p. 17.
9 Coversation with the author, November 1986.
10 Unpublished interview with Art & Language by Mike Archer and John Roberts, 1985.
11 *Ibid.*
12 *Ibid.*
13 Art & Language, *Julian Opie's sculptures*, Lisson Gallery Publications, London, 1985, p. 10.

7 Painting and sexual difference

1 See Jane Gallop, *Feminism and psychoanalysis: the daughter's seduction*, London, 1982.
2 Roszika Parker and Griselda Pollock, eds., *Framing feminism*, London, 1987.
3 Jean Grimshaw, 'Philosophy and aggression', *Radical philosophy*, no. 47 (Autumn 1987), p. 18.
4 Jean Fisher, *On the margins of forgetfulness*, Lisson Gallery/Renaissance Society Publications, London, 1987.
5 *Ibid.*, p. 6.
6 *Ibid.*, p. 10.
7 *Ibid.*, p. 10.
8 *Ibid.*, p. 23.
9 *Ibid.*, p. 29.
10 Jacqueline Rose, *Sexuality in the field of vision*, London, 1985, p. 3.
11 Mary Kelly, 'Re-viewing modernist criticism', *Screen*, vol. 22, no. 3 (1981), p. 62.
12 John Berger, 'The artist and modern society', *The twentieth century*, August 1955, p. 154.
13 Rose, *Sexuality in the field of vision*, pp. 227-8.
14 First shown at the Institute for Contemprary Art, London, in 1976.
15 Kelly, 'Re-viewing modernist criticism', p. 62.
16 *Ibid.*, p. 61.
17 See Michele Barratt, 'Feminism and the definition of cultural politics', *Feminism, culture and politics*, ed. Rosalind Brunt and Caroline Rowan, London, 1982.

18 Jacques Lacan, Ecrits: a selection, London, 1977.
19 Rose, Sexuality in the field of vision, p. 78.
20 See for example Kristeva's 'Woman can never be defined', New French feminisms, ed. Elaine Marks and Isabelle de Coutivion, New York, 1981.
21 Luce Irigaray, This sex which is not one, Ithaca, 1985. See also Margaret Whiteford, 'Luce Irigaray and the female imaginary', Radical philosophy, no. 43 (Summer 1986), pp. 3-8.
22 Peter Gidal, 'Fugitive theses re Therese Oulton's The passions No 6 and the Metals paintings', (1984), Gimpel Fils Publications, London, 1984.
23 Rosa Lee, 'Resisting amnesia: feminism, painting and postmodernism', Feminist review, no. 26 (Summer 1987), pp. 5-28.
24 Ibid., p. 24.
25 Ibid., p. 24.
26 Ibid., p. 18-19.
27 Michele Barratt, 'The concept of difference', Feminist review, no. 26 (Summer 1987), p. 31.
28 Germaine Greer, Obstacle race, London, 1982.
29 First shown at the Air Gallery, London, 1987.
30 Artist's collection.
31 Series first shown in 'Black skin/bluecoat', Bluecoat Gallery, Liverpool, 1985.
32 John Roberts, 'Interview with Sonia Boyce', Third text, no. 1 (Autumn 1987), pp. 55-64.
33 T. J. Clark, 'Clement Greenberg's theory of art', Pollock and after: the critical debate, ed. Francis Frascina, London, 1985, p. 55.
34 Terry Eagleton, Walter Benjamin or towards a revolutionary criticism, London, 1981.
35 Jane Gallop, Feminism and psychoanalysis: the daughter's seduction, p. 74.
36 See Druscilla Cornell and Adam Thurschwell, 'Feminism, negativity, intersubjectivity', Feminism as critique, ed. Seyla Benhabib and Druscilla Cornell, Cambridge, 1987.
37 See also Peter Dews, The logics of disintegration, London, 1987.

8 Postmodernism and the critique of ethnicity: the work of Rasheed Araeen

1 See G. W. F. Hegel, The philosophy of fine art, London, 1920. For a discussion of 'historic' and 'non-historic' nations see Renaldo Munck, Marxism and nationalism: the difficult dialogue, London, 1985.
2 G. W. F. Hegel, Lectures on the philosophy of religion, London, 1985, quoted in Partha Mitter, Much maligned monsters, Oxford, 1977, p. 217.
3 Mitter, Much maligned monsters.
4 Hegel, Philosophy of fine art, p. 7, quoted in Mitter, Much maligned monsters, p. 212.
5 See Friedrich Creuzer, Symbolik and mythologie der alten Völker, Leipzig and Darmstadt, 1810. See also chapter 4 of Mitter's Much maligned monsters.
6 Edward Said, Orientalism, London, 1978, p.58.
7 Ibid., p. 51.
8 Ibid., p. 62.
9 Mitter, Much maligned monsters, p. 202.
10 Salman Rushdie, Satanic verses, London, 1988.
11 Rasheed Araeen, 'The art Britain really ignores', Making myself visible, London, pp. 102, 103.
12 See One Azania, one nation, written under the pseudonym of No Sizwe, London, 1980.

13 Unpublished inteview with Rasheed Araeen by John Roberts, 1985.
14 Rasheed Araeen, 'From primitivism to ethnic arts', *Third text*, no. 1 (Autumn 1987), p. 17.
15 See Richard Wright, 'Blueprint for Negro writing', *Race and class*, vol. 3, no. 4 (1980), pp. 403-12.
16 Keith Piper, statement, 1984, not paginated.
17 *Ibid.*
18 '*Paki-bastard*' first performed July 1977 at Artists for Democracy, London; *Burning ties* first shown at the Pentonville Gallery, London, 1983; *Ethnic drawings* first shown at the Pentonville Gallery, London, 1983.
19 Unpublished interview with Rasheed Araeen by John Roberts, 1985.
20 First shown at the Pentonville Gallery, London , 1984.
21 Unpublished interview with Rasheed Araeen by John Roberts, 1985.
22 First shown at the Pentonville Gallery, London, 1986.
23 Unpublished interview with Rasheed Araeen by John Roberts, 1985.
24 Nigel Harris, *The end of the third world: newly industrialising countries and the decline of an ideology*, Harmondsworth, 1986, p. 122.
25 Aijaz Ahmed, 'Jameson's rhetoric of otherness and the "national allegory"', *Social text*, no. 17 (Autumn 1987), pp. 3-25. Fredric Jameson's essay 'Third world literature in the era of multinational capitalism' is in *Social text*, no. 15 (Autumn 1986), pp. 65-88.
26 Ahmed, 'Jameson's rhetoric of otherness', p. 10.
27 *Ibid.*, p. 10.
28 Jameson, 'Third world literature', p. 71.
29 *Ibid.*, p. 69.
30 Ahmed, 'Jameson's rhetoric of otherness', pp. 12-13.
31 Fredric Jameson, 'A brief response', *Social text*, no. 17 (Autumn 1987), p. 26.
32 Ahmed, 'Jameson's rhetoric of otherness', p. 11.
33 Unpublished interview with Rasheed Araeen by John Roberts, 1985.
34 Fredric Jameson, 'Postmodernism, or the cultural logic of late capitalism', *New left review*, no 146 (July/August 1984), p. 92.

Index